REFLECTIONS OF

REALITY:

AMERICAN PAINTINGS FROM

THE COLLECTION OF

JOHN AND SUSAN HAINSWORTH

by
RICHARD H. LOVE
and
MICHAEL PRESTON WORLEY, Ph.D.

Haase-Mumm Publishing Company, Chicago
2005

ISBN 0-940114-55-0
Published by Haase-Mumm Publishing Co., Inc., Chicago
Printed in the United States of America
First Edition

Library of Congress Cataloging-in-Publication Data

Love, Richard H.
 Reflections of Reality: American Paintings from the Hainsworth collection / by
Richard H. Love and Michael Preston Worley.
 p. cm.
 Includes bibliographical references and index.
 ISBN 0-940114-55-0 (alk. Paper)
 1. Painting, American--19th century--Catalogs. 2. Painting, American--20th
century--Catalogs. 3. Painting--Private collections--United States--Catalogs. 4.
Hainsworth, John, M.D.--Art collections--Catalogs. I. Worley, Michael Preston, 1950- II.
Title.

ND210.L685 2004
759.13'074'77311--dc22
 200407318

CONTENTS

PREFACE
by John Hainsworth, M.D.

During the first 25 years of my life, the possibility of becoming a collector of American art would have seemed remote. During that time, my primary means of artistic expression and interest was musical, having begun classical piano lessons at the age of five. Besides music, however, I had little exposure to the arts, being raised by parents who were both strongly oriented to science and mathematics. My progress through undergraduate studies and subsequent medical school was also relatively goal oriented, ever since I made the decision to become a physician in the sixth grade. However, even during my childhood, my interest in collecting became apparent, in extensive collections of stamps and coins.

My appreciation of painting and the visual arts developed slowly, after I had completed medical school. During those years, I first had the time and the means to travel, and began to visit art galleries and museums. Also at that time, I was lucky to meet and later marry Susan, who was considerably more knowledgeable about art and artists than I was. I remember vividly my first visit to the Art Institute of Chicago. Of all the many masterpieces, I remember standing for 20 minutes in front of Renoir's *On the Terrace*. Here were a beautiful young mother and daughter in Sunday dress, seated comfortably on a public terrace. With the rich blues and violets of the dresses, the mother's scarlet hat, the profusion of flowers, all in a brilliant midday light, this painting was one of the most visually arresting in the museum. However, the allure of this painting went beyond the array of brilliant colors – for me, Renoir had somehow captured the beauty, vitality, and optimism of youth on this canvas. Thirty years later, I still visit this painting every time I'm in Chicago.

As time has passed, this type of strong reaction to certain paintings has intensified, along with increased experience and knowledge. Fortunately, Susan shares the same response to art (although not always to the same paintings), so our first order of priority when visiting a new city is to locate the museums. Just recently, we both stood transfixed in the National Gallery in London, viewing the late works of Caravaggio. Here, in these depictions of familiar Biblical scenes, were captured the gamut of human emotions--fear, anguish, cruelty, doubt, forgiveness, love--all as powerful today as when created by this greatest of masters 400 years ago.

Our own collection began slowly, at least in part due to our financial status at the time. Our first purchases were original prints by master artists. Although these are not unique works, it was thrilling at the time to own actual pieces created by great artists. To this day, our Mary Cassatt etchings and drypoints remain sentimental favorites. We continued to haunt museums and art galleries wherever we traveled, gradually gaining more insight into European and American painting. The second phase of our art collecting started in the late 1980s, when we began to purchase oil paintings by contemporary American artists. During those years, we made frequent visits to the galleries in Santa Fe, as well as those in other major U.S. cities. With the guidance and assistance of our long-time friend and collector Ron Bronitsky, MD (who was himself putting together a notable collection of Southwest American and Indian art), we developed increasing appreciation of the regional art from the Taos and Santa Fe art colonies. Even as we purchased works by contemporary artists, we became increasingly fond of the works of the Taos masters, particularly E. Martin Hennings and Walter Ufer, as they captured the unique light and "sense of place" of northern New Mexico.

The idea for our current collection evolved gradually, as our appreciation of the breadth and variety of 19th and early 20th century American art increased. We were fortunate that American art of this period remains undervalued when compared to European art, allowing us the opportunity to acquire some works by great American masters. Our preference for representational art led us to focus on the art from the mid-

nineteenth century through the 1930's, at the point when modernism and abstract art became the dominant movements. Several of the earliest works in our collection are Hudson River School paintings, representing the first uniquely American art movement. The major piece in this group is the large-scale work entitled *The Tunnel near Giornico on the St. Gotthard Pass*, painted in 1862 by Russell Smith, following his European Grand Tour. The grandeur of nature, which provided an harmonious presence for man, was a major goal of the Hudson River painters, and is beautifully typified in this painting. Other Hudson River School works include those by Sarah Barstow, Samuel Gerry, Joseph Hekking, as well as an exquisite late luminist work by Jasper Cropsey. During the last part of the nineteenth century, two of the most celebrated American landscape artists were tonalists George Inness and Alexander Wyant; works by both of these artists are represented in this collection.

During the latter part of the nineteenth century, aspiring American artists went to Europe, primarily France and Germany. While many painters studied at the academies and visited the Salon in Paris, others opted for training at the Munich Academy. The beautiful works of John White Alexander and Carl Cutler demonstrate a couple of the styles of figure painting that one would see at the Salons. The still-life by J. Alden Weir, painted prior to his conversion to impressionism, shows his more traditional side. However, many of the Americans in Europe at that time responded to the avant-garde movements in France, notably impressionism, which comprises a large part of this collection. Our impressionist works begin with examples from the very early American practitioners of the French aesthetic (Robert Vonnoh, Dawson Dawson-Watson, Theodore Earl Butler) who adopted the techniques in France in the 1880's, and spent significant portions of their lives as expatriates in Europe. As impressionism gained acceptance in America, a number of already well-known American artists returned from Europe with the intention of adapting the French technique to American subjects. Several of these artists, led by Childe Hassam and others, formed a group subsequently known as "The Ten," and held their own exhibitions in New York beginning in 1898. Depicting typically American cityscapes and the New England countryside, as well as acting as teachers for a new generation of American artists, this group played an important role in the developing American art scene. Works by several of these artists (Hassam, Weir, John Twachtman) are represented in this collection. Other well known artists in the New York area also worked in the impressionist technique. One of the best examples – and one of the finest works in this collection – is F. Luis Mora's *In the Orchard*. In this painting, several well-dressed members of the "leisure class" enjoy an outdoor picnic on a bright, sunny day. Such images were common impressionist subjects; in this large painting, the picnickers are frozen in an informal, candid moment. The scene's transitory nature has been successfully captured by the superb juxtaposition of adjacent areas of light and shade – the essence of impressionism.

During the early 1900's, interest in art spread beyond the metropolitan centers, and a number of regional art colonies developed. Impressionism was initially a common aesthetic in these colonies, and in our collection, works from several of the prominent colonies (Cos Cob, Old Lyme, Cape Ann, the Hoosier School) are represented. At the same time, American painters who sought directions other than impressionism turned their attention to the rapidly growing urban centers, and began to paint images illustrating the daily activities of working-class (as opposed to leisure-class) people. However, these artists seldom produced images of hopeless poverty; rather, they focused on life in the bustling, crowded cities, with common people doing their best to cope with the hardships imposed. At the forefront of this movement was the group of realist painters led by Robert Henri (often referred to as the "Ashcan" painters owing mostly to their choice of subject matter). Our collection includes examples of the work of several of these painters; most typical are John Sloan's depiction of the New York-New Haven coaling station and Everett Shinn's theater scene. The move towards depicting the unique and varied qualities of the American landscape and people continued with the American Scene painters and regionalists, whose heyday was the 1930s. The spectacular landscapes of Carl Peters and Carl Krafft capture the essence of upstate New York and rural Arkansas, respectively. The collection ends chronologically with works by several regionalist artists. It is

hard to imagine scenes that exude typical "Americana" more than those of a southern revival meeting (Thomas Hart Benton), cotton pickers in Missouri (Joseph Vorst), or a traveling circus (Lewis Krawiec).

The American landscape has always provided a major inspiration to our nation's artists, and a wide variety of landscapes is represented in this collection. Although a few of the earlier works were painted abroad, most of the paintings represent American scenes. Landscapes range from American icons, such as the Grand Canyon and Niagara Falls, to the more intimate depictions of the American forests, mountains, and streams in various seasons of the year. Genre pictures in the collection also represent typical American themes: pre-Civil war buckskin-clad trappers, boys on a raft, an outdoor laundry day, and Sunday afternoon picnics. Finally, figurative works in the collection range from the small charming portrait by William Sydney Mount, painted in 1847, to the sun-filled depictions of beautiful women with great bravura by impressionists Louis Betts, Arthur Houlberg, and George Schultz. Our goal was to create a collection that would capture, in part, the multifaceted spirit of America, during a time when our nation was rapidly developing into a world power. In celebrating the beauty of the land and its people, these artists reflect the general sense of optimism and Manifest Destiny so pervasive at the time. As Americans they struggled to prove the strength of their visions both at home and abroad. They believed in themselves and the art they were producing.

In the end, however, our motivation in collecting was not to create an encyclopedic chronicle of American art, but rather to assemble works that we find beautiful, and, in some way, personally moving. Great painting always transcends the merely representational, as the artist injects his own thoughts, feelings, and interpretations into the image. In writing about art, the German impressionist Max Liebermann said: "What makes a few hieroglyphics on a piece of paper or a few colored spots on the canvas give rise to the highest spiritual feeling within us? What else but the spirit, which infused life into the chalk, into the brush! Only the spirit creates reality...To make visible the invisible: that is what we call art." Susan and I both marvel at the good fortune that has allowed us to acquire these paintings, and to serve as their temporary caretakers. Hardly an evening passes that we don't circle through our home and pause in front of these wonderful images. We are proud to exhibit this collection of American paintings, and hope that they bring to others a small measure of the enjoyment they have brought to us.

INTRODUCTION
by Richard H. Love

In the smallest sense of art collecting, many are capable of gathering a few images to decorate their walls; however, in the larger sense, few invest the time, trouble and money to create a collection worthy of distinction. Nevertheless, the history of American art is rich with outstanding collections of paintings. Fortunately Americans now share the cultural tradition outlined and occasionally defined by those benevolent collectors. Some were exceedingly wealthy philanthropists while others were persons of more modest means. A few actually exhausted their meager incomes to acquire works that inspired them. In any instance, all were driven to seek out, acquire and live with superb works of American art. Frequently these collections figured substantially into the holdings of museums.

Some of these persons are well known to the history of American painting. Especially worthy of mention are Charles Willson Peale (Philadelphia Museum), William T. Evans (Metropolitan Museum and Montclair Museum), George A. Hearn (Metropolitan Museum), E.B. Crocker (Crocker Art Museum, Sacramento), Thomas B. Clarke (National Gallery of Art), Joseph Green Butler (Butler Institute of American Art), William Corcoran (Corcoran Gallery), Isabella Stewart Gardner (Gardner Museum, Boston), Gertrude Vanderbilt Whitney (Whitney Museum of American Art), Maxim Karolik (Museum of Fine Arts, Boston), Dr. Albert Barnes (Barnes Foundation), Amon Carter (Amon Carter Museum, Fort Worth), Thomas Gilcrease (Gilcrease Museum, Tulsa), Samuel Nickerson (Art Institute of Chicago), John B. Herron (Indianapolis Museum of Art), Sheldon Swope (Swope Art Museum, Terre Haute), Roland P. Murdock (Wichita Art Museum), Gertrude Herdle (Memorial Art Gallery of the University of Rochester), Daniel Terra (Terra Foundation), and many more.

All of these men and women sought the substance of American art. They studied its obvious traits, characteristics, subtleties, dynamics, even the spiritual qualities. Arguably, the common denominator was their belief that American artists had revealed essential visions in their imagery. Even when the subjects were not American, there was something noticeably American about their paintings. They chose works for their collections that inspired them. They acquired what they were convinced were valuable cultural products worth saving.

There was really no secret to their search. They focused on art that inspired them, each with varying degrees of knowledge. Some pursued their paintings with obsession, others with strong perseverance but all to *discover* works that would uplift their aesthetic sensitivities. Some bought art that reflected the latest trends while others chose their pictures to conform to the opinions of art scholars. Some kept their collections quite private while others shared them with the public by lending their pictures to exhibitions. Accordingly, certain collections have achieved notable fame as a result of the collector's vision and altruism. Generally, collectors are known for their vision, some for their prophetic views, others for their conformity; yet all of them find great reward in pursuit of the next "great painting."

The Hainsworths are collectors who are not bound to specific rules about collecting. Their paintings have been acquired for personal reasons that have centered on considerable connoisseurship and devotion to the history of American art. Seldom have I seen a collector more motivated by art knowledge than John Hainsworth. His constant study of the history of American art is impressive, to say the least. Always seeking objectivity in a subjective discipline, Dr. Hainsworth is one driven by the intellectual scope of American art. His library has grown as a result of his indefatigable desire to familiarize himself with both the obvious and subtle factors that made an impact on the art he finds most interesting. Concepts are important to the Hainsworths. For example, to understand the aesthetic foundations of the Hudson River School was

important to them but John's insatiable quest to dig deeper prompted an impressive search for facts on the careers of Cropsey, Barstow, Russell Smith and Inness. Even outside the framework of the history of American art, these three painters reveal fascinating personal reactions to the art communities in which they created their images. And when their impressive canvases are considered within the large scope of the lengthy and complex history of the Hudson River School, the rationale for the acquisition of these three works is clear. The same may be said about every work in the Hainsworth Collection. Notwithstanding John's intellectual approach to American paintings, both Susan and John Hainsworth, when selecting art, do not disregard their subjective reactions and they consider what Robert Henri called the "art spirit." This is especially true of Susan, whose reaction to most acquisitions was usually "from the heart."

There are in fact other collections of American art that are equally impressive but they are usually not available for viewing. The Hainsworth Collection will travel for more than two years to various venues in the nation. Obviously this is no ordinary achievement in terms of logistics. The show speaks for itself as an important contribution to cultural education. Having devoted their time and resources to a collection that will surely achieve an outstanding reputation, the Hainsworths are sharing their vision with the public. Like other collectors before them, they have found aesthetic integrity in their images, so much so that the collection will undoubtedly be remembered as a patriotic collection assembled by the head and heart. Theirs is not a sparkling, trendy group of modernist pictures from the post-war era, but a conservative slice of American painting from the past two centuries. Here the viewer will find images that reveal a growing nation whose cultural makers struggled to acknowledge their European roots yet proudly defined their own aesthetic identities. During the formative years in which these canvases were created, one of the greatest things an American artist could achieve was to be considered as equally skillful as his European counterpart. At the same time, one was expected to contribute to a new aesthetic direction that would one day *prove* an American tradition. To a greater or lesser degree, that goal was achieved by American artists of the nineteenth and twentieth centuries. In fact, as one views American art in its proper and honest perspective, one discovers more and more fascinating qualities of that tradition. The Hainsworth Collection contributes to that discovery and serves to provide insight as to just what is American about American painting.

ACKNOWLEDGMENTS

We would like to thank Richard H. Love for his invaluable assistance in the development of this collection. His advice, expertise, and friendship have been essential to the success of this entire endeavor. His insistence on finding the best, most typical examples of each artist's work has often made the search more difficult, but has always been worth the extra effort. Special thanks as well to Michael Worley, Ph.D., for the many hours he spent researching and co-writing this book, and to the entire staff at R. H. Love Galleries for their constant cheerful assistance and attention.

Susan K. Hainsworth
John D. Hainsworth, MD

America, My Country
by Ralph Waldo Emerson

America, my country, can the mind
Embrace in its affections realms so vast
(Unpeopled, yet the land of men to be)
As the great oceans that wash thee enclose?
'Tis an ambitious charity that makes
Its arms meet round –
And yet, as sages say, the preference
Of our own cabin to a stranger's wealth,
The insidious love and hate that curls the lip
Of the frank Yankee in the tenements
Of ducal and royal rank abroad,
His supercilious ignorance
Of heraldry and ceremony,
And his tenacious recollection
Amid the colored treasuries of art
That circle the Louvre or the Pitti house, –
Tuscany's unrivalled boast, –
Of the brave steamboats of New York,
The Boston Common, and the Hadley farms
Washed by Connecticut;
Yea, if the ruddy Englishman speak true,
Of the vast Roman church, and underneath
The frescoed sky of its majestic dome,
The American will count the cost
And build the shrine with dollars in his head;
And all he asks, arrived in Italy,
Has the star-bearing squadron left Leghorn?
Land without history, land lying all
In the plain daylight of the temperate zone,
 Thy plain acts
Without exaggeration done in day;
Thy interests contested by their manifold
 good sense,
In their own clothes without the ornament
Of bannered army harnessed in uniform.
Land where – and 'tis in Europe counted a
 reproach –
Where man asks questions for which man was
 made.
A land without nobility, or wigs, or debt,
No castles, no cathedrals, and no kings;
Land of the forest.

1. ADAM EMORY ALBRIGHT
(Monroe, Wisconsin 1862 - 1957 Warrenville, Illinois)
The Raft
Oil on canvas, 48 x 36 in.
Signed lower left

Albright was trained at the Art Institute of Chicago and at the Pennsylvania Academy of the Fine Arts under Thomas Eakins (1883-86) before going to Munich and Paris for further instruction.[1] At the PAFA Albright sketched from the nude model and studied anatomy. He also mentioned photography as a teaching aid. In 1893 Albright exhibited *Morning Glories* at the World's Columbian Exposition in Chicago. In *The Raft* two boys enjoy a summer afternoon on their little raft, which the painter set at a diagonal. The two-figure group forms a stable pyramidal composition, which creates an overall monumental effect. The standing boy is in an admirable academic pose, almost like a statue. The way he holds the pole reinforces the pyramid effect with a major diagonal. The loose, painterly technique of rendering the water lilies and decorative treatment of the trees reflected in the upper right-hand corner immediately bring images of Giverny to mind, however, there is nothing similar in Monet's oeuvre prior to 1895. Albright spent the 1887-88 season in Paris but there is no record of a visit to Giverny; this would have been right at the beginning of the establishment of the American artists' colony right next to Monet's home and gardens.

Albright,[2] who would eventually build an eleven-room house and work in a log studio in Hubbard Woods, a suburb north of Chicago, might have chosen the Skokie Lagoons or the Des Plaines River for the location of *The Raft*.[3] But in 1895 he was still living in Edison Park in a smaller log house. Albright, "the James Whitcomb Riley of the Brush," sought to depict the universal spirit of childhood: "His pictures are joyous, full of sunshine, and show a deep feeling for nature. . . . these pictures [bring] back memories of happy days gone by before the shackles of the work-a-day world were felt."[4] *The Raft* shows that by 1895, Albright was obviously influenced by impressionism. A year later, Adam Albright began to exhibit at the Art Institute annual, where 185 of his paintings would be on view over the years. In 1897, twin sons were born – the one named Ivan would become the more famous Albright, the master naturalist painter of unidealized but super-detailed models. In 1903, *The Raft* was exhibited at the Carnegie Institute. Later Albright painted in Brown County, Indiana, where he was one of the few figure painters.

[1] In *For Art's Sake* (Privately printed, 1953), Albright's description of the experience in Europe is anecdotal and not too helpful.

[2] Ibid., (Albright's autobiography, *For Art's Sake*) is a major source.

[3] Another possibility might be Mill Pond at Annisquam, Cape Ann (MA) where Albright took his family in the summer. An American location seems the most likely.

[4] Minnie Bacon Stevenson, "A Painter of Childhood," *American Magazine of Art* 11 (October 1920): 432-434.

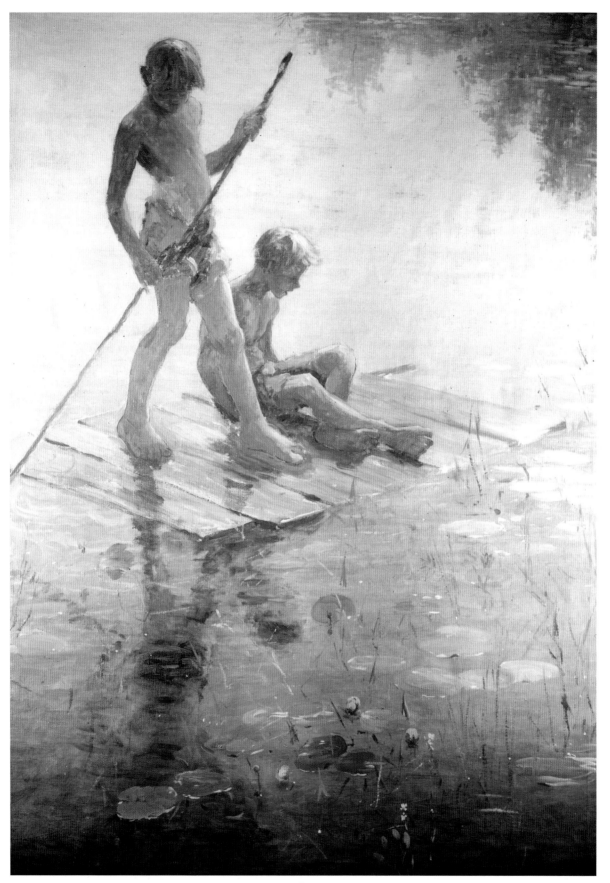

2. JOHN WHITE ALEXANDER
(Allegheny City, Pennsylvania 1856 - 1915 New York City)
Study in Black and Green
30 x 25 in. Unsigned

John White Alexander began his journey as an artist at *Harper's Weekly*, first as an office boy then as an illustrator. In Munich he associated with the "Duveneck Boys" and met Henry James and James Abbott McNeill Whistler when the group summered in Venice. Frank Duveneck (1848-1919) was so pleased with Alexander that he allowed him to teach a few of his classes. Following travels from New Orleans to North Africa, Alexander found himself back in Europe; he established himself in Paris in 1890, at the beginning of his busiest decade. The painter and his wife entertained the following celebrities at their apartment: the naturalist author Octave Mirabeau, Rodin, Oscar Wilde, the Symbolist poet Mallarmé, André Gide, and Joseph Pennell. Alexander exhibited at the "new" Paris Salon, organized by the Société Nationale des Beaux-Arts, in 1893, which immediately allied him with the progressives.

In 1897 Alexander painted his most Symbolist work, *Isabella and the Pot of Basil* (Museum of Fine Arts, Boston), which was based on William Holman Hunt's version dated 1867. Both take a poem by Keats as their subject. Other than that, Alexander was not too concerned with subject matter, for he followed Whistler and the "Art for Art's Sake" premise that a painting was foremost a pleasing arrangement of decorative forms. Alexander specialized in full-length figure paintings of women in flowing gowns and his elegant sweeping lines reflect elements of Art Nouveau. From Whistler, Alexander adapted a limited use of muted color, subtle, thin brushwork through which the weave of the canvas is apparent, and the practice of giving aesthetic titles to paintings, such as *Etude* and *The Yellow Girl*.

Study in Black and Green is a study for the larger version in the Metropolitan Museum of Art (50 x 40 inches), formerly owned by George A. Hearn, the generous collector who was a trustee of the Metropolitan Museum the last decade of his life.[5] The painting was purchased in 1908, the year in which Alexander was named President of the National Academy of Design. Arthur Hoeber found the work to have "a charming disposition of light and shade [and] an abiding sense of the decorative. . . ."[6] Naturally certain areas of the sketch have not been worked out, the lower right, for example, and details are more subtle in the final version. By 1906 Alexander had turned from his thinly applied paint surfaces of the 1890s to more bravura brushwork. Many American painters, including Alexander, focused on universal or ideal women in interiors, "personifications of a 'poetic sensitivity' . . . embodiments of beauty as well as nobility of spirit."[7]

[5] Doreen Bolger Burke, *American Paintings in the Metropolitan Museum of Art, Vol. III* (New York: 1980), p. 211, gives the complete bibliography for this painting.

[6] Arthur Hoeber, "Spring Exhibition of the National Academy of Design," *International Studio* (1908): CIV. See also the same author's article, "John W. Alexander," *International Studio* 24 (May 1908): LXXXV-LXXXIX.

[7] Sandra Leff, *John White Alexander 1856-1915: Fin-de-Siècle American*. Exh. cat. (New York: Graham Gallery, 1980), p. 15.

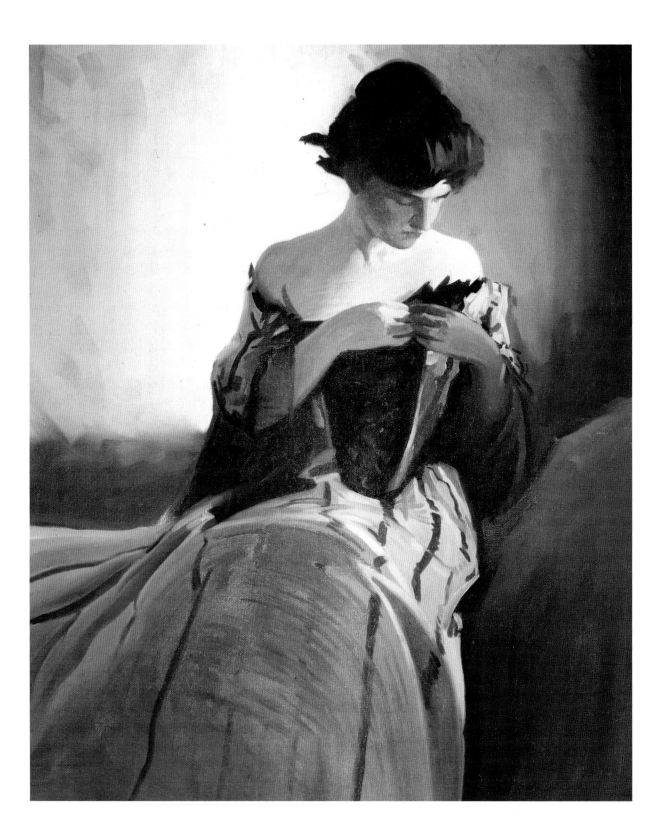

3. SARAH M. BARSTOW
(active in New York City, 1860-1891)
Mountain View with Breaking Sun
Oil on canvas, 14 x 24 in.
Signed and dated 1879, lower right

 S.M. Barstow, identified as both Sarah and Salome Barstow (dates unknown), was a prolific New York woman painter, active in the last half of the nineteenth century. She showed her landscapes early on at the National Academy of Design (1861-91) and in the Pennsylvania Academy annuals (1867-69) but apparently she was centered in Brooklyn where she exhibited at the Brooklyn Art Association between 1877 and 1886. All in all, about 115 works were on display over the years. Between 1858 and 1891 Barstow gave her address (182 Washington Street) in Brooklyn. In her earliest period she exhibited both still-life and landscape paintings, then she turned almost exclusively to landscape, seeking out mountainous regions in the Northeast, such as the Catskills, the Adirondacks, and the White Mountains. Trips to Europe are indicated: Switzerland in 1865 and 1878, Germany, Holland and Belgium in 1881, and France in 1885. Jean Lipman and Alice Winchester (*Primitive Painters in America 1750-1950*) listed Salome Barstow as a still-life painter on velvet, yet this painter was active in Massachusetts around 1820, which does not fit the landscape painter located in Brooklyn.

 The site of this wonderful storybook landscape is not known. The typical Hudson River School composition includes a distant majestic mountain (recalling the "purple mountain majesties" in our national anthem), which looms up behind the mountain lake, and an inviting strip of land in the foreground. Although it lacks the Sublime grandeur of Albert Bierstadt's Far West panoramas, Barstow's landscape does bring to mind his compositions.

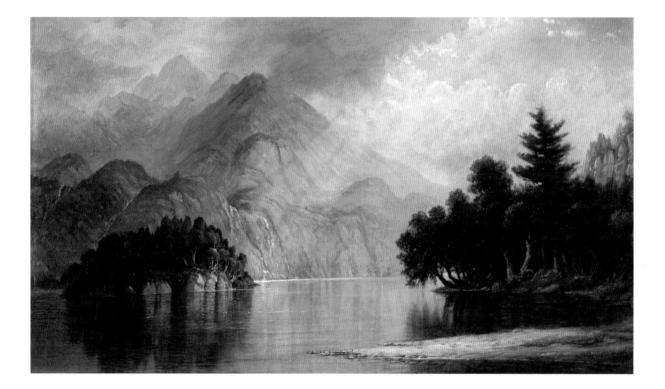

4. THOMAS HART BENTON
(Neosho, Missouri 1889-1975 Kansas City, Missouri)
Lord, Heal the Child
Oil on canvas, 12½ x 16¾ in.
Signed lower right

This preparatory painting for an oil and tempera on canvas (John W. Callison Coll., Kansas City; 42¼ x 56¼ in.) was executed in 1934, when Benton was rising like a beacon in the American art world. His self-portrait appeared on the cover of *Time* magazine at the end of that year (Christmas issue).[8] At that time, Benton became known as a Regionalist, along with John Steuart Curry and Grant Wood, and the media established them as the triumvirate of Regionalists. Benton had already completed the Whitney mural, "The Arts of Life in America" and another mural for the State of Indiana's exhibit at the Chicago World's Fair (1933).

We know that Benton was extremely interested in his composition to the fullest extent because, in addition to the preparatory work, there are several extant drawings that show the Holiness band; they range in date from 1930 to 1934. Benton's interest in the healing-by-prayer procedure goes back at least to 1926 when a Holy Roller camp meeting in Western Virginia inspired him. In fact, there is a certain rough similarity to a drawing of 1926 to the interior scene he presents in *Lord Heal the Child*. As an American Regionalist who was interested in the common population, such a display of spiritual devoutness would have fascinated him for most of his life but especially in 1934 when he focused upon this rather humble congregation in Greenville, South Carolina. The scene depicts worshipers in a "Holiness" church in that town.[9] In his painting style, Benton eliminated superfluous detail to arrive at the fundamental simplicity of the church service. The dynamic of these common folk is second only to their hope to invoke the power of the Holy Spirit to heal the child as she sits surrounded by the lady preacher and the well-meaning congregation. Such an image reveals Tom Benton at his best.

Benton himself described the scene, which he witnessed:

> When we got into the House of God the woman preacher was at
> work on a sickly child. She was praying . . . She stepped quickly
> back and forth on the pulpit, raised her hands, and prayed again.
> After a while I saw Red climb up on the platform. He sat with his
> banjo among a lot of other players, fiddlers, guitarists, and
> harmonica blowers. He was moved by the seriousness of the
> occasion and I could see his lips saying, "Amen, amen."

(TEXT CONTINUED ON PAGE 145)

[8] "U.S. Scene," *Time* Magazine 24 (24 December 1934): 24-27.

[9] See Robert L. Gambone, *Art and Popular Religion in Evangelical America, 1915-1940* (Knoxville: University of Tennessee Press, 1989), p. 11 for an excellent description of the painting and a treatment of its context.

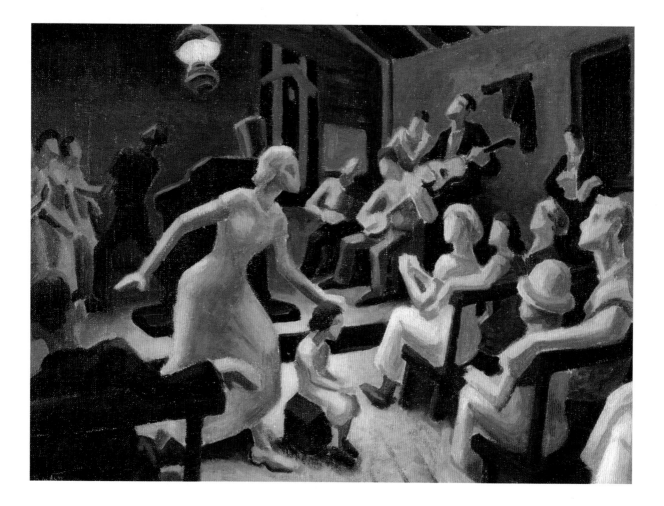

5. ARTHUR BEST
(Mount Pleasant, Ontario, Canada 1859 - 1935 Oakland, California)
The Grand Canyon
Oil on canvas, 20 x 26 in.
Signed and dated 1922, lower left

Known as a "painter of the Grand Canyon," landscapist Arthur W. Best traveled to Oregon with his brother Harry (1863-1936) in 1895. The brothers arrived as musicians in a band: Arthur played clarinet and Harry, the violin. Both moved to San Francisco and became landscape painters. While Harry started out as a cartoonist for the *San Francisco Post*, Arthur and his wife Alice (1829-1926) established the Best Art School, which grew out of a sketching club. Between 1898 and 1904 Arthur exhibited at the Mark Hopkins Institute, then a year later he was commissioned by the Southern Pacific Railroad to paint appealing images of the Southwest and Mexico for their publicity department. In 1906 many of his works were destroyed in the San Francisco Earthquake.

Meanwhile, Best was a member of the Berkeley League of Fine Arts and the Bohemian Club. In 1909 he won a bronze medal at the Alaska-Yukon Exposition in Seattle. Best died in 1935 in Oakland, California, where the Oakland Museum has one of his works. Best's paintings are also to be found at the Phoenix Art Museum, the University of Oregon, the Santa Fe Railroad Collection, and the Charles M. Russell Gallery in Great Falls, Montana. Another stunning view by Best, *The Grand Canyon* is in the Anschutz Collection.

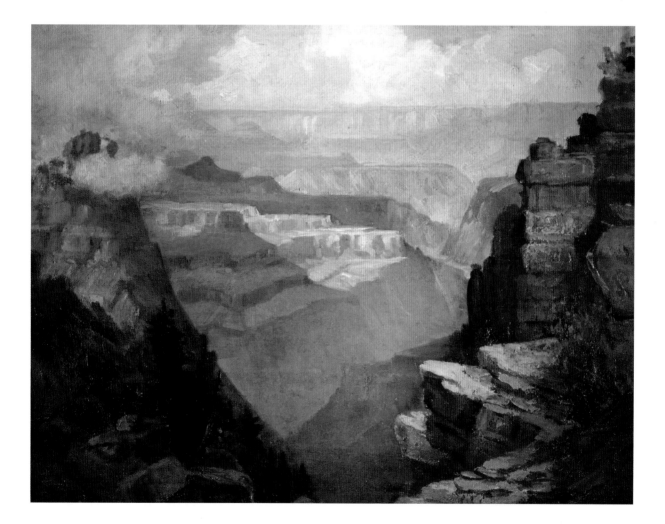

6. LOUIS BETTS

(Little Rock, Arkansas 1873 - 1961 Bronxville, New York)
Ladies in the Garden, Old Lyme
Oil on canvas, 40 x 30 in.
Signed lower left

Betts began in commercial art and illustration but started exhibiting early at the Art Institute of Chicago. The greater chance of finding work in New York lured him away from Chicago around 1900. He enrolled in the painting classes at William Merritt Chase's Shinnecock Hills Summer School on Long Island, in 1901. Betts followed Chase to the Pennsylvania Academy where he was the winner of the Cresson Traveling Scholarship a year later. In Europe he copied works of Frans Hals in Holland then studied independently in Paris. A two-week trip to Madrid with Chase led to an infatuation with Velázquez. His copy of the Spanish painter's *Queen Mariana* so impressed the Prado's director, that he called it the best copy ever made at the Prado. A one-man show took place after Betts returned to America in 1906 at the O'Brien Galleries in Chicago. That December, James William Pattison devoted an article to Betts in *The Sketch Book*.[10] The many portraits illustrated there give an idea of the style Betts had developed by that time. Typically, three-quarter-length figures occupy most of the picture space and look directly at the viewer, revealing a forthright expression. The male sitters are forcefully posed in a hand-on-hip stance that suggests influence from Titian, Bronzino, or another old master.

In 1912 Betts was elected an Associate to the National Academy of Design. He seems to have turned more to impressionism around that time. By 1915 he was a full member of the Academy and he won a bronze medal at the Panama-Pacific International Exposition in San Francisco. Around 1919, critics were describing his paintings as "very impressionistic and bold."[11] Indeed, more paintings appear that demonstrate application of thicker pigment with broad brushwork.

Our painting relates to the later style of Betts, shown in the University of Minnesota's *Under Flickering Leaf Shadows* (ca. 1934), in which two nudes are rendered in thick impasto, partially with a palette knife. In *Ladies in the Garden, Old Lyme*, post-impressionistic, highly saturated colors have been heavily applied. Purple shadows on the white dresses were derived from impressionism but the palette seems to rely more on theory or inner expression than on simple plein-air observation. In addition, the use of black outlines shows a reaction against the impressionist aesthetic. The subject, however, of smartly dressed ladies with sunbonnets and parasols, lies within the American Genteel Tradition and exudes the "Good Life" holiday spirit of the era before the first world war.

[10] James William Pattison, "Louis Betts — Painter," *The Sketch Book* 6 (December 1906): 171-180.

[11] An important article during that period is W. B. M'Cormick, "Louis Betts — Portraitist," *International Studio* 77 (September 1923): 523-525. Our quote comes from W. H de B. Nelson, "The New York Academy 1918," *International Studio* 57 (January 1919): lxxx.

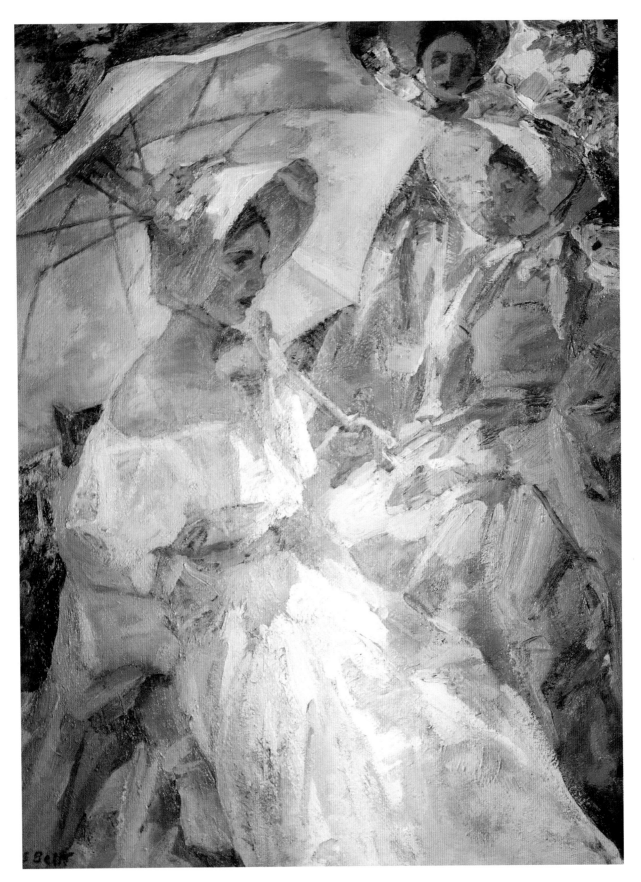

13

7. FRANK MEYERS BOGGS
(Springfield, Ohio 1855 - 1933 Meudon, France)
La Seine, Paris
Oil on canvas, 23½ x 30½ in.
Signed and dated 1897, lower right

 Boggs was a prominent American expatriate painter who established himself in France.[12] Following basic art studies in Brooklyn, Boggs went to Europe where he remained for six years. The first two years were spent in Hamburg, then he went on to Paris (ca. 1875), just when the impressionist movement was underway. Boggs, however, would develop a painting style somewhere between tonalism and impressionism. One of his associates was Johan Jongkind, a precursor of impressionism with whom Boggs is often compared. Frank Boggs passed the rigid exams at the Ecole des Beaux-Arts and studied under Gérôme, who advised him to become a landscape painter. Back in America, Boggs exhibited at the Society of American Artists' first show in 1878, then at the National Academy of Design. He returned to Paris in 1880 where he exhibited in the Salon. The French government purchased his painting *Place de la Bastille* in 1882 for the Luxembourg Museum.

 Boggs became known internationally, as he participated in important venues in America and in Europe. At the Exposition Universelle of 1889 he won a silver medal for three paintings. By 1898 Paris was his permanent home. He became established, conservative and some say predictable but one French critic pointed out in 1907 how independent Boggs was: "he paints what he likes [and] he prefers nuance to color." Boggs was highly honored and was posthumously awarded the coveted Legion of Honor. In *La Seine, Paris*, we see the church of Notre-Dame in the far distance. Barely visible is the east end with the radiating chapels and flying buttresses, therefore we are looking from the southeast (upstream) on the Right Bank because to the right of Notre-Dame we see the Ile Saint-Louis. This is a typical gray day, associated with Northern France, and Boggs chose a very limited palette in this superb plein air river view. The sky dominates much as it would in a painting by Jongkind or Boudin.

[12] A relatively unresearched painter, Boggs was the subject of a few articles, for example, Emile Sedeyn, "Frank-Boggs," *L'Art et les Artistes* 18 (November 1913): 70-77; but a full monograph was published in 1929: see Arsène Alexandre, *Frank Boggs* (Paris: Le Goupy).

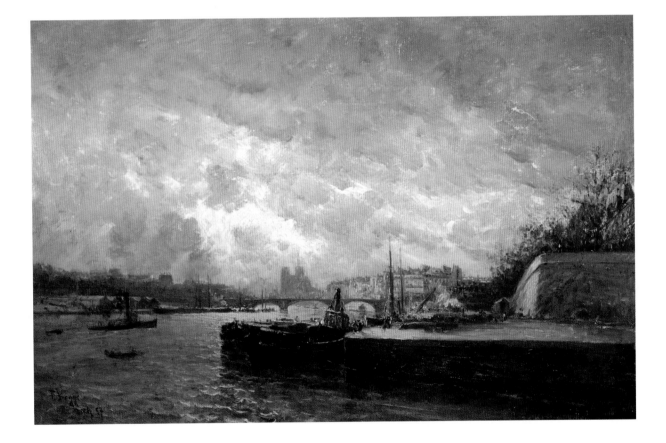

8. EDWARD DARLEY BOIT
(Boston 1840 -1915 Rome)
Looking into the Valley of the Arno, Morning
Oil on canvas, 22 x 28½ in.
Signed and dated 1898, lower left

Boit's first experience abroad was in Italy (1867), where his infant son John Cushing Boit died unexpectedly.[13] In 1868 Boit already had a one-man exhibition at Boston's Doll and Richards Gallery. During that year, John Singer Sargent stayed at the home of Boit and his wife, Mary Louise Boit, on Beacon Street. Later Boit would study under Frederic Crowninshield (1845-1918), and on a return trip to Rome in 1878 he would take lessons from William Stanley Haseltine (1835-1900). Probably following the advice of Crowninshield, Boit went to Paris to enroll in the atelier of Thomas Couture (1815-1879). Boit exhibited paintings in the Paris Salon between 1876 and 1886 (the years of the great impressionist group shows) — during that time he listed himself as a student of the landscape painter Louis Français (1814-1897). This shows that Boit was still interested in the naturalist-Barbizon landscape tradition, while in 1886, more progressive artists were already moving beyond impressionism. The titles of Boit's exhibited works indicate that he traveled to England, to Normandy, and south to Spain, then to Cannes. In 1888, at Boit's exhibition of watercolors at the St. Botolph Club in Boston, a writer called the painter one of Boston's "cleverest impressionist watercolorists."[14] Yet while Boit discovered some avant-garde techniques through Sargent and by painting in Paris in the 1870s and 1880s, his palette remained more dull than that of many other plein air painters. David Dearinger points out that Boit did display the "interest in specificity of site, climate and date, common among French and American Impressionist artists."[15]

Boit was in Italy off and on, between 1891 and 1915. He had a studio near Florence at Cernitojo. *Looking into the Valley of the Arno, Morning* has a hint of Camille Corot's plein-air style, with its gentle lighting and subtle, naturalistic tonalities.

[13] The child was buried in Rome's Testaccio Cemetery. See Regina Soria, *Dictionary of Nineteenth-Century American Artists in Italy, 1760-1914* (East Brunswick, NJ: Associated University Presses, 1982), p. 69.

[14] "Art in Boston," *Art Amateur* 18 (1888): 29.

[15] David B. Dearinger, in William H. Gerdts, *Masterworks of American Impressionism from the Pfeil Collection* (Alexandria, VA: Art Services International, 1992), p. 61.

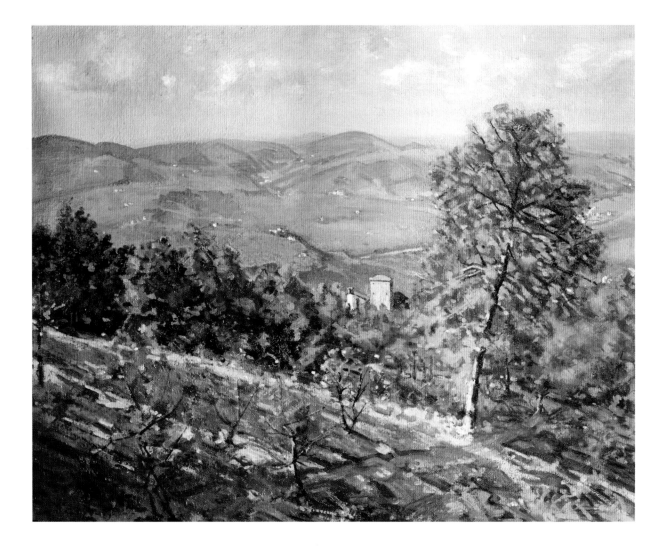

9. THEODORE EARL BUTLER
(Columbus, Ohio 1861 - 1936 Giverny, France)
Catskill Clove
Oil on canvas, 45½ x 45½ in.
Signed lower right
Date: ca. 1913

Butler, one of America's most innovative post-impressionists, might easily have been eclipsed by his famous father-in-law, Claude Monet, had he not developed his own style and subject matter — his own "baby-bathing" genre.[16] In many ways he prophesied the Nabis and the Fauves. From the Art Students League in New York (1883) Butler traveled to Paris to enter the various academies of art. With Theodore Wendel, Butler visited the village of Giverny in the spring of 1888, thus he was part of the first wave of American expatriates who would establish an artists' colony close to Monet's home and gardens. Butler married Monet's step-daughter Suzanne Hoschedé, following Monet's initial opposition, in 1892. Soon Butler was producing one striking canvas after another, influenced by the avant-garde painters Sérusier and possibly others, seeking a simplification of form and his own pictorial synthesis. Butler was the only American besides Thomas Meteyard (1865-1928) to exhibit with Pierre Bonnard, Maurice Denis and other progressives at the Barc de Boutteville show (1894). In 1897 the prestigious Vollard Gallery hosted a show for Butler, then the painter revisited America, where he painted his famous *Brooklyn Bridge* (1900).

At that time, some critics regarded Butler's paintings as "impressionism gone mad," an expression that curiously anticipates French critics' descriptions of the canvases of the Fauves a few years later. *Catskill Clove* was painted on another return trip to America, in 1913, when the art world was about to experience the sensational Armory Show, which opened on 17 February. The picturesque Catskills had attracted painters since the several paintings by Thomas Cole (1825-29).[17] The specific area called Kaaterskill Clove was "the largest of the gaps providing access to the mountain top and to areas west of the mountains"[18] and it was the center of an international leather trade. In *Appleton's Illustrated Hand-Book*, the Clove is described as the "portion of the Catskills . . . most preferred by artists by study. . . ." Tourism developed before long between the Kaaterskill Clove and the Susquehanna Turnpike.

(TEXT CONTINUED ON PAGE 145)

[16] The standard monograph is Richard H. Love: *Theodore Earl Butler: Emergence from Monet's Shadow* (Chicago: Haase-Mumm Publishing Co., 1985).

[17] Cole completed around ten major paintings of the Catskills, including *Stony Gap, Kaaterskill Clove* (ca. 1826; Omaha, NE: Joslyn Art Museum) and *The Clove, Catskills* in 1827 (New Britain Museum of American Art).

[18] Kenneth Myers, *The Catskills: Painters, Writers, and Tourists in the Mountains 1820-1895* (Yonkers, NY: Hudson River Museum, 1987), p. 30. The word clove derives from the Dutch *klove*, which means a rocky fissure, gap or ravine.

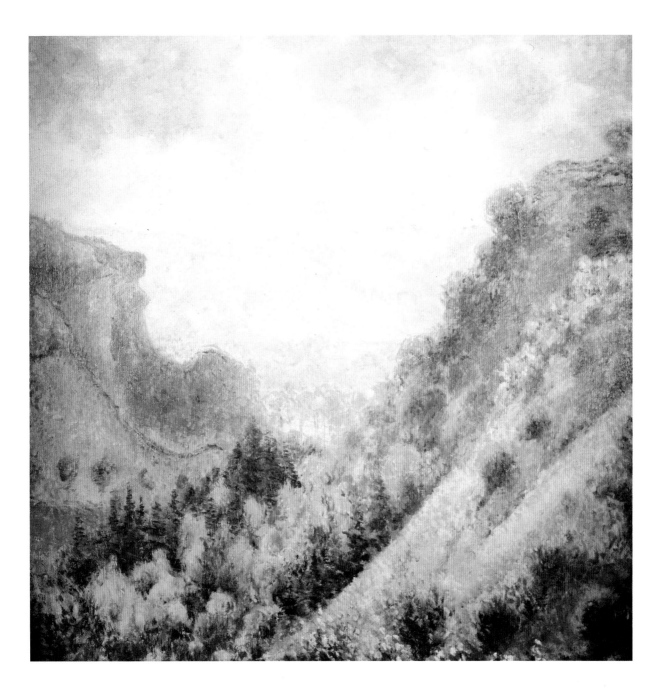

19

10. GIANNI CILFONE
(San Marco, Italy 1908 -)
Girl on a Swing
Oil on canvas, 16 x 10 in.
Signed lower right
Date: ca. 1938

Little five-year-old Gianni came to the United States with his parents from the province of Foggia, in Italy. After initial art training at the Chicago Academy of Fine Arts and the Art Institute of Chicago, Cilfone took lessons from Hugh Breckenridge, John F. Carlson (1874-1945) and several others. Cilfone exhibited *Moonrise* and *Portrait of E. L. Smyth* at the Art Institute's 1929 annual. Later he led sketching groups to Brown County, Indiana[19] and was active in the Hoosier Salon (1949-58), in the North Shore Arts Association, in the Chicago Galleries Association (1940-46) and in the Association of Chicago Painters and Sculptors. Cilfone had his own studio in Nashville, Indiana and was a member of the prestigious Salmagundi Club in New York, where he won prizes. In February 1950 a two-man show at the Chicago Galleries Association featured thirty oil paintings of Cilfone and watercolors by W.F. McCaughey. Critics praised Cilfone's views of Gloucester harbors, purple mountain vistas in Vermont, and picturesque Indiana scenes. In the *Chicago Tribune* (19 February 1950), local critic Eleanor Jewett characterized his landscapes as "emotional in quality and decorative in color." In 1953, Cilfone conducted a class in landscape painting at the Austin, Oak Park and River Forest Art League.

Girl on a Swing is a highly expressionistic oil sketch in which the model completely blends into the sharply lit, glaring landscape. Paint has been applied aggressively, almost like a savage, the technique that Charles Hawthorne recommended to his students in Provincetown. As a source for this strongly coloristic technique, Robert Loftin Newman comes to mind, yet Cilfone seems closer to Seldon Gile (1877-1947) and William Clapp (1879-1954), members of the dynamic group of painters known as The Society of Six (based in Oakland, California), who attempted to express the joy of vision through painterly abstraction.

[19] See William H. Gerdts and Judith Vale Newton, *The Hoosier Group: Five America Painters* (Indianapolis: Eckert Publications, 1985) and Lyn Letsinger-Miller, *Artists of Brown County* (Bloomington, IN: Indiana University Press, 1994).

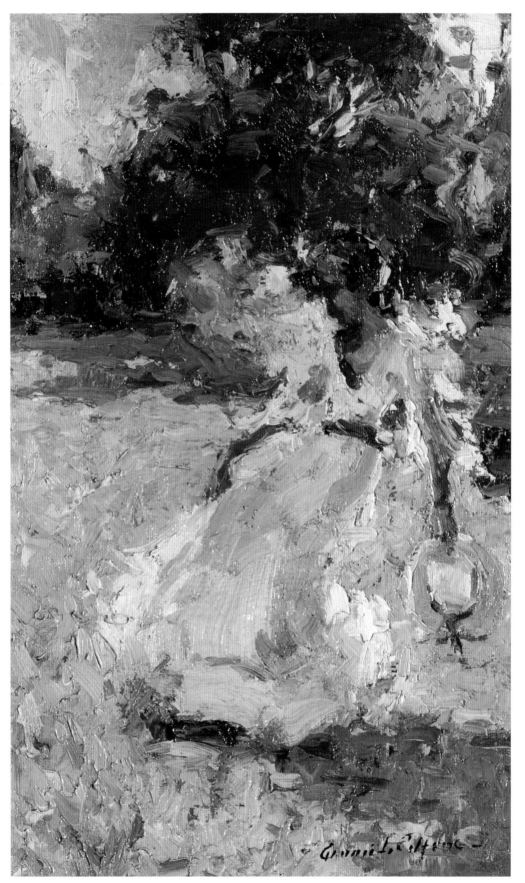

21

11. GUSTAVE CIMIOTTI
(New York City 1875 - 1969 New York City)
The Breeze
Oil on canvas, 32 x 38 in.
Signed lower right

When he was sixteen, Gustave was already producing watercolors of note and he was studying piano, then around the age of twenty, he gave up a potential career as a concert pianist to study art and he enrolled in the Art Students League (1895-98), where he demonstrated an amazing talent for figure drawing. Cimiotti sailed for Paris in the summer of 1899; by October he was sketching in the Académie Julian. After a mini-Grand Tour to Italy, Switzerland, and the Low Countries, Cimiotti returned to America in October of 1900. Two years later he opened a studio in New York City. Among his earliest experiences at exhibiting was a one-man show at Bauer-Folsom Galleries in December of 1908. Critics admired the uncluttered simplicity of his style and high-keyed palette that he learned while in France: "a certain refreshing brightness," as a writer in the *New York Globe* (3 December 1908) expressed it. Others found a decorative quality in his art and admired his highly saturated pigment, as well as his individual expression. Meanwhile, Cimiotti made visits to the studio of Albert Pinkham Ryder (1847-1917) and was influenced significantly by his ideas of composition in large masses, and by the bold use of the palette knife.

Cimiotti took part in the Armory Show in 1913 and became a member of the New York Water Color Club, where he served on the jury, and the Salmagundi Club. Another one-man show opened in January 1927 at the Grand Rapids Art Gallery in Michigan. A year later Cimiotti was elected a member of the Grand Central Art Galleries, and between 1928 and 1936 he taught landscape painting at the Berkshire Summer School of Art in Monterey, Massachusetts; then he directed the Newark School of Fine and Industrial Art (1935-43), where he had been a faculty member. Cimiotti's canvases were featured in an exhibition that December at the National Gallery of Art. In late 1943, Cimiotti moved to Laguna Beach, California where he took an interest in painting flowers and attempted to sell his works, then he returned to New York in 1945. He continued to teach and exhibit until his death at the age of ninety-three in 1969.

Cimiotti saw art as "a magnificent intellectual fabric unraveled from the realities of our lives" and visualized a society improved by subjugating greed and promoting art education. For Cimiotti, the artist had to invest something of himself in every creative work and at the same time, remain universal. *The Breeze* features an imposing wind-blown mass of trees slightly off-center on an arid hill, before an extensive valley. Overall, the palette suggests autumn. The sky is also rather agitated with dispersing cumulus and cirrus clouds. A great distance is indicated to the left, as the eye follows isolated clusters of trees and rolling hills. The distinctive landscapes by Gustave Cimiotti, with their simplicity of composition, their boldness and special clarity of light and their use of broad, regularized forms and a full range of values, set him apart from many late American impressionists and other plein-air painters who adopted the French aesthetic.

12. WILLIAM CLUSMANN
(North La Porte, Indiana 1859 - 1927)
Down the Road
Oil on canvas, 30 x 40 in.
Signed lower right

Clusmann was a prolific painter, highly active in Chicago, where he exhibited a grand total of 156 works at the Art Institute of Chicago between 1889 and 1925, the heyday of American impressionism. After 1925 he became a regular at the Hoosier Salon. Clusmann was also a member of the Chicago Water Color Club and the Chicago Society of Artists. First, he was trained under the Hungarian academic painter Gyula Benczúr at the Munich Academy. In his dissertation on American artists in Munich, Aloysius G. Weimer surmised that Clusmann arrived in Munich in July of 1880.[20] By that time, the exceedingly influential Wilhelm Leibl (1844-1900) had already left the scene but his circle of followers, the Leiblkreis, had changed the direction of progressive art in the city and this liberal influence extended even to the academy. Therefore, Clusmann would have responded to this more painterly, less finished technique, a kind of painterly-colorist-virtuoso trend in which one attacked the canvas directly with a richly loaded brush. For many American artists, this was a logical stepping stone to full-blown impressionism. Frank Duveneck had taken a group of students to Polling, a village outside Munich, in 1878 and the so-called "Duveneck Boys" would have rubbed shoulders with Clusmann, as well. Perhaps he even joined them at the Max-Emanuel Café, where the bohemian spirit reigned. In 1884, Clusmann won an Honorable Mention in Stuttgart.

In 1889, Clusmann gave his address as 70 Monroe Street in Chicago. Five years later he was living on 12th Street and between 1895 and 1907 he was on the North Side. The painter happened to be in Germany again in 1917 when America declared war — he was allowed to return home but had to leave his paintings behind. Back in Chicago, he developed a lighter palette for his plein-air scenes of the Windy City, such as *Lincoln Park, Chicago* (private collection). In this and in ***Down the Road***, one easily identifies with his sincere image of a slice of nature and admires Clusmann's ability to render the effects of full sunlight in a clearly depicted space. In a forthright, unassuming manner, Clusmann truly captured the Spirit of Place of the rural areas surrounding Chicago. The sky in *Down the Road* is admirable for its splendid luminous quality, and it seems like a distant echo of what Claude Monet had achieved decades earlier. Countless American artists transcended the lessons of the French impressionists to create an original American idiom.

[20] Aloysius G. Weimer, "The Munich Period in American Art," Diss., University of Michigan, 1940, pp. 433-435.

13. NICOLA CONIGLIARO
Ring of Life
Oil on canvas, 25 x 30 in.
Signed and dated 1949, lower left

Italian-American artist Nicola Conigliaro was the son of Mr. and Mrs. Giuseppe Conigliaro, immigrants from Sicily. Following five years as a professional football player and service as a U.S. Marine during World War II, Conigliaro studied at the Layton School of Art, Milwaukee, where he graduated in 1949. A year later he established the Open Studio in Milwaukee, where he conducted classes and established exhibitions twice a year. Conigliaro did everything himself, from erecting a platform for the model, to building the easels and chairs for the students. The Open Studio grew "to become a kind of clearing house for the younger Milwaukee artists . . . and Nic has become a recognized promoter of Milwaukee art and artists." In a local newspaper Conigliaro stated, "It's my good luck that I'm doing work now that I love. So, my main ambition is to spread good will, especially for people less fortunate than me . . . Artists at every level work at the studio for free, if they can't afford to pay anything."

Conigliaro managed to do his own paintings, when not helping students. Already in 1951 he won the City of Milwaukee Purchase Prize. In 1954 the artist won a silver medal and membership in the Accademia Letteraria Araldica, an international cultural honorary society based in Naples, Italy. Shortly thereafter, he received that society's gold medal. The circus was Conigliaro's favorite theme: clowns, horses, monkeys, and merry-go-rounds. He also painted *Festa of San Giuseppe* or St. Joseph Festival, a procession that dazzled the artist since his childhood. The painting, presented to the Society of St. Joseph, was also a memorial to his deceased brother Vincent, who inspired him to become an artist. In addition, he executed portraits of General A. A. Vandegrift, commandant of the Marine Corps, which hangs in the Department of the Navy (Washington, DC), that of Rocky Graziano, and others. Graziano also commissioned a full-length portrait in a boxing pose. Cecil B. DeMille admired his work and acquired samples. For John Ringling North (Sarasota, Florida), Conigliaro painted images of clowns: Felix Adler, Paul Jerome, Emmett Kelly, Lou Jacobs and Paul Jung.

In *Ring of Life* we see a circus rider jumping through a hoop, on a moving horse. The amazed throng in the background has been rendered with great panache in artificial light. The shape of the hoop is repeated in the gently hanging rope loops and elsewhere in the composition, including the implied circular arena. Forms are admirably clear and solidly sculptural, as we would expect from an Italian-American. As a child, Nicola was too poor to attend an actual circus, so he would peek under the curtain and he also managed to chat with the clowns in their tent. He was amazed that so few of them actually spoke English but they all got along, and this made him wonder why society could not perform in such a harmony: "If these clowns can live together, happy and friendly, why can't people and countries get along together in the world?"

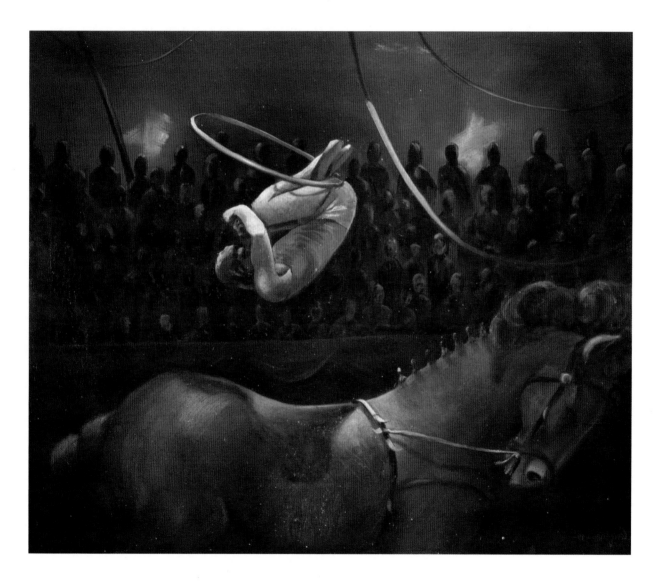

14. JASPER CROPSEY
(Rossville, Staten Island, New York 1823 - 1900 Hastings-on-Hudson, New York)
Cliffs in Autumn
Oil on canvas, 12½ x 18¼ in.
Signed an dated 1893, lower right

Cropsey, raised on his parents' 100-acre farm on Staten Island, preferred drawing to farm work, as a child.[21] From the early years, Cropsey professed the imitation of nature as the basis of art. He set sail for Europe in 1847, and was able to discover parts of England, Scotland, France, Switzerland and Italy: in Rome Cropsey stayed in Thomas Cole's old studio with his new bride and communed with American sculptors Thomas Crawford and William Wetmore Story. While there, he developed an appreciation for romanticism — a more poetic and sentimental appreciation of nature's beauties. Back in New York, Cropsey made ends meet by teaching, including pupils such as David Johnson. He finished up Italian views in the studio but also went on summer sketching trips to paint en plein air. For *The Crayon* in 1855 he wrote an article titled "Up Among the Clouds," in which he advised the accurate depiction of naturalistic details and continued the concepts of Asher B. Durand, urging a spiritual quest in art, yet the landscape art that he developed was more objective than Thomas Cole's dramatic romanticism. On the other hand, Cropsey expressed an interest in allegorical landscapes.

Accordingly, Joshua C. Taylor saw Cropsey as being caught between a transcendental idealism and a more down-to-earth realism.[22] Between 1856 and 1863 he was back in Europe, where the influence of the Pre-Raphaelites and a personal introduction to John Ruskin intensified his precise observations of natural phenomena. He even managed to shock British viewers (Queen Victoria included), who were not used to the brilliant New England autumnal hues in *Autumn on the Hudson River* (National Gallery, Washington), which he exhibited at the Great London International Exhibition in 1862. Such scenes of America were much in demand and the painting won him a medal. Another famous work is *Starucca Viaduct, Autumn* in the Toledo Museum of Art, painted three years later, in which a train appears as a symbol of technology intruding in the New World Eden. *Cliffs in Autumn* comes from the late period, during which Cropsey had established himself at Hastings-on-Hudson in a house named Ever-Rest, complete with a built-on studio. In the late works, Cropsey maintained the classical traditions of American landscape painting. The sense of atmosphere is remarkable here, especially in the hazy background. Completely out of touch with the progressive developments of American impressionism, Cropsey still produced imagery that appealed to sensitive observers like Henry James, who admired the brilliant color and overall strength of execution. Cropsey never forgot the lessons of Ruskin, who insisted on moral and religious idealism.

[21] One of the best studies is still William S. Talbot, "Jasper Cropsey 1823-1900." Diss., New York University, 1972.

[22] Joshua C. Taylor, "Foreword," in William S. Talbot, *Jasper F. Cropsey 1823-1900* (Washington, DC: Smithsonian Institution Press, 1970), pp. 7-8.

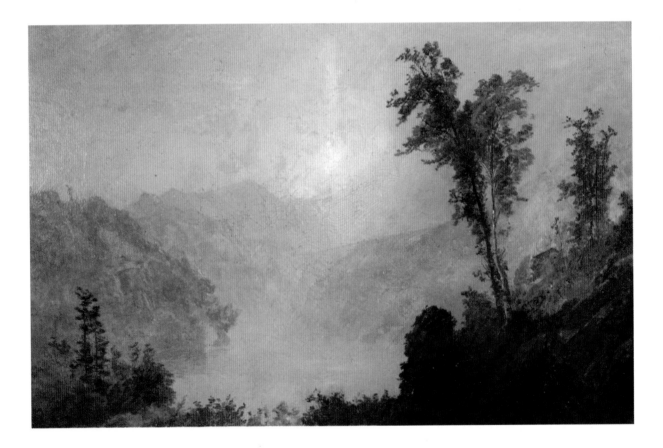

15. CARL GORDON CUTLER
(Newtonville, Massachusetts 1873 - 1945 Boston)
La Mansarde [The Attic]
Oil on canvas, 51 x 38 in.
Signed lower right

Cutler is an example of a painter who began in the genteel Salon milieu who grew into a modernist later on in his career. His training was in the Boston School tradition at the Museum of Fine Arts, Boston. From there he transferred to the academies of Paris where his teachers were Benjamin Constant and Jean-Paul Laurens. In 1899 he exhibited this work, *La Mansarde* and *Mère et enfant* at the Paris Salon. He re-exhibited both of these works at the Art Institute of Chicago later that year. In 1900 *The Attic* showed up again at the Pennsylvania Academy's annual show. Even at this early date, Cutler reveals a special interest in color, while most Salon painters maintained a naturalistic palette of grays, yellow ochres, dull reds, and brown hues. The surprising, bold purple and yellow shawl and the green fabric hanging behind the easel contrast with the neutral brown, tan and gold hues of the model's skirt and the various wood surfaces in *La Mansarde*. Cutler also studied under George Hitchcock in Holland. Hitchcock would have shown him plein-air techniques and a free use of color, however, he would have stressed strong drawing, especially of figures out-of-doors. Reportedly, Cutler was influenced by Seurat, as *Portrait of a Lady in a Big Hat* (1915; Colby College) actually shows pointillism and strictly uniform brushwork. Back in New England, Cutler joined the Boston Art Club and the Copley Society and he worked at Fenway Studios between 1906 and 1941.

Later Cutler developed a special interest in color theory, publishing *Modern Color* with Stephen C. Pepper in 1923.[23] The authors wanted to teach a simple method of using color, considering all aspects of light, values, contrasting hues, special problems with plein-air painting, and developing a scale of color. Cutler became a member of the "Boston Five," a group of modernist watercolor painters, which included Charles Hopkinson. Cutler exhibited widely, including *China Cupboard* and *Portrait Study* at the Armory Show and portraits at the Corcoran biennials of 1930 and 1937. Every summer he went up the coast of Maine for inspiration.

[23] (Cambridge: Harvard University Press, 1923).

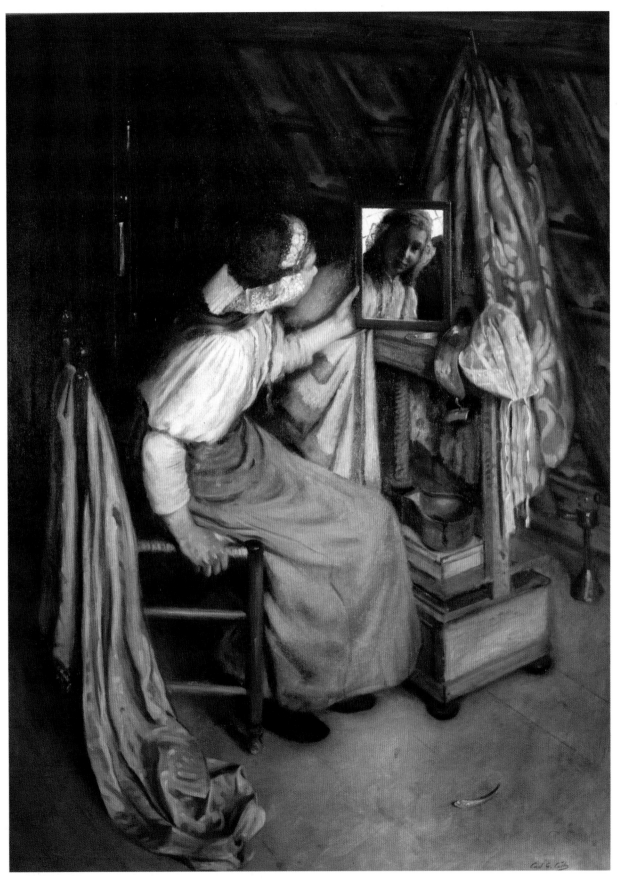

16. CHARLES DAHLGREEN
(Chicago 1864 - 1955)
Sunlight in Brown County
Oil on canvas, 32 x 39 in.
Signed lower right

After working in commercial art as a painter of banners and emblems and trying his hand at prospecting in the Klondike, Dahlgreen decided at the age of forty to study art seriously and to become a painter. He enrolled at the School of the Art Institute of Chicago under John H. Vanderpoel (1857-1911), Frederick Freer (1849-1908) and Wellington J. Reynolds (1869-1949). Beginning in 1906 Dahlgreen exhibited his works at the Art Institute, and by 1943 the total number of paintings he had displayed there was over one hundred. Dahlgreen studied for a brief time in Düsseldorf. As early as 1914, he visited Brown County, Indiana and in the following year he won an Honorable Mention for thirty-one of his prints on view at the Panama-Pacific International Exposition. Dahlgreen taught at the Art Institute of Chicago and was a member of various local art societies: the Art Service League of Chicago, the Art Students League of Chicago, Chicago Painters and Sculptors, and the Chicago Society of Etchers. Although Dahlgreen did not exploit broken color to the fullest, his brushwork was spontaneous, he worked en plein air and he observed atmosphere with a keen eye. An interesting still-life entitled *Breakfast Table* (ca. 1934) shows Dahlgreen's experimental side and proves he was no foe to modernism.

Theodore C. Steele (1847-1926) was the first to set up a studio in Brown County, in 1907, the same year that Adolph Shulz (1869-1963) encouraged fellow Chicago painters to explore the area. Hamlin Garland also noticed a "charming variety of hills, hollows, brooks, and woodlands, just far enough south to have the mellow atmosphere."[24] *Sunlight in Brown County* is a pure example of Hoosier impressionism.[25] This inviting image of bucolic tranquility exudes that special variety of rural Indiana charm and it represents the uniquely American Spirit of Place, rendered in a modified French impressionist technique. The dominant palette is composed of soft violets and greens. Bold brushwork and darker values in the foreground give way to subtle, delicate strokes in the distance, which create the effect of a moisture-laden haze. We stand in the cool, shaded foreground on a path that leads to the group of farmhouses. Dahlgreen beautifully captured the feeling of a hot and humid summer afternoon, what Adolph Shulz exalted in his description of Brown County back in 1900: "All this country was enveloped in a soft, opalescent haze. A sense of peace and loveliness never before experienced came over me and I felt that at last I had found the ideal sketching ground."[26]

[24] Hamlin Garland to Theodore Steele, 1920; cited in *Indianapolis Star*, 18 December 1926.
[25] See Gerdts and Newton, 1985 and Letsinger-Miller, 1994, op. cit.
[26] Adolph Shulz, "The Story of the Brown County Art Colony," *Indiana Magazine of History* 31 (December 1935): 282-289.

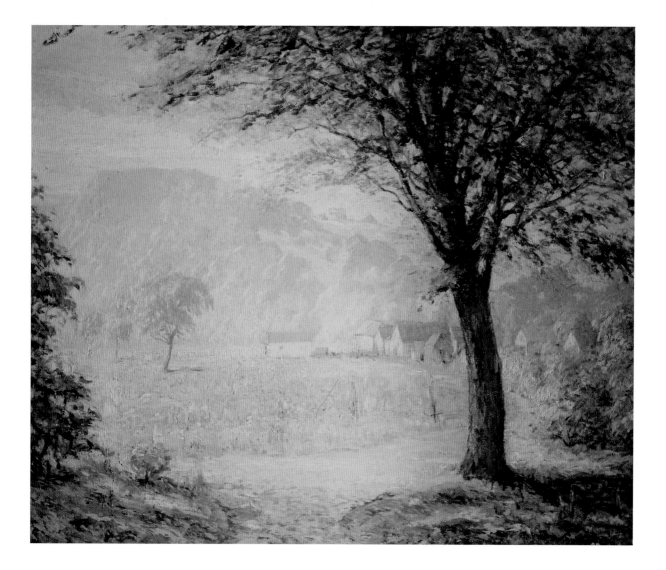

17. DAWSON DAWSON-WATSON
(London, 1864 - 1939 San Antonio, Texas)
Harvest Time
Oil on canvas, 34 x 50 in.
Signed lower right, date: ca. 1891

London-born Dawson-Watson, the son of an illustrator, studied with America's first impressionist, Mark Fisher (1841-1923) and was already exhibiting at the Royal Academy as a teenager. In Paris he worked under John Singer Sargent's teacher, Carolus-Duran, and others. One of the first to discover Giverny, Dawson-Watson told how the initial group of American painters (John Leslie Breck, Willard Metcalf, Theodore Wendel, Theodore Robinson and the Canadian William Blair Bruce) noticed Giverny in passing, then convinced the innkeeper Baudy to add rooms to his hotel to accommodate them. Reportedly, Breck invited Dawson-Watson to join them. He signed the Hôtel Baudy guest register on 12 May 1888 and spent five years there. Dawson-Watson had discovered Monet's work in 1886 but he claimed that the group was unaware of Monet's presence at Giverny.

Harvest Time shows a continuation of Dawson-Watson's interest in peasant subject matter but there is no longer an academic composition. Instead, this haphazard view shows only a wedge of sky in the upper right. We are immersed in the field, which contains bravura brushwork and subtle violet shadows. Other impressionist elements include the violet-toned roofs near the upper edge of the canvas, as well as the unusual composition. The painter convincingly conveyed a hot summer day and the figures suggest spatial recession. A later description in 1906 of the artist as a "painter of light" applies here: "one always feels in studying one of his compositions that the whole field is flooded with the light of out-of-doors."[27]

In 1893, Dawson-Watson went to America where he spent four years directing the Hartford Art Society. The St. Botolph Club in Boston exhibited his works in 1894. After spending the years 1897 to 1900 in Canada, Dawson-Watson moved to Boston, then to St. Louis in 1904 but he did not exhibit at the Universal Exposition that year. He taught at the St. Louis School of Fine Arts (1904-15) and organized a summer school in Brandsville, Missouri, not far from the Arkansas border. Dawson-Watson's final years (1926-39) were spent in San Antonio, Texas.

[27] Quoted from "A Collection of the Works of Dawson Dawson-Watson," *Exhibition of Selected Paintings by Western Artists* (St. Louis: City Art Museum, 1906).

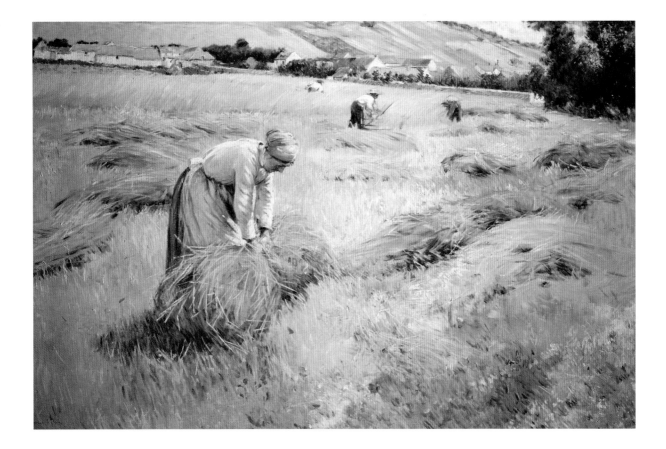

18. CARL F. GAERTNER
(Cleveland 1898 - 1952)
Returning Home
Oil on board, 24 x 40
Signed and dated 1948, lower right

 Gaertner studied at Western Reserve University and at the Cleveland School of Art. One of his teachers was Henry G. Keller, one of Cleveland's leading painters who reacted against the city's "pale, timid, watered Impressionism."[28] Keller would have urged Gaertner to paint more boldly, with a rigorous sense of "Significant Form," owing to his appreciation of Cézanne. For three successive years (1923-25) Gaertner was awarded first prize of the class of Industrial Painting for the following works: *Up the River at Upson's, The Shops*, and *Snow and Steel*. Edna Clark, in *Ohio Art and Artists* listed further works by Gaertner, "all dramatic interpretations of modern industry . . . vital, artistic pictures."[29] She also mentioned *The Popcorn Man* (1931), a poetic and mysterious night scene, which reminded some of the work of George Bellows. Meanwhile, Gaertner was exhibiting works at the Pennsylvania Academy of the Fine Arts (1924-52), at the Corcoran Gallery (1930-51), and he also had a solo show at Macbeth Gallery in 1947.

 Gaertner taught at the Cleveland School of Art, his alma mater. The Union Commerce Bank acquired Gaertner's *The Furnace* of 1924, and his painting executed two years later called *The Pie Wagon* is in the collections of the Cleveland Museum. Both are dark, snow-covered scenes of industrial yards, what definitely could be called midwestern Ashcan urban realism. A late work, *Spring Comes on the Hudson* (1944) is in the Whitney Museum of American Art. In *Returning Home*, Gaertner employed his usual dramatic, dark palette and one will notice a skillful use of the palette knife.

[28] William Mathewson Milliken, *The Henry G. Keller Memorial Exhibition* (Cleveland: Cleveland Museum of Art, 1950).

[29] Edna Clark, *Ohio Art and Artists* (Richmond, VA: Garrett and Massie, 1932), p. 360.

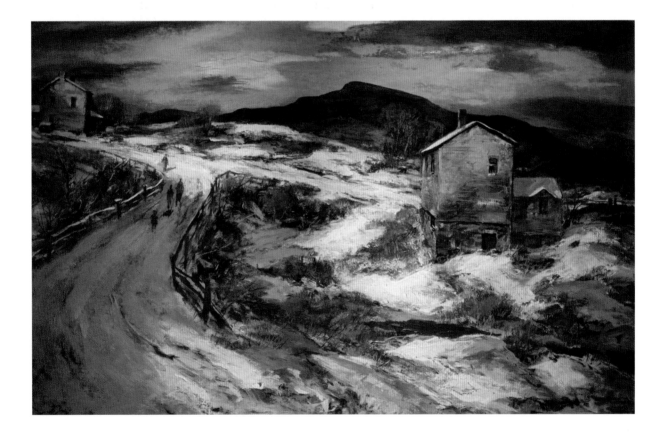

19. SAMUEL LANCASTER GERRY
(Boston, 1813 - 1891)
Crossing the Bridge
Oil on canvas, 12 x 20½ in.
Signed lower left

This versatile artist, mostly self-taught, became a founder and one of the first presidents of the Boston Art Club (1854). In the beginning he was inspired by Thomas Cole and Asher B. Durand, then he spent three years in Europe (1837-40). In the 1840s, Gerry was associated with the White Mountain School.[30] *The Flume*, in the New Hampshire Historical Society (ca. 1882), is a vertical format landscape, whose gorge features a fallen boulder trapped at the top, creating a picturesque effect, while his *Harvest Time, Red Hill, Squam Lake, New Hampshire* (ca. 1857) is a pure Hudson River School landscape with its stable, vertical tree on the left and an open expansive panorama through which the eye is gently led into the distance. Gerry made two more trips to Italy (1850-54; 1874-75). At the Philadelphia Centennial Exhibition he exhibited *American Tourists*, most likely painted on the third trip to Italy.[31] Thirty-eight paintings by Gerry are listed in the Boston Art Club exhibition record between 1875 and 1891. In 1885, Gerry wrote *Reminiscences of the Boston Art Club and Notes on Art*.[32]

Crossing the Bridge shows a lush forest landscape dominated by a stream. A woman holding a parasol is crossing a rustic bridge toward a clearing. Light comes from the left in this scene, probably painted in the late afternoon. The reflections in the water are of a brilliant execution.

[30] See *The White Mountains: Place and Perceptions.* Exh. cat. (Hanover, NH: University Press of New England, 1980), pp. 96-97.

[31] Clara Erskine Clement and Laurence Hutton, *Artists of the Nineteenth Century and Their Works* [1884] (Reprint: St. Louis: North Point, Inc., 1969), p. 292. See also Soria, 1982, p. 144.

[32] MS, Boston Athenaeum Collection; see typescript in Museum of Fine Arts, Boston Library.

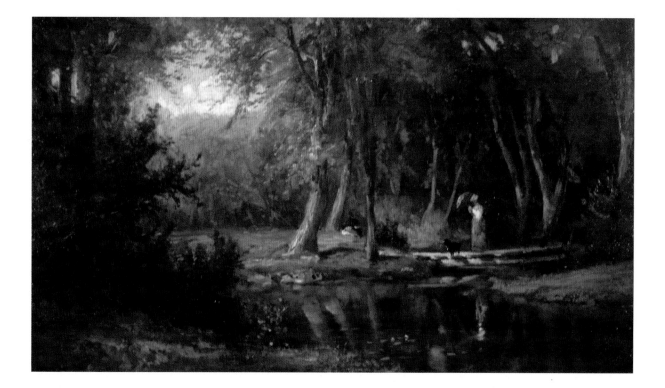

20. EDMUND GREACEN
(New York City 1876 - 1949 White Plains, New York)
Le Pont de Vernon, vu de Giverny
Oil on canvas, 25¾ x 32 in.
Signed, lower right

Thomas Edmund Greacen, the painter's father, enjoyed a prosperous career in the wholesale shoe trade. Young Edmund, after a trip around the world, enrolled in the Art Students League in 1899, which he left for the Chase School. Robert Henri, F. Luis Mora and Frank V. DuMond (1865-1951) were some of his teachers. From Chase Greacen learned techniques of drawing with the fully loaded brush. He began exhibiting his work at the National Academy of Design in 1903, then he joined the Society of American Artists. Two years later he was with Chase, who took his class to Spain. Greacen settled in Giverny with his family in 1907 and soon became a part of the so-called third generation of American expatriate painters, among whom were Richard E. Miller, Theodore Earl Butler, Frederick Frieseke and Karl Anderson (1874-1956). Works from 1907 reflect the influence of Monet and Butler (*Effet de neige*, exhibited in the Paris Salon of that year), while *The River Epte* is even more dazzling with vibrant, broken brushwork and rich, jewel-like color.

After returning to the States, Greacen began to spend summers at Old Lyme where he met William Chadwick (1879-1962) and Childe Hassam, who changed the colony's aesthetic direction from tonalism to impressionism. Greacen exhibited regularly at national venues, worked en plein air both in the country and in the city, and during the first world war he decorated barracks and canteens for French troops. Later (1924) he helped establish what became Grand Central Art Galleries, which included an art school.[33]

[33] There is still no extensive monograph on the artist, but Elizabeth Greacen Knudsen, *Edmund W. Greacen, N.A.: American Impressionist 1876-1949* (Jacksonville, FL: The Cummer Gallery of Art, 1972) is quite helpful.

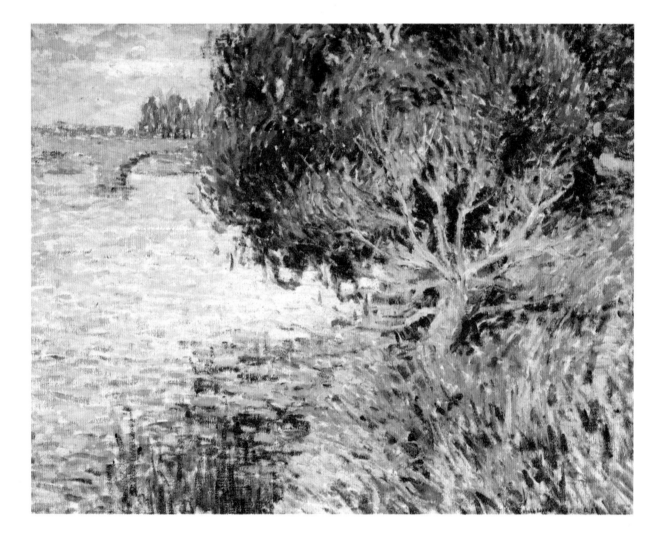

21. EDMUND GREACEN
(New York City 1876 - 1949 White Plains, New York)
The White Vase
Oil on canvas, 30 x 25 in.
Signed lower right

 This rare still-life by Greacen suggests a quiet moment in the artist's studio, perhaps when the weather was too unpleasant for plein-air painting. One must wonder if one of Greacen's students had such a work in mind when he or she asked: "Does Mr. Greacen look through a piece of gauze while he paints?" A critic appreciated the color of Greacen's works: "the kind that flows from lovely ancient frescoes."[34] The subdued, pastel tones represent a departure from the French impressionist formula. The palette here is predominantly pink, green and yellow, with an unassuming gray-green to define the surrounding areas. The surface of the table, enlivened by a few fallen petals, has a remarkable sense of luminosity despite its lack of finish, in the traditional sense. Note the area near the bottom edge of the painting, which is hardly more than priming.

[34] The two quotes were made by Elizabeth Greacen Knudsen, op. cit., pp. 13-14.

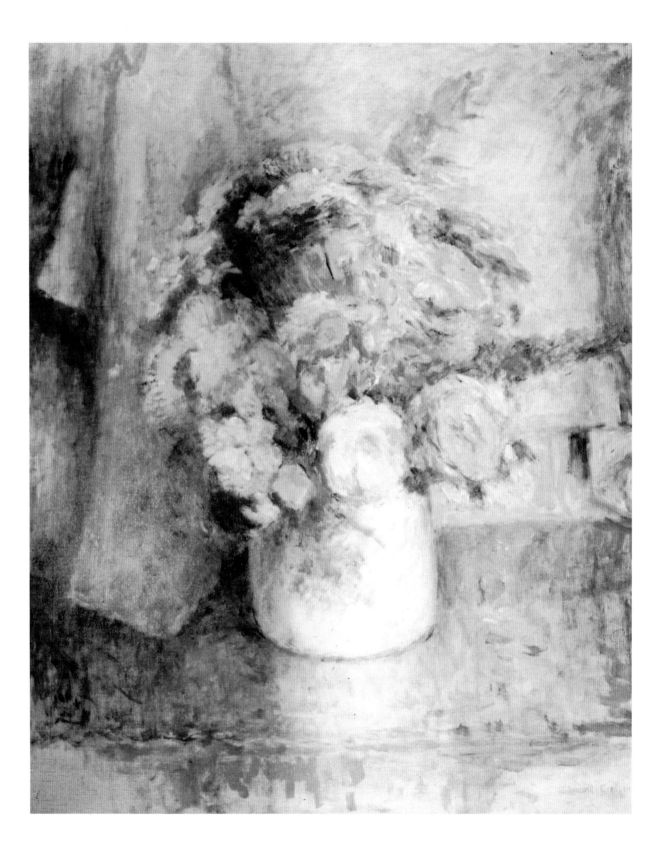

43

22. LOUIS C. HANKES
(St. Cloud, Minnesota, 1882 - 1943 Chicago)
In the High Sierras
Oil on canvas, 30 x 35 in.
Signed lower right

Hankes studied at the Art Institute of Chicago; in 1911 he had a studio space in the Tree Studio Building but his home was on the far West Side. At one point, Hankes lived in Marblehead, Massachusetts. In his landscapes, Hankes was fond of winter scenes and gray days. At the Art Institute he exhibited *Winter* and *Gray Day* in 1911, *Winter* and *December* in 1914, *Good-bye, Summer*, *Reflections* and *Golden Autumn* in 1915, and two watercolors in 1917: *February* and *The Bridge*. *The Red Barn* was the painting by Hankes in the AIC's exhibition of 1919. His technique resembles that of John F. Carlson.

In the High Sierras is admirable for its bold execution, a broad but controlled brushwork in which forms are defined by dynamic strokes of impasto pigment, and a basically sculpturesque treatment of nature's massive forms. Spatial depth has been laid out with utmost clarity. Broken brushwork and blue and violet shadows are remnants of the impressionist aesthetic. The setting of ***In the High Sierras*** resembles that of William Keith's *Donner Pass* (ca. 1890; Palm Springs Desert Museum), with the lake and purple mountains in the distance. Another possibility is Mount Ritter above Lake Ediza, which Edgar Payne and others depicted. Naturalist and writer John Muir (1838-1914) described in *The Yosemite* (1912), "the majestic mass of Mount Ritter, with a glacier swooping down its face nearly to my feet, then curving westward and pouring its frozen flood into a dark blue lake."

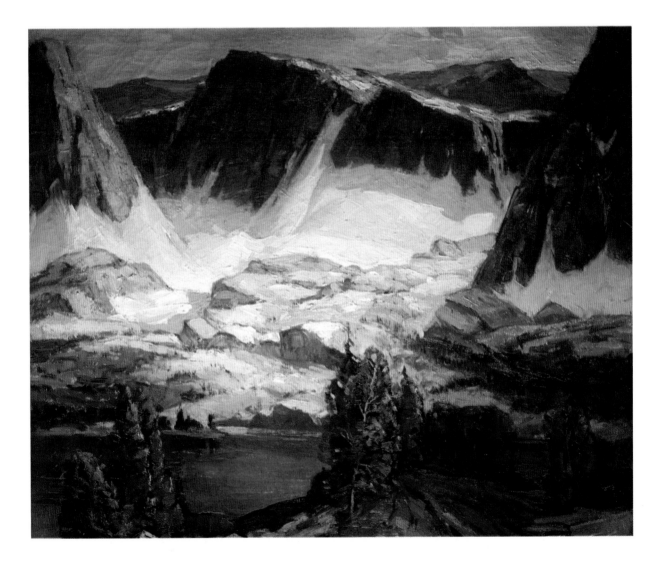

23. CHILDE HASSAM
(Dorchester, Massachusetts 1859 - 1935 East Hampton, New York)
View from Newburgh, New York
Watercolor on paper, 15 x 22 in.
Signed and dated 1914, upper right

Perhaps the best known of America's impressionists after Mary Cassatt, Childe Hassam[35] was independent of Monet and his circle in Giverny. His elementary art training was in Boston, and at the age of twenty-four, Hassam was already teaching watercolor classes, then on his first European trip he executed watercolors all along his "Grand Tour." After working in the Barbizon mode, Hassam was attracted to the urban genre painters of Paris, such as Jean Béraud. Back in New York, he painted the elegant public squares and fashionable tree-lined avenues. For Hassam, the French impressionist technique was "the only truth." His brilliant career exemplified the "Good Life" of the American impressionists, full of social engagements, evenings at prestigious clubs, and constant trips to Europe and to exotic locales.[36] Hassam became involved with the group of painters known as the Ten, who broke away from the Society of American Artists in late 1897. They would soon become "a kind of academy of American Impressionism," as E. P. Richardson later defined it.[37] Hassam took part in the Armory Show in 1913, then at the close of the first world war he executed his famous Flag Series. With these works, Hassam went beyond impressionism toward abstraction, bending the rules of perspective, simplifying forms and emphasizing patterns.

Newburgh, on the west bank of the Hudson River, boasts the Hasbrouck House, which served as George Washington's quarters in 1782-83, and the Tower of Victory, which commemorates the disbanding of the Continental Army in October 1783. Among artists, Gifford (1879-1956) and Reynolds Beal (1866-1951) had a family home in Newburgh. Gifford Beal wrote, "The best part of my life was passed at Newburgh on the Hudson before 1914. All of my family was alive and only one married. . . . The house was always full of visitors because there were so many children. . . ."[38]

(TEXT CONTINUED ON PAGE 146)

[35] Two important recent studies on the artist are Ulrich W. Hiesinger, *Childe Hassam, American Impressionist* (New York: Jordan-Volpe Gallery and Munich: Prestel-Verlag, 1994); and Warren J. Adelson, Jay E. Cantor and William H. Gerdts. *Childe Hassam, Impressionist* (New York: Abbeville Press, 1999). An important exhibition was organized by the Metropolitan Museum of Art in 2004.

[36] Richard J. Boyle, *American Impressionism* (Boston: New York Graphic Society, 1974), pp. 178-179.

[37] Edgar P. Richardson, *Painting in America: The Story of 450 Years* (New York: Thomas Y. Crowell, 1956), p. 306.

[38] Quoted in Sidney Bressler, *Reynolds Beal: Impressionist Landscapes and Seascapes* (Cranbury, NJ: Associated University Presses, 1989), p. 13.

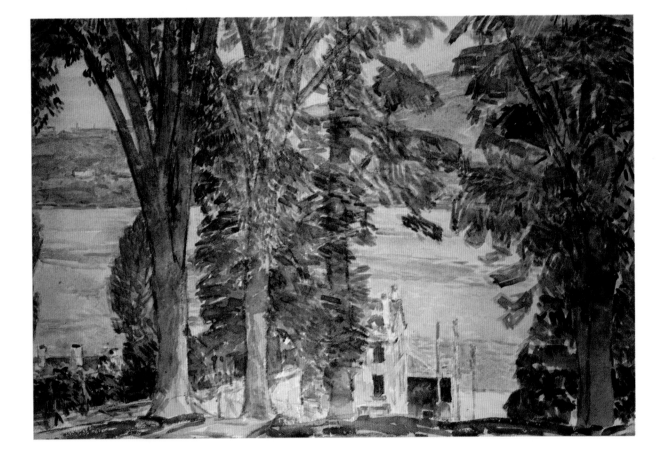

47

24. CHARLES HEBERER
(Saint Louis 1868 - 1951)
Farmyard, La Celle-au-Pontaise
Oil on canvas, 15 x 18 in.
Signed and dated 1894, lower left

St. Louis native Charles Heberer began studying at the St. Louis School of Fine Arts, established in 1879.[39] There was instruction in drawing, painting, anatomy, and perspective, as well as art history, European history and literature.[40] Heberer decided to study further in Paris, at the Académie Julian, and between 1890 and 1895 he was successful enough to exhibit his works in the Paris Salon: these were unlocalized evening landscapes and rustic spots in Normandy. *A Farm in Normandy* was engraved for the catalogue of the Salon of 1890.[41] Meanwhile, Heberer submitted one work to the World's Columbian Exposition in Chicago (1893), entitled *The End of November* (unlocated). "November" was a familiar title among plein-air painters associated with Bastien-Lepage, Alexander Harrison, and others who painted in Brittany. Characteristic works by Heberer from that period display the popular influence of Bastien-Lepage's plein-air tonalism, in which clearly defined forms, usually figures of peasants, occupy spaces filled with softly diffused light.

A year later (1894) comes Heberer's **Farmyard, La Celle-au-Pontaise**, a lyrical summer landscape most likely executed just east of Rambouillet along a brook called La Celle. Here tonalism has given way to the more progressive use of a bright palette, pure pigments, and a restricted range of values. There is plenty of free brushwork with broken color, especially in the sky area near the horizon. The violet colored roofs and hints of violet in the sky add to this radiant plein air painting elements that acknowledge impressionism. Thus by 1894, Heberer, like so many other painters working in and around Paris, was at least experimenting with the French aesthetic.

In 1898, Heberer exhibited *A Sunday Morning with Burns at Mossgiel* at the Art Institute of Chicago. The title refers to the poet Robert Burns (1759-1796), whose farm was called Mossgiel. Heberer was interested in historical genre and he apparently admired the poet: he also painted *Robert Burns and Highland Mary*, on auction not long ago. Overshadowing the genre element, however, is the lush forest landscape with a shallow brook indicated below. Heberer was associated with the Society of Western Artists. For some reason, although living in St. Louis like Dawson-Watson, he did not participate in the Universal Exposition in that city in 1904. In fact, his artistic activity seems to have slowed down until his death much later in 1951.

[39] There had been an art academy in St. Louis, the Western Academy of Art, which opened in 1859 and inaugurated its first annual exhibition a year later. This institution finally merged with the St. Louis School of Fine Arts in 1879.

[40] Other instructors included Carl Gutherz (1844-1907) and Mary Fairchild (1858-1947), who would become the wife of the sculptor Frederick MacMonnies, then Mrs. Will Hicok Low.

[41] In this work (cat. no. 1184), a diagonal tree dominates the composition, which features cattle in the foreground. Shafts of light form counter-diagonals and the whole effect of rays of sun streaming in through foliage must have been stunning.

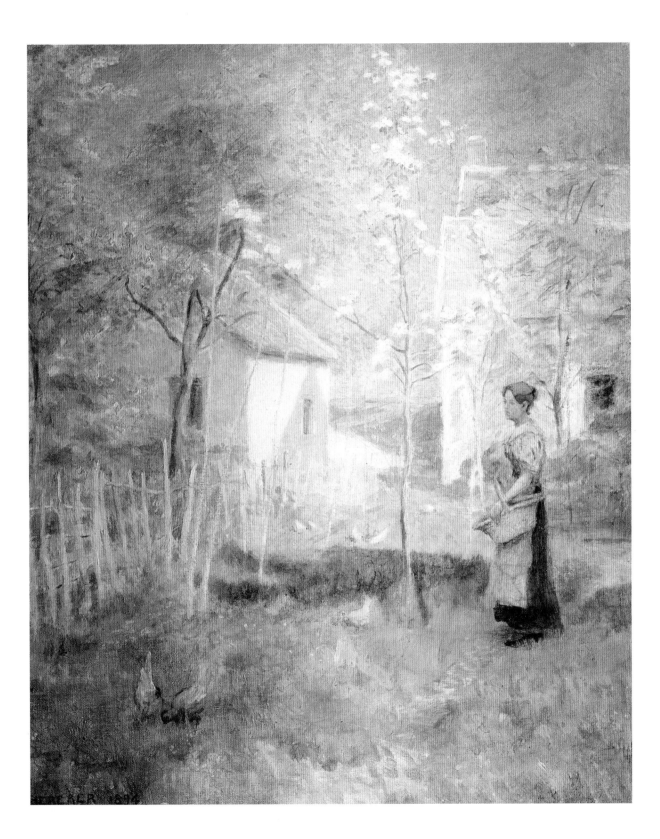

49

25. JOSEPH HEKKING
(The Netherlands 1830 - 1903 Grosse Ile, Michigan?)
Mountain Landscape
Oil on canvas, 17 x 14 in.
Signed lower right

Largely a marine painter, Joseph Antoine (or Antonio) Hekking was born in the Netherlands in 1830 and was trained in Paris. He was in New York by 1859 and began exhibiting at the National Academy of Design two years later — he would participate in several annual shows until 1875. The works include *Housatonic Scenery* and *Moonlight in the Adirondacks* in 1861, *A Summer Afternoon in New England* and another landscape in 1862, *Storm in the Adirondacks* in the following year, and *Night on the Ausable* in 1875. Another landscape appeared in the Pennsylvania Academy's 1861 exhibition. Meanwhile he had served in the Civil War in a New York regiment. Henry French, back in 1873, said that Hekking painted in Connecticut from time to time. By 1878, Hekking was in Detroit. He exhibited at the Detroit Art Museum, which became the Detroit Institute of Arts, and at the Detroit Artists' Association.

Some of Hekking's landscapes recall seventeenth-century Dutch prototypes with their panoramas and predominance of sky area. *Mountain Landscape*, on the other had, uses a vertical format. Since Hekking's addresses were Cherry Valley and Poughkeepsie, New York (when he was not residing in New York City), one could easily imagine that Hekking painted this on an excursion to the Adirondacks to the north or to the Catskills, directly south of Cherry Valley. Poughkeepsie is also close to the Catskills. *Mountain Landscape*, in the Hudson River School tradition, could have been influenced by Thomas Cole's works. Gerdts mentions that Hekking's paintings have been compared to those of Jervis McEntee (1828-1891).

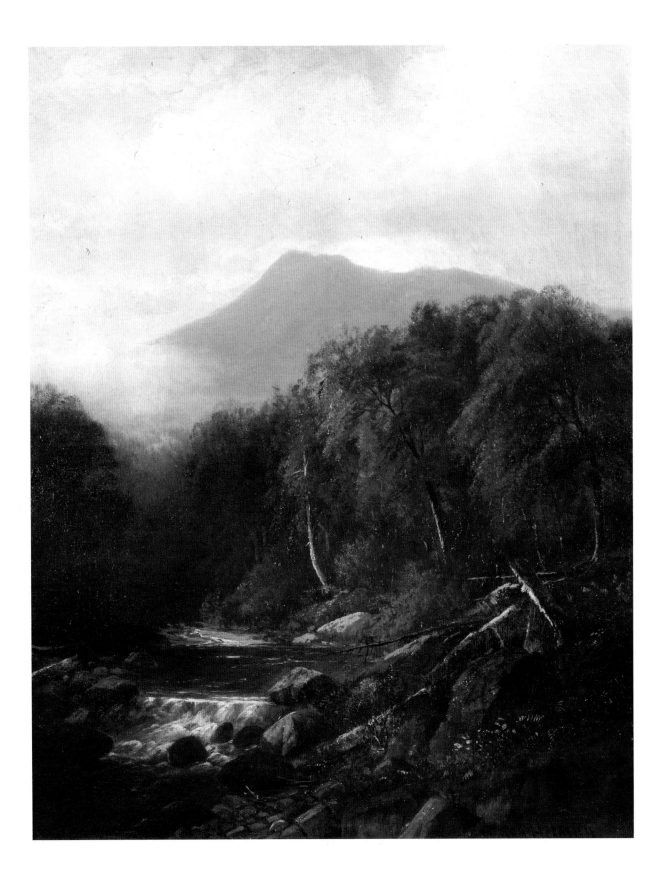

26. WILLIAM PENHALLOW HENDERSON
(Medford, Massachusetts 1877 - 1943 Tesuque, New Mexico)
Portrait of Woman in Red Coat
Pastel and charcoal on paper, 11 x 7½ in.

Largely associated with the Santa Fe-Taos artists' colonies, Henderson grew up in Massachusetts then moved to a cattle farm in Texas, then to Clifton, Kansas.[42] Back in his home state, Henderson enrolled at the School of the Museum of Fine Arts, Boston under Edmund Tarbell (1899) then he toured Europe on the Paige Scholarship (1901-03). Roughly between 1904 and 1915, Henderson lived in Chicago and Lake Bluff, Illinois, exhibiting portraits, picturesque views, and Whistler-inspired compositions, and teaching at the Chicago Academy of Fine Arts. While Henderson's works show the influence of *Japonisme* and the Nabis, he seems to have by-passed impressionism to work in various post-impressionistic modes, using high-keyed color. James William Pattison regarded Henderson's style as mysterious and poetic, placing him in the Symbolist group. Henderson did illustration work, painted murals and delighted critics with his subtle pastels. Once in Santa Fe in 1916, Henderson experimented in various modernist modes to arrive at a creative eclecticism, in which everything from Oriental philosophy to Dynamic Symmetry played a part. He was one of the founders of the New Mexico Painters group in 1923 and two years later he formed the Pueblo-Spanish Building Company and began to design furniture. Carl Sandburg wrote on Henderson's impressive works in a special exhibition in January of 1921 at the Art Institute of Chicago.

Portrait of Woman in Red Coat is intensely Whistler-inspired. After Whistler met Albert Moore (1841-1893) in 1865, he began to feature single standing figures in vertical formats. In the late 1880s he picked up the motif again. Henderson selected a brownish-gold paper that Whistler was fond of, and he left wide areas untouched on the top and side margins. There is only a hint of a flower-patterned wallpaper. The lace collar and plumed cap suggest elements of Northern costume but the figure seems to have more of a theatrical, make-believe air, as if a girl model had emerged from her mother's closet. In 1915, Henderson did in fact design costumes for the Chicago Fine Arts Theatre production of *Alice in Wonderland*.[43] Harriet Monroe,[44] the Chicago socialite and founder and editor of *Poetry: A Magazine of Verse,* praised Henderson's pastels in the *Chicago Sunday Tribune* (20 October 1912): "Mr Henderson's pastels are the only pastels since Whistler. Here, in these little frames, is great art Each one of these little pastels gives us the ecstasy of a fine moment. . . ."

[42] See Emma M. Church, "William Penhallow Henderson, Painter," *The Sketch Book* 5 (November 1905): 117-120.

[43] Sandra K. Feldman, *William Penhallow Henderson, The Early Years: 1901-1916.* Exh. cat. (New York: Hirschl and Adler Galleries, 1982), p. 9.

[44] Monroe also wrote "The Columbian Ode," which was delivered at the World's Columbian Exposition in 1893. She died in 1936 at the age of seventy-six, on her way to ascend the Inca ruins at Machu Pichu.

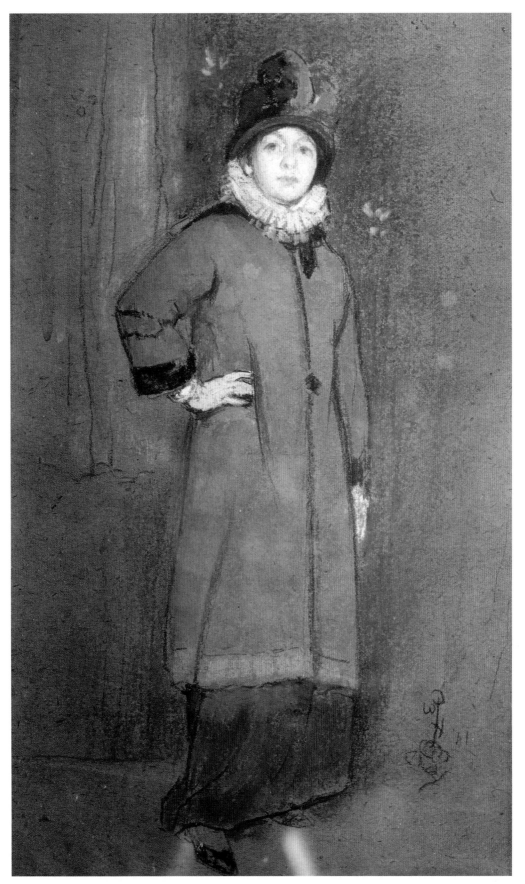

53

27. ROBERT HENRI
(Cincinnati 1865 - 1929 New York City)
The Old Beggar, Bretagne
Oil on canvas, 32 x 44
Signed lower right
Date: ca. Fall of 1889

Robert Henri (pronounced hen -rye) was the leader of the group of painters called The Eight, or the Ash Can School. His main thesis was "Art for Life's Sake," as opposed to the "Art for Art's Sake" theory, which placed Art in its own realm, isolated from any moral, social or political concerns. Some of his group of painters made their debut at the National Arts Club in 1904 where they were referred to as late-impressionists, but their real impact came in 1908 when Macbeth Gallery featured the works of the definitive group, referred to as the Eight — at the same time the "Ash Can School" label was created by the critics. Henri began at the Pennsylvania Academy, a student of Thomas Eakins, which shows the roots of his integrity. He studied in Paris, as well, and underwent a brief impressionist phase, which he abandoned around 1898 for a dark palette that was derived from Velázquez, Goya and Manet. Henri was critical of the impressionists' depictions of upper class society — for him, it was more meaningful to explore the urban scene in all its aspects, even the nitty-gritty world of the Bowery, and he was especially attracted to earthy types, including gypsies, toreadors, tough Irish-American street urchins, etc. Henri established his own school after being involved at the Chase School, or New York School of Art, and published his influential book, *The Art Spirit*.

The Old Beggar, Bretagne comes from Henri's early student days in France. He left for Europe in the fall of 1888 and enrolled in the Académie Julian. When it came time for the winter *concours* (drawing contest), Henri received an eighth honorable mention: Bouguereau praised him on the honesty of [his] endeavor and [his] rapid progress." Henri attended the opening of the Exposition Universelle in May of 1889. In addition, the annual Paris Salon had opened: Henri probably dragged himself through every gallery where over two thousand paintings were on display. Toward the middle of April Henri enrolled for another four-week term at the Académie Julian, drawing under Bouguereau and visiting the Louvre to sketch and make copies. He obtained a permit to copy Rembrandt's *Portrait of a Young Man* (private collection). At the Louvre, Henri wrote how crowds of people were gaping at him, making him uncomfortable (Henri Diary, 25 April 1889). Following this, Henri visited the studio of Alexander Harrison, who convinced him to visit Brittany. After the school year of 1888-89 he traveled there with his friends. Henri and James Fisher went to Concarneau and were joined by Irving Couse. Cecilia Beaux was also working there under Harrison. Henri practiced plein air figure painting in the manner of Harrison, and also did small-scale seascapes. In September he and Edward Redfield hiked to Pont-Aven and stayed at the Pension Gloanec. Henri could have painted *The Old Beggar, Bretagne* at this time, or slightly later. He returned to Brittany – Concarneau in the summer of 1894, and again in May 1899 – but we opt for the earlier date. This image of a beggar is the genesis of Henri's future art of urban realism.

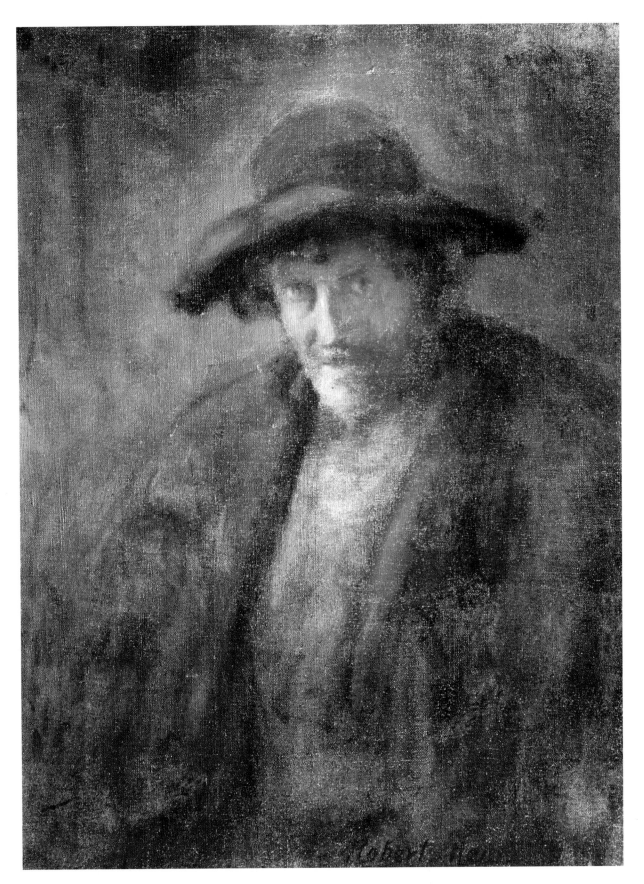

28. ROBERT HENRI
(Cincinnati 1865 - 1929 New York City)
Isadora Duncan
Watercolor, 12 x 8 in.
ca. 1915

PROVENANCE:
Violet Organ, sister of Mrs. Robert Henri

Isadora Duncan (1878-1927), the famous leader of modern dance shown in this watercolor, is mentioned in *The Art Spirit*: Henri called her "perhaps one of the greatest masters of gesture the world has ever seen. [She] carries us through a universe in a single movement of her body. Her hand alone held aloft becomes a shape of infinite significance." Later he added, "Isadora Duncan dances and fills the universe. She exceeds all ordinary measure." And "when a great artist, as Isadora Duncan, affects us, that is when we realize her, we are great as well as she." John Sloan executed an oil painting of Isadora Duncan on stage, slightly earlier, in 1911 (Milwaukee Art Center). That February, he called her performance "the great thing of the day and the year. . . . Isadora as she appears on that big simple stage seems like all womanhood – she looms as big as the mother of the race. A heavy solid figure, large columnar legs, a solid high belly, breasts not too full and her head seems to be no more important than it should to give the body the chief place. . . ."[45]

At the British Museum, the young Isadora Duncan studied Greek art, which had an impact on her dancing style. Her life was full of tragedy: her two children were drowned in an accident in 1913; a later child died at birth; and her husband, the Russian imagist poet Sergei Yesenin (1895-1925) committed suicide. Her own death came by strangulation, as her scarf was caught in her car's moving wheel.

[45] *John Sloan's New York Scene from the Diaries, Notes and Correspondence 1906-1913.* Ed. Bruce St. John (New York: Harper and Row, 1965), pp. 507-508.

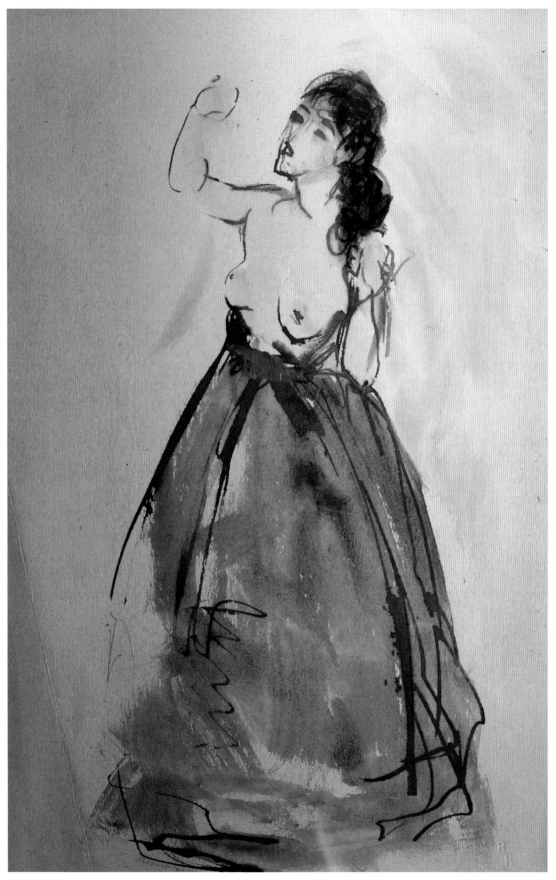

29. HOWARD HILDEBRANDT
(Pittsburgh, 1873 - 1958)
Two Women Sewing
Oil on canvas, 12 x 16 in.
Signed lower right
ca. 1915 (?)

 Known mainly as a portrait painter, Howard Logan Hildebrandt maintained studios in New Canaan, Connecticut and at the Silvermine artists' colony. From the National Academy of Design, Hildebrandt entered the Académie Julian under Jean-Paul Laurens and Benjamin Constant, and the Ecole des Beaux- Arts in Paris for further studies. In 1898, he was already exhibiting at the National Academy and at the Carnegie Institute. Hildebrandt was among the earliest artists to gather in the studio of Solon Borglum (1868-1922), which became the Silvermine Guild of Artists upon Borglum's death, and Hildebrandt was elected the group's third president, in 1924. In the following year he served as vice president of Allied Artists of America, the group with which he exhibited earlier. For example, in 1914, he showed *By the Brook, Tangiers*, and *The Vendor – Tangiers*. The titles of most of Hildebrandt's exhibited works are less exotic. Between 1902 and 1949, he exhibited seventy-three paintings at the National Academy annuals: many portraits, flower paintings, and genre scenes that indicate the American impressionists' preoccupation with genteel subject matter and the "Good Life," for instance, *Sunlight, Afternoon Tea*, and *Summer Days*. It would be tempting to identify *Two Women Sewing* as *The Sewing Bee*, shown at the NAD in 1915. It does have the look of that era, at the height of American impressionism, and in particular one is reminded of the intimism of Frederick Frieseke, a leading American expatriate who established himself in Giverny. The figure types of Louis Ritman also come to mind. Hildebrandt taught at Grand Central Art Galleries, and he was also an active exhibitor at the Art Institute of Chicago (1897-1924). The Butler Institute of American Art has another of Hildebrandt's paintings also dated 1915, *Sicilian Bandits*, and his works may also be found in the National Academy, the Lotos Club and at Pennsylvania State College.

 At the 1939 New York World's Fair, Hildebrandt's charming *Girl in White,* still in the tradition of Mary Cassatt, was on display. It shows that he held on to the Genteel Tradition while the world was under great turmoil, threatened by Hitler and other Fascist dictators. Most American paintings at the Fair were the typical, broadly painted scenes of everyday life, conceived of with a hint of modernist abstraction. Some artists offered completely abstract images, for instance, Lawren Harris, Carl Robert Holty and John Xceron, ushering in a new era.

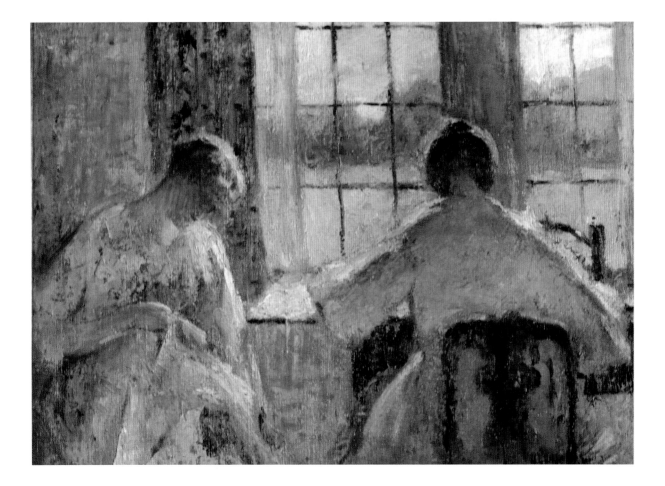

30. CHARLES SIDNEY HOPKINSON
(Cambridge, Massachusetts 1869 - 1962 Cambridge)
Surf in Morning Sunlight
Oil on canvas, 24½ x 25½ in.
Signed lower right
Date: ca. 1906-07

Hopkinson was trained by his father, the headmaster at the Hopkinson Classical School. Later at the Art Students League his teachers were as varied as Kenyon Cox and John H. Twachtman.[46] In 1892 Hopkinson was exhibiting at the Boston Art Club, in the National Academy of Design and a year later at the Pennsylvania Academy of the Fine Arts. Later in 1893 he was a student at the Académie Julian. In 1895 Hopkinson exhibited *Woman with Monkey* at the Champ de Mars Salon (the "new" Salon) and in 1896, four of his works were accepted there. In the 1897 exhibition his *Breton Fisherman* appeared, showing that Hopkinson took an interest in Brittany, the popular destination for many expatriate American painters. We also know that Hopkinson studied with the French Symbolist painter Edmond-François Aman-Jean (1860-1935).

Back in America, Hopkinson would maintain an active exhibition schedule, especially at the National Academy (1892-1949), at the PAFA (1896-1944) and at the Corcoran Gallery (1907-53). In important international shows he won medals, for example at the Pan-American Exposition in Buffalo (1901) and at the Universal Exposition in St. Louis (1904). Unlike many American impressionists, who by 1913 were considered conservative, Hopkinson (along with Hassam) took part in the ultramodern Armory Show, submitting four works there. Seven of his paintings appeared at the Panama-Pacific International Exposition in 1915, where he walked away with a silver medal. Hopkinson was part of the "Boston Five," a progressive group of young watercolorists.[47] He seems to have made his living mainly as a portraitist -- he painted hundreds of them, and thrived even during the Depression years.[48] The Museum of Fine Arts, Boston has a magnificent group portrait of the Hopkinson Family dated 1924. His pensive and tense portrait of *Calvin Coolidge* may be found in the White House.

(TEXT CONTINUED ON PAGE 146)

[46] A useful, brief biography may be found in Trevor J. Fairbrother, *The Bostonians: Painters of an Elegant Age, 1870-1930* (Boston: Northeastern University Press, 1986), pp. 214-215. See also Anne W. Schmoll, *Charles Hopkinson, N. A. (1869-1962): Moods and Moments.* Exh. cat. (Boston: Vose Galleries, 1991).

[47] The other four were Marion Monks Chase (1874-1957), Charles Hovey Pepper (1864-1950), Harley Perkins (1883-1964) and Carl Cutler.

[48] Reportedly, his first commission was a portrait of an infant later known as e.e. cummings (Schmoll, 1991, p. 5). The author estimates Hopkinson's annual income was $30,000 during the 1930s.

31. ARTHUR HOULBERG
Woman with a Parasol
Oil on canvas, 32 x 26 in.

This unresearched but highly competent Chicago painter exhibited *Wash Day* at the Art Institute of Chicago in 1921. We do know that he worked at the Ox Bow Artists' Colony, which was the Art Institute's summer school program, beginning in 1914. *Woman with a Parasol* suggests that Houlberg learned from midwestern members of the "third generation" of American expatriate painters at Giverny, specifically Richard E. Miller, Karl Buehr and Karl Anderson. There is the same colorful, decorative palette, richly applied, luscious impasto and an abundance of plein-air sunlight. Buehr was also fond of the Japanese parasol motif. Houlberg was at home with the new expressionistic use of color: touches of heightened, hot pinks and apple-green on the flesh give a sense of excitement. The broad slashes of color in the background foliage seem especially daring. Houlberg's technique is quite close to that of his Ox Bow colleague, Frederick Fursman (1874-1943), who was influenced by the Fauves. Fursman and Walter Marshall Clute (1870-1915) were credited with discovering the site of Ox Bow in Saugatuck, Michigan, in 1910.

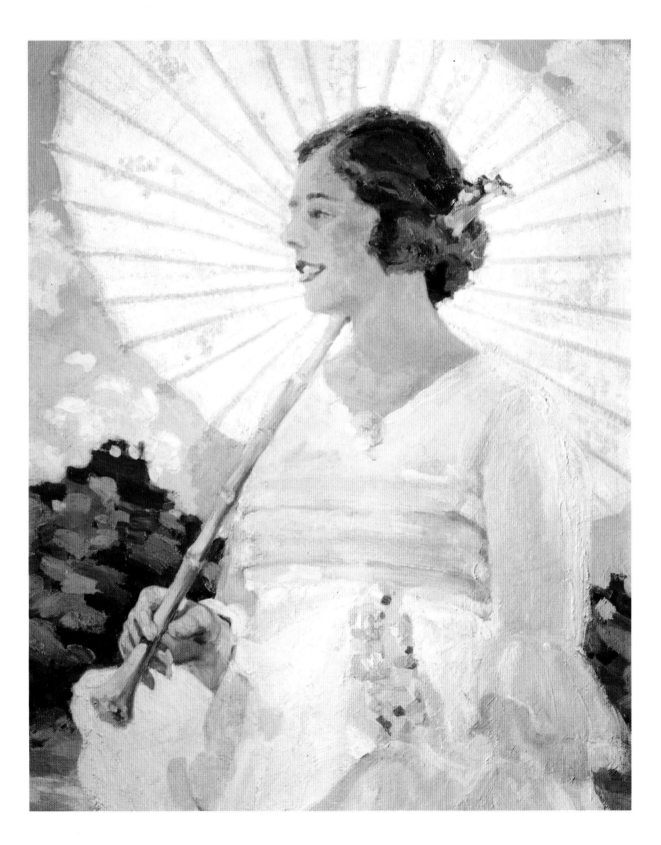

32. EDITH M. HOWES
(active in Boston, 1879-1903)
Washing Day
Oil on canvas, 20 x 26¾ in.
Signed lower right

Little is known of Edith Howes, even though she exhibited her oil paintings and watercolors regularly at the Boston Art Club (1884-98) and one year at the Pennsylvania Academy of the Fine Arts (1896-97). Howes was a member of the Copley Society and the Boston Water Color Club. She focused on landscapes, local genre (*Mending the Net* and *A Cape Cod Fisherman*), and views of Boston (*A Winter View from Beacon Hill*). In addition, Howes traveled to Brittany (*A Breton Farm* was exhibited in 1887), and to England in the late 1890s (*A Dorset Village*; 1896). Erica E. Hirshler mentions an Edith Howe[s] as one of the council members at the School of the Museum of Fine Arts, Boston, which shows her esteemed talent and degree of respectability. In 1885 the school's governing council began to admit women, thereby "it was possible for a woman to play an influential role in the arts in Boston."[49]

In *Washing Day*, a woman in her side yard kneels beside a fountain to do her wash. She has already spread out linens to dry, toward the foreground. This appears to be a plein air landscape because everything is so natural and we feel the clear, warm day. The technique is conventional, with no references to impressionism: shadows are simply dark green and there is no use of violet or broken color. This combination genre scene and landscape is a record of the humble, everyday activities of rural life.

[49] Erica E. Hirshler, *A Studio of Her Own: Women Artists in Boston 1870-1940* (Boston: Museum of Fine Arts, Boston, 2001), p. 91.

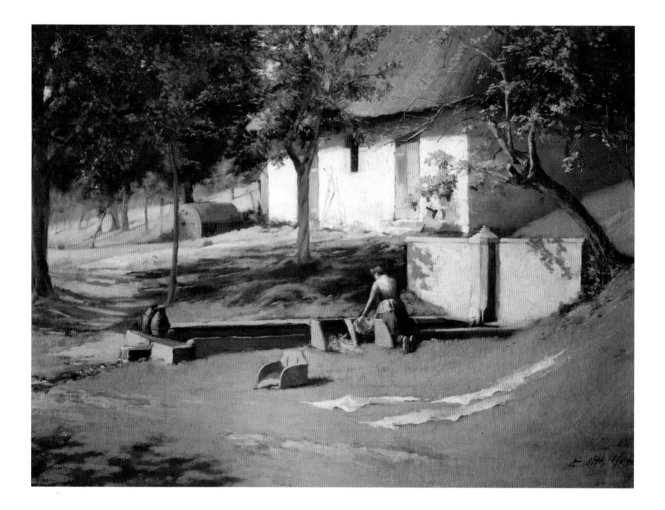

33. GEORGE INNESS
(Near Newburgh, New York 1825 - 1894 Bridge of Allan, Scotland)
Perugian Valley
Oil on canvas, 15½ x 24 in.
Signed lower left. Date: ca. 1873-75

The landscapes of George Inness are in a category all their own. Early on he expressed admiration for the American masters Cole and Durand, then in the 1850s, Barbizon School influence can be detected. Toward the end of the decade, Inness was more experimental, and by 1860 he had more or less matured stylistically.[50] He produced allegorical landscapes and became a follower of Emanuel Swedenborg (1668-1772). For Inness, in his belief that material objects have a spiritual "correspondence," the path of the true artist was toward spiritual development. Swedenborg explained how humanity became so distant from its spiritual origins (*essentia* = love and wisdom) that the Lord was born into the world through a mortal woman. The turning of man's love from God to one's own ego caused extreme evil.[51] We read in the letters of Inness how artists who merely "copy appearances" are limited materialists, and for him, this included the Dutch genre painters and the impressionists. For Inness, the artist had to "unite exterior and interior truths."[52]

LeRoy Ireland, in his catalogue of the works of George Inness,[53] describes *Perugian Valley* as follows: "Groups of olive trees and taller trees across the foreground, where figures are seen on the green slope overlooking a view of the river, spanned by an arched bridge in the distance and flowing between hilly shores. Mountain peaks rising in the far distance." The painting has been erroneously called *Delaware Valley*, however it dates from the painter's third trip to Europe (1873-75). During this period Inness moved toward formal refinement, and as Nikolai Cikovsky states, he used color arbitrarily, and tended to flatten the landscape depth. But that is not the case here. A gentle series of sloping diagonals leads the eye slowly into the distance, as spatial depth is suggested by alternating light and dark planes, down to the Tiber River. Inness observed highly nuanced atmospheric effects in *Perugian Valley*. There is a remarkable violet-gray mist in the middleground and more violet in the distance. We know that Inness executed oil sketches on the spot; such works are studies directly from nature, and this larger landscape is in that tradition.

[50] See Nicolai Cikovsky, Jr., *The Life and Work of George Inness*. Outstanding Dissertations in the Fine Arts series (New York: Garland Publishing, 1977), for the stylistic development.

[51] It would be interesting to relate Swedenborgian philosophy to the writings of the early American critics of modernism, who frequently referred to the artist's ego as a misleading inner force. For example, the art of Matisse, in Kenyon Cox's opinion, expressed pure, eccentric egotism, and Royal Cortissoz concluded that Vincent van Gogh's so-called "inventive genius . . . [could be] explained rather by incompetence suffused with egotism." (Quoted from Cortissoz, "The Post-Impressionist Illusion," in *Art and Common Sense*, New York: Scribner's, 1913). See also Cortissoz, "Egotism in Contemporary Art," *Atlantic Monthly* 73 (May 1894): 649.

[52] George Inness," Strong Talk on Art," *New York Evening Post*, 3 June 1879.

[53] LeRoy Ireland, *The Works of George Inness: An Illustrated Catalogue Raisonné* (Austin, TX: University of Texas Press, 1965), p. 156.

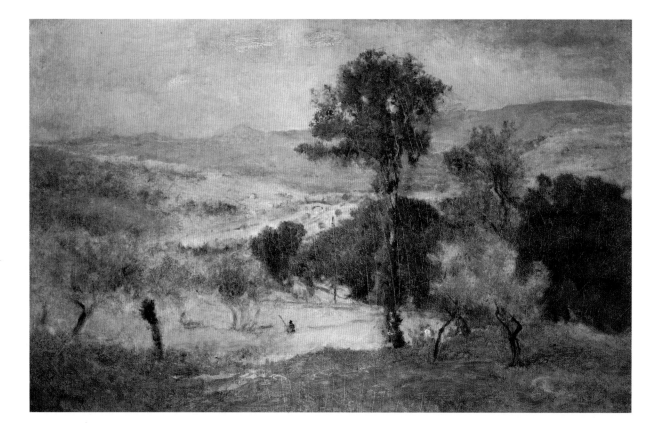

34. WILLIAM H. KINNICUTT
(Cleveland, Ohio 1865 - 1934)
Public Square, Cleveland
Oil on canvas, 30 x 36 in.
Signed lower right
Date: ca. 1919-20

This Cleveland artist was the son of a merchant who made a fortune supplying the Union Army during the Civil War. William began his studies at the Cleveland School of Art with DeScott Evans (1847-1898), then transferred to New York where he pursued both art and medicine. Kinnicutt joined the Cleveland Society of Artists in the early 1910s and exhibited only in the Cleveland area, including at the annual "May Show" at the Cleveland Museum of Art. This juried exhibition, commenced in 1919, was designed to include both fine and applied arts. To promote the artists themselves, all works were offered for sale.[54] Kinnicutt's paintings are quite rare.

Public Square, Cleveland should be considered an example of Ohio proto-regionalism, that is the period preceding the American Scene and regionalist movements of the 1930s. This colorful, modern urban landscape communicates the intense spirit of optimism following the first world war. Commerce is booming as the twenties are about to roar. The square is crowded with shoppers, people going to work, out-of-town visitors and fun seekers. The bustling, old-fashioned downtown area is depicted in all its former splendor, when Americans valued the convenience of a central location accessible by streetcar, unlike today, when in most cities, one is forced to drive to generic suburban malls filled with the same predictable chain stores. Kinnicutt chose a grid composition with a large open square in the foreground where people wait for streetcars. Behind this is a basically flat, expansive façade topped with billboards. The upper zone is an intriguing pile of cube-like structures and "prettified" smokestacks, symbols of industrial progress, but which to our eyes seem rather ominous.

[54] See Jay Hoffman, Dee Driscole, and Mary Clare Zahler, *A Study in Regional Taste: The May Show 1919-1975* (Cleveland Museum of Art, 1977).

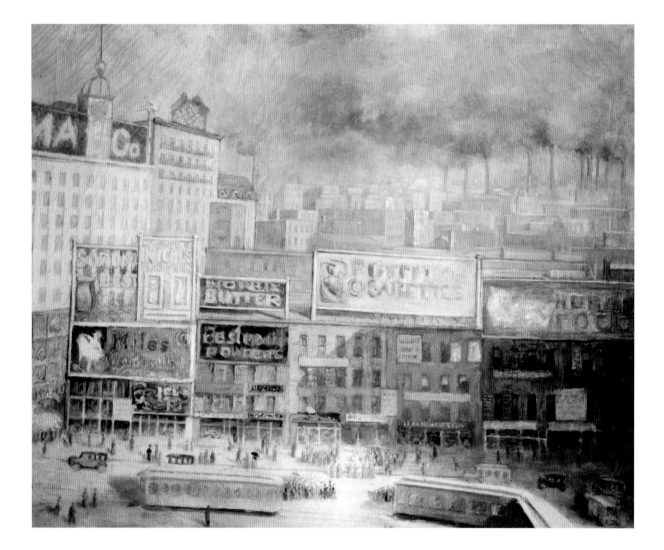

35. CARL KRAFFT
(Reading, Ohio 1884 - 1938 Oak Park, Illinois)
At Sundown
Oil on canvas, 41 x 50 in.
Signed lower right

Krafft was one of the many students of John H. Vanderpoel at the School of the Art Institute of Chicago where he arrived around 1907. There he would have met mural painter Eugene Savage (1883-1978), E. Martin Hennings (1886-1956), and Louis Ritman. Krafft became versatile in oil, watercolor, pastel, etching and lithography. Before long, he found employment as a commercial artist and in his spare time he painted en plein air. At the Art Institute annuals he would exhibit until 1935. Krafft's work exemplifies late decorative impressionism with an impasto application of luminous, broken color. For V. E. Carr, "Intensity, tonal values and their relation to masses and movement of line in composition are the prime factors of his art."[55]

Seeking an isolated area in which to paint, Krafft ventured down to the Ozark Mountains in Northern Arkansas and Southern Missouri around 1914 with his friend Rudolph F. Ingerle (b. 1879). They brought other midwestern artists to the area and founded the Society of Ozark painters in 1915. Krafft's focus of operations was the little town of Arcadia and along the Gasconade River. By 1916, he was referred to as the "painter-poet of the Ozarks," as he received an Honorable Mention from the Chicago Artists Guild. Numerous awards followed and Krafft was honored with a one-man show at the Art Institute of Chicago. Later he became active in the Art League of Oak Park. The Great Depression was difficult for the artist, who made etchings and sold them for a few dollars. Following a nervous breakdown, Krafft died at the age of fifty-four.

Most likely, *At Sundown* was painted in the Ozarks. It is a highly picturesque affair, full of winding, spindly trees, and executed with lively brushwork, thick impasto and an autumnal palette of orange, yellow, and touches of green and violet.

[55] V. E. Carr, "Carl R. Krafft," *American Magazine of Art* 17 (September 1926): 475-480.

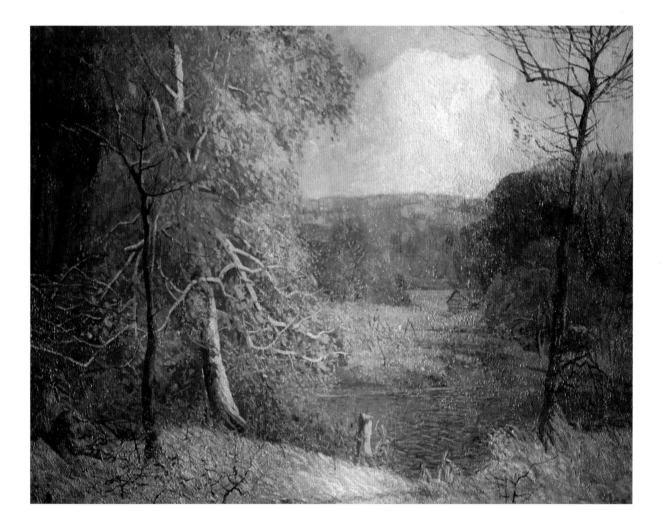

36. WALTER KRAWIEC
(born in Poland, 1889)
Circus Rider
Oil on canvas, 16 x 20 in.
Signed lower right

Walter Krawiec, born in 1889 in Poland, became a painter, illustrator and cartoonist in Chicago. Two of his teachers were "establishment" Chicago painters: Ralph Clarkson (1861-1942) and Walter Clute. Krawiec was the cartoonist for the *Polish Daily News* and he illustrated P.R. Martin's *First Cardinal of the West* (1934). He was a member of Chicago Painters and Sculptors, the Chicago Gallery Association and the Cliff Dwellers.

In *Circus Rider*, a performer enters from the left on horseback, carrying a floral hoop. The horse and dog have been rendered in a convincing manner in this colorful slice of life. Even though this is an image of circus genre, there is something more monumental about the group, with the small procession led by the horse trainer. The little dog seems almost as proud as the noble old horse and the performer on horseback poses even for us innocent bystanders. Perhaps she spots a photographer not far away. At the Art Institute of Chicago, Krawiec exhibited between 1927 and 1949 — in 1933 two of his circus pictures were on display: *Between the Acts* and *The Big Top*. Krawiec was fond of horses: *Pony Riders*, *Spotted Horses* and *Derby Day* are a few more titles of his exhibited works. The artist's wife Harriet (b. 1894) was also a painter.

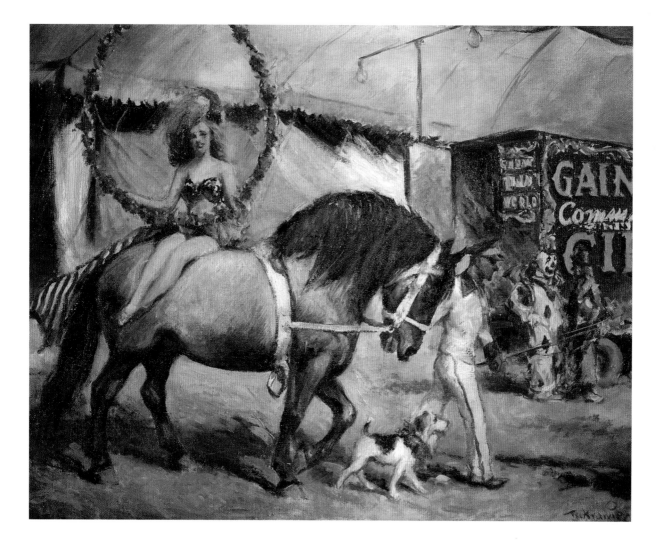

37. BERNARD LaMOTTE
(Paris 1903 - 1983 New York City)
Central Park — New York
Oil on canvas, 21 x 25 in.
Signed lower right with
inscription: "A Madame. . . ."

This landscape painter studied under Lucien Simon (1861-1945), the portraitist and genre painter.[56] He married the widow of Twentieth Century Fox president Sidney R. Kent, Lilyan White Kent, a painter and sculptor, then was introduced to such stars as Marlene Dietrich, Charlie Chaplin, and Greta Garbo. LaMotte had a studio in Montmartre called Le Bocal [Fish Bowl], where Antoine de Saint-Exupéry wrote *Le petit prince*. He knew Picasso and Utrillo, and he traveled widely, as far away as Tahiti and India. In 1936, LaMotte exhibited gouaches at New York's Wildenstein Gallery. He had a studio over La Grenouille Restaurant on 52nd Street in New York, and became an American citizen in 1951. Working in a vivid Fauve manner, LaMotte produced oils on canvas, decorative screens, book illustrations, and theatrical sets and costumes. His paintings recall the works of Matisse, Bonnard and Dubuffet. LaMotte also did delightful murals in French restaurants in New York City, for instance a port scene of St. Jean de Luz in a corner of La Côte Basque Restaurant (1958). Three years later he executed a mural for the White House pool under the Kennedy Administration (now in the John F. Kennedy Library and Museum, Boston). In 1965, almost every painting he exhibited at Palm Beach Galleries (Florida) was sold.

Influenced by the French painter Utrillo and others, LaMotte executed most of his work en plein air. He did so with this oil known as *Central Park -- New York*. In this scene as in most of his works, this Parisian-educated New York artist worked directly from his subject, applying his pigment with a seemingly effortless bravura. Three distinct registers create the composition: the foreground of Central Park itself, the geometric buildings that make up the well-known New York skyline, and the sky and clouds. LaMotte was not sparing in his use of color in the foreground, while he relegated skyline forms to somber tones in the architectural part of the composition, no doubt an influence of the Cubist palette. The painter excluded figures and automobiles here, thus retaining pictorial severity. The scene reveals a purposefully reticent artist, as one might expect from the Cubist influence LaMotte absorbed while living in France. All in all, this New York City landscape reveals a serious depiction of a scene frequently romanticized by other painters.

[56] See *Bernard LaMotte (1903-1983)*. Exh. cat. (Boston: Vose Galleries, 1993).

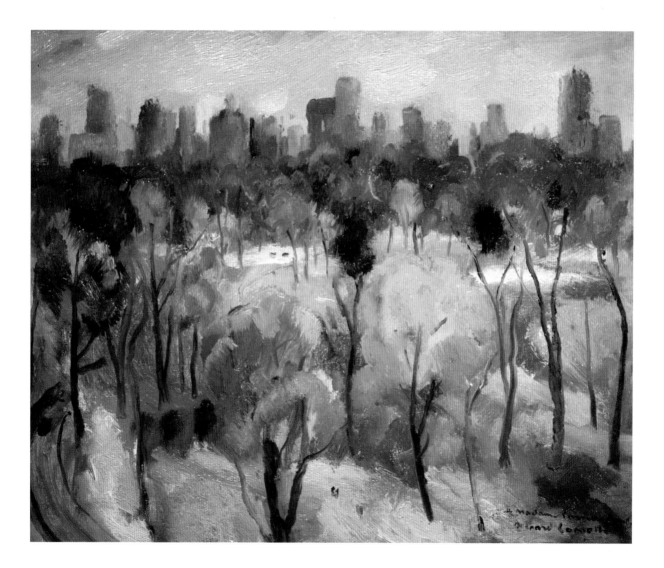

38. ERNEST LAWSON
(Halifax, Nova Scotia 1873 - 1939 Miami, Florida)
The Waterfall at Shore Mills, Tennessee
Oil on canvas, 14 x 16
Signed lower right

This "urban, Ash Can post-impressionist" began his studies at the Kansas City Art Institute in 1888.[57] Two years later he was at the Art Students League in New York, then at Cos Cob he fell under the influence of J. Alden Weir. Like many others, Lawson went off to Paris to enroll in the Académie Julian (1893). At Moret-sur-Loing he met Alfred Sisley, who was in poverty with only several more years to live. At that time, Lawson was sharing a room in Paris with Somerset Maugham, who would model the character of Frederick Lawson (from *Of Human Bondage*) on the real Ernest Lawson. Back in New York, Lawson began his "Harlem River" period in 1898. He exhibited his works regularly at the National Academy of Design, at the Pennsylvania Academy and elsewhere. Lawson's bold canvases pleased progressive critics like James Gibbons Huneker, who called the artist a "sensitive pantheist." Lawson and his wife moved to Greenwich Village and joined the MacDougal Alley coterie. At the 1908 show at Macbeth's Gallery, where the Eight made their debut, Lawson sold *Winter on the River* to Gertrude Vanderbilt Whitney (still in the Whitney Museum). Also in that year he became an Associate of the National Academy.

Dr. Albert Barnes bought several of Lawson's works in 1912, then at the Armory Show, Lawson exhibited three landscapes. The W.A. Clark Silver Medal enabled the Lawsons to travel to Segovia, Spain in 1916. He continued to win impressive awards, and the critic Guy Pène du Bois declared that Lawson's *Vanishing Mist* (Carnegie Museum) was "one of the greatest American landscapes."[58] Lawson taught at the Kansas City Art Institute and at the Broadmoor Art Academy in Colorado Springs. He is best known for depictions of the New York City industrial areas along the rivers, excavation sites, massive iron bridges, docks and fishing shacks and unsightly urban places. Lawson's highly structured compositions reveal the influence of Cézanne, and his canvases of thick impasto make him a post-impressionist. He seems to have straddled the fence between two art worlds: he had one foot in the National Academy and the other in modernist territory, as he was one of the organizers of the Armory Show. Lawson, however, was primarily a naturalist who took little interest in the issues that excited Marcel Duchamp, Kandinsky, Picasso and Hans Hofmann.

This vibrant view of a waterfall in Tennessee is a perfect example of why F. Newlin Price and Huneker described Lawson's palette as one "of crushed jewels."[59] The waterfall is a marvelous wall of vertical brush strokes of a variety of brilliant colors, framed on the left by a diagonal land mass with gently curving trees, all placed within a remarkably classical composition.

[57] Henry Berry-Hill and Sidney Berry-Hill, *Ernest Lawson: American Impressionist 1873-1939* (Leigh-on-Sea, UK: F. Lewis Publishers, 1968) is still one of the best sources.

[58] Guy Pène du Bois, *Ernest Lawson* (New York: Whitney Museum of American Art, 1932), p. 10.

[59] See F. Newlin Price, "Lawson, of the 'Crushed Jewels,'" *International Studio* 78 (February 1924): 367-370.

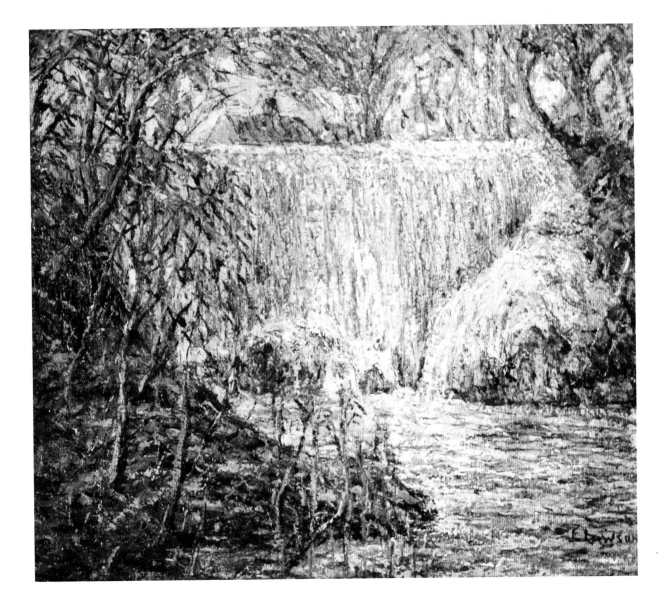

39. JAMES LEWIN

(Swansea, Massachusetts 1836 - 1877 Milton, Massachusetts)
The Sharpshooter
Oil on canvas, 16 x 26 in.
Signed and dated 1860, lower right

The focus of this painting, half-genre scene, half-landscape, is the group of sharpshooters on the river bank, positioned behind a rectangular-shaped outcropping. Wild trees fan out along diagonals that lead the eye to the figure group. The right half of the picture is a pure Hudson River School landscape vista, bathed in a gentle mist.

Lewin was a fine Rhode Island landscape painter who also executed still-lifes and engravings. Most of the extant works by Lewin are in private collections. Sadly, his sketchbook was deaccessioned from the Rhode Island School of Design's Art Museum around 1950, even though it came from an important donor and trustee, Isaac C. Bates. John Nelson Arnold, an intimate friend of the artist, included him in his *Art and Artists of Rhode Island* (Providence: 1905). For Arnold,

> there was a poetic element in [Lewin's paintings], a subtle, romantic
> quality that appealed to everyone. This was before the days of fads
> in art, when the artist went humbly to nature and made conscientious
> transcript of the woods and meadows, skies and streams. . . . His
> delicate and exquisite creations, both in landscape and still life, were
> eagerly sought for by art lovers. . . . (quote, p. 31)

The painter Sarah W. Whitman (1842-1904), a famous designer of book covers and painter of Niagara Falls, wrote a memorial essay after Lewin's death at the age of forty. She described his character; despite his capricious moods, he was "generous, affectionate and exquisitely sensitive." In addition, Lewin was fond of literature and he published articles as well as his own poetry.

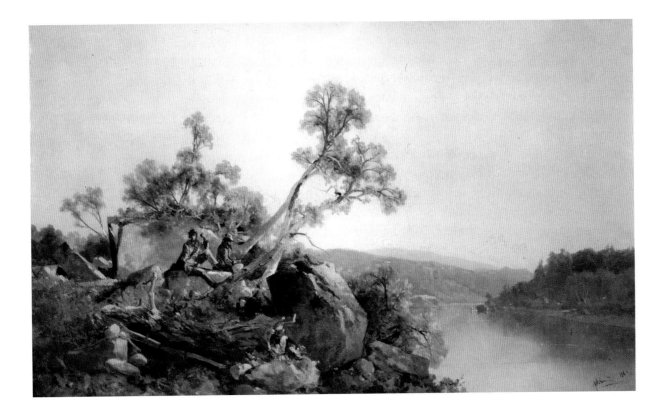

40. EDMUND DARCH LEWIS
(Philadelphia 1835 - 1910 Philadelphia)
Along the Susquehanna River
Oil on canvas, 9¾ x 15¼ in.
Signed and dated 1871, lower right

Lewis, from Philadelphia,[60] studied under German-born Paul Weber (1823-1916), formerly court painter to the Grand-Duke of Hesse-Darmstadt, who also taught William Trost Richards, Thomas Moran (1837-1926) and others. Lewis began exhibiting at the age of nineteen, at the Pennsylvania Academy of the Fine Arts and continued to do so until 1891. An early work, *The Queen of the Antilles*, was an emulation of Frederic Edwin Church's *Heart of the Andes* (Metropolitan Museum of Art). Earl Shinn (pseud. Edward Strahan) admired the luminous work, in which every object seems to have been caressed by light. The Pennsylvania Academy has Lewis's *Lake Willoughby*, a vast 80-inch canvas signed and dated 1867. Lewis became an incredibly successful and prolific painter, then turned his attention from oil painting to watercolor. Later he devoted himself to collecting decorative art: tapestries, furniture, objets d'art, precious ceramics, as well as paintings of old and modern masters. The wealthy artist had two adjoining homes built on South 22nd Street in Philadelphia to show off his collection and to entertain members of fashionable society.

The artist's sketchbook from 1871, the year *Along the Susquehanna River* was executed, proves that he made his way up the Susquehanna River, in the vicinity of Harrisburg, stopping at Marietta, Duncannon and Clarks Ferry. One of the outstanding features of this painting is the clarity of form, which does not exclude a pleasing softness, and this links Lewis to the Luminist tradition. Throughout there is a decorative use of small, delicate brushstrokes that enliven the surface. One should notice the introduction of pure color — touches of vivid green and violet in the lower left-hand corner, and there is a peach tone in the river itself to indicate reflections of clouds. In the luminous sky there is an indication of moisture, especially toward the right. The full range of values, which is lacking in later impressionist paintings, always helps to emphasize solid form and here it corresponds to the crispness of the air. The viewer's eye is led at an ever so slight diagonal into the distance, while the focal point is a church steeple, around which huddle the village houses. One of the figures in the tiny canoe, rendered in bright red, provides a striking color accent.

[60] The major source is Michael W. Schantz, *Edmund Darch Lewis 1835-1910.* Exh. cat. (Philadelphia: Woodmere Art Museum), 1985. In addition, the Washington County Museum of Fine Arts in Hagerstown, Maryland featured the watercolors of Lewis from private collections in an exhibition in the summer of 1992.

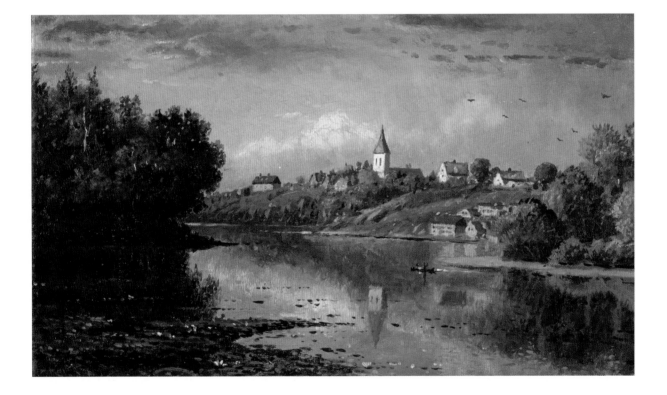

41. E. BARNARD LINTOTT
(London 1875 - 1951 New York City)
Ballet Girl in Pink
Oil on canvas, 30 x 25 in.
Signed upper right

After a period of versatile training as a painter, British-born Edward Barnard Lintott interrupted his career with political duties, acting as the British Ambassador to Russia. Following his return to art, he demonstrated definite ability in portraiture, still-life, and a variety of other subjects. Lintott traveled widely and enjoyed representation by exclusive art galleries. Although he executed some unusually sensitive works prior to World War I, the bulk of his artistic productivity was later.[61] Lintott studied in England and then crossed the Channel to continue at the Académie Julian, then at the Ecole des Beaux-Arts where he refined his ability to draw the human figure.[62] Lintott executed portrait studies and works in a plein-air manner during various sketching trips.

Like Louis Kronberg before him, Lintott became fascinated with the ballet and theater as subjects for painting: "The artist-diplomat made much use of the Chancery and Embassy box at the Marinsky Theatre . . . and became personally acquainted with many members of the 'Corps de Ballet.'"[63] In *Ballet Girl in Pink*, the dancer bends down to lace up her slipper. Naturally, the subject and the nonchalant pose itself prompt one to compare Edgar Degas. The ungainly, stooped-over bather in his pastel, *The Tub* (The Hill-Stead Museum, Farmington, CT) comes to mind. Yet Degas' series of dance class pictures have little in common with Lintott's highly tectonic composition with the centrally placed figure. Light streams through the window of the relatively dark room, illuminates the dancer's back, defines the contours of her arms and legs, and it brings the highly polished wooden floor to our attention. There is a delightful sense of texture, achieved with controlled brushwork.

After a long and distinguished career in London, Lintott relocated to America in the early years of the Depression. In New York he worked as a portraitist, submitted paintings to various national annuals, and soon enjoyed one-man shows in Chicago, New York, and Boston. His wife, Marie Sterner Lintott, herself a respectable art dealer, was instrumental in the promotion of Lintott's work. He was also fortunate to have been represented by important art galleries such as M. Knoedler & Co. and Macbeth in New York, as well as by Doll and Richards in Boston. It appears that the artist's most active period of exhibition was in the decade of the thirties. Lintott became a citizen of the United States, and in the summer of 1942, seventy-seven of his works were mounted for a retrospective exhibition at the Berkshire Museum in Pittsfield, Massachusetts. He continued to receive praise from critics throughout the forties for his unusually diversified subjects.

[61]　　See *E. Barnard Lintott. Exhibition of Oils, Watercolors and Drawings*. Exh. cat. (Bridgehampton, Long Island, NY: Clayton-Liberatore Gallery, September, 1970).

[62]　　*E. Barnard Lintott*. Exh. cat. (Littleton, MA: James R. Bakker, 1975).

[63]　　See "Lintott Paints the Ballet and the Theatre," *Art Digest* 13 (15 January 1939): 14.

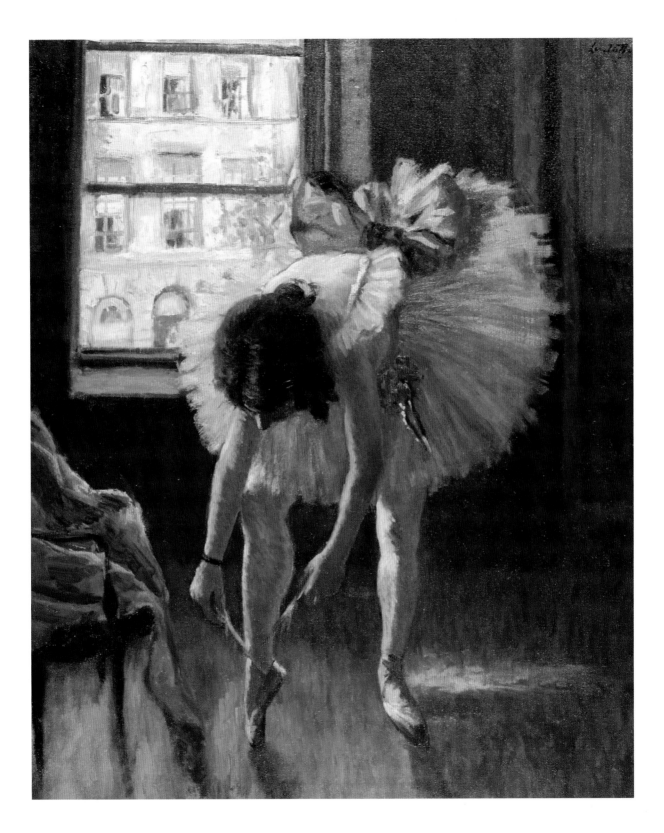

42. HARRIET RANDALL LUMIS
(Salem, Connecticut 1870 - 1953 Springfield, Massachusetts)
The Birches
Oil on canvas, 21 x 26 in.

Harriet Eunice Randall received a well rounded education at the Connecticut Literary Institution in Suffield.[64] Little is known about Harriet's childhood and adolescence; in 1892, she married Fred Williams Lumis, an architect living in Springfield, Massachusetts.[65] Her first formal painting instructor was Willis S. Adams (1844-1921) and she produced her first landscapes under his influence, resulting in works in the tonalist tradition.[66] From Adams, she turned to Leonard Ochtman, who was moving more toward impressionism at that time. Under Ochtman at the New York Summer School at Mianus, near Cos Cob (ca. 1910-13), Lumis began to loosen her technique, set a brighter palette, and replace the more traditional, broad vista type composition with more specific slices of nature. Harriet Lumis first submitted her works at the age of forty-two (in 1912) to the Albright Gallery in Buffalo. A local critic reported that her canvases were "all characterized by unusual refinement of color and a poetic, but sure touch."[67] She followed this by showing three of her canvases in the 1913 annual exhibition of the Connecticut Academy of Fine Arts, and in the same year she exhibited at the Providence Society of Artists. Lumis became an inspired, highly productive painter, perpetually striving for artistic maturity. At the age of fifty, she attended Hugh Breckenridge's summer school at Rocky Neck, in Gloucester, home of America's celebrated artists' colony. In addition, she was one of the founding members of the Springfield Art League in 1919.

The Birches proves that Lumis painted forms more as solid objects than did the typical French impressionist. Her original style paralleled her conviction that "America not only has an art of her own but she has an art [that] will stand as high as the contemporary art of any European country."[68] Lumis was attempting to contradict another woman impressionist painter, Cecilia Beaux, who claimed that America had no art that was comparable to that of France. The technique of Lumis changed from a heavy application of impasto texture to a use of wash-like patches of subtle hues, contrasted with large areas of brilliant broken color. Using saturated color, she attained a natural luminism without the high-keyed palette associated with her earlier years.

[64] *Fifty-first Annual Catalogue of the Connecticut Literary Institution, Suffield, Conn., for the Academic Year 1883-84* (Hartford, CT: 1884), p. 7.

[65] Gary Roberts, New England Historic Genealogical Society, to Judith D. Corbeille, 6 October 1977, R. H. Love Galleries Archives, Chicago. Richard H. Love, *Harriet Randall Lumis: 1870-1953. An American Impressionist.* Traveling exh. cat. (Chicago: R.H. Love Galleries, 1977) is still the major source.

[66] On Adams, see Roger Black, *Willis Seaver Adams / Retrospection.* (Deerfield, MA: The American Studies Group, The Hilson Gallery, Deerfield Academy, 1966).

[67] *Buffalo Express*, 22 April 1912.

[68] Harriet Randall Lumis, quoted in the *Springfield* (MA) *Union*, 3 February 1922.

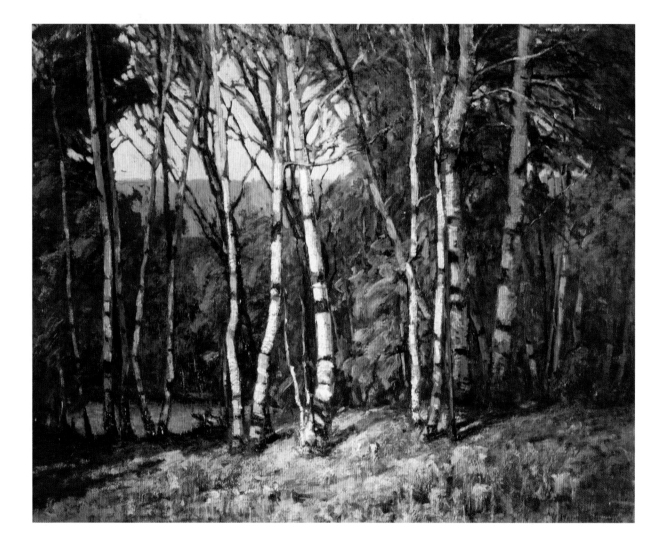

43. JOHN WORTHINGTON MANSFIELD
(Norwich, Connecticut 1849 – 1933 Ipswich, Connecticut)
Niagara Falls with Bridge and Rainbow
43 x 29½ in.
Signed lower right
Date: 1904-06

After growing up in Chelsea, Massachusetts and serving briefly in the Union Army during the Civil War, Mansfield went to study art in New York.[69] He received instruction from Lemuel Wilmarth (1835-1918) at the National Academy of Design, then he traveled to Europe in 1871. Mansfield entered the atelier of Léon Bonnat but like many, failed the demanding exams of the Ecole des Beaux-Arts. Surely Mansfield would have seen the sensational first group show of the French impressionists in the spring of 1874. That summer he was in Barbizon and the following year he may have met Charles-François Daubigny (1817-1878), a leading Barbizon School painter who captured the fleeting aspects of nature. A year later Mansfield was executing etchings at Auvers-sur-Oise; Stephanie R. Gaskins[70] believes he would have encountered the students of Carolus-Duran at Grèz in the Forest of Fontainebleau.[71] If this is true, in the summer of 1876 he could have met Robert Louis Stevenson and Will H. Low. Having returned to New York, Mansfield exhibited two landscapes of the Oise Valley at the National Academy in 1877 and a *View near Auvers* in 1878. That year he developed an interest in winter scenes in the New England woods and mountains. While another Barbizon landscape showed up at the Boston Art Club in 1880,[72] two works: *An Adirondack Brook* and *Sunshine and Shadow among the Berkshire Hills* were exhibited at the Pennsylvania Academy the following spring. By 1885, Mansfield was teaching in Boston's New England Conservatory of Fine Arts but two years later he moved to Ipswich.

(TEXT CONTINUED ON PAGE 146)

[69] See Frederic A. Sharf and John H. Wright, *Chronology and Partial Checklist of the Paintings and Drawings of John Worthington Mansfield, An American Artist Rediscovered (1849-1933)*. Exh. cat. (Essex Institute, 1977-78).

[70] Stephanie R. Gaskins, "Five Ipswich Painters," in *The Ipswich Painters at Home and Abroad: Dow, Kenyon, Mansfield, Richardson, Wendel* (Gloucester, MA: Cape Ann Historical Association, 1993), p. 8.

[71] Grèz-sur-Loing, usually thought of as a center of tonalism, is where the innovative Irish painter Roderic O'Conor would influence Edward Potthast, later in 1889. American impressionist Robert Vonnoh was also active there.

[72] No. 52: *November in the Forest, France.*

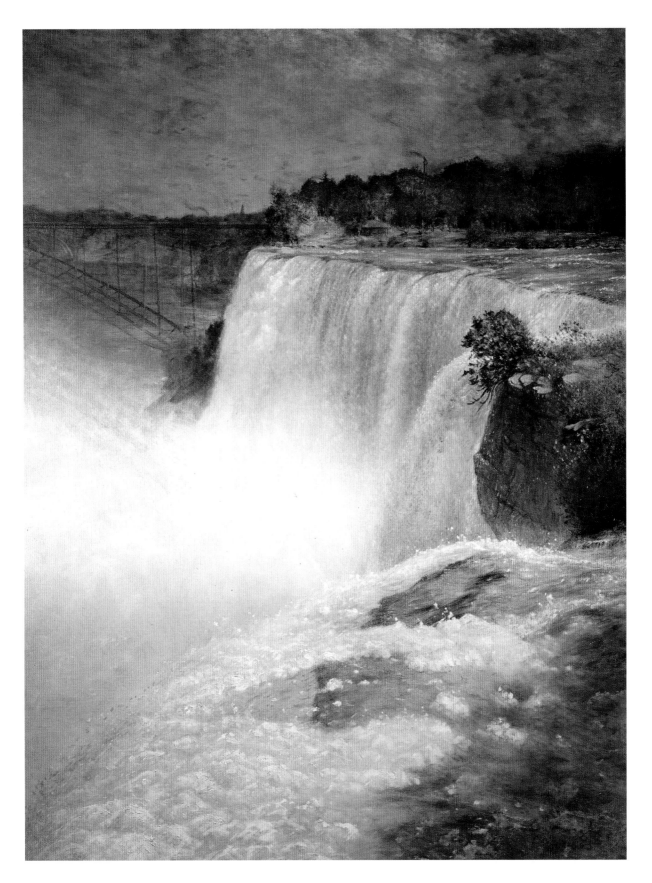

44. RICHARD E. MILLER
(St. Louis, 1875 - 1943 St. Augustine, Florida)
Landscape with Figure
Oil on canvas, 16¼ x 13½ in.
Signed lower right

Miller was one of the significant members of the third generation of American expatriate painters in Giverny, an artist of international distinction.[73] In 1893, eighteen year-old Miller enrolled in the St. Louis School of Fine Arts, a branch of Washington University. Five years later, he received a traveling scholarship, which allowed him to study in Europe. In Paris, Lawton Parker took Miller to the Académie Julian (1898-1901) where he became a student under Jean-Paul Laurens and Benjamin Constant. Miller's earliest paintings executed in Paris are highly naturalistic, almost in a Flemish manner. This gave way to the driving influence of impressionism, which became his means to render contemporary French genre. For the most part, he concentrated on the single figure in an intimate setting. Early on, Miller won awards: a gold medal at the Paris Salon of 1901, a bronze medal for a portrait at the Pan-American Exposition in Buffalo in the same year, and another gold medal at the Paris Salon in 1904. Miller significantly lightened his palette for his plein-air studies and began a series of Parisian street scenes, some of which depicted the grand city at night. Miller also underwent Whistler's influence. Declared *hors concours*, Miller was hired to teach at the Académie Colarossi, and finally he was honored with the coveted Légion d'Honneur.

Miller discovered Giverny around 1906 where he taught at Mary C. Wheeler's summer school. Meanwhile, he made an impact internationally, exhibiting in Venice in 1905, 1907 and 1909, where he was acclaimed by critics. He and Frieseke traveled to Italy to see a gallery of their paintings at the Venice Biennale. By 1910, Miller had learned the principal tenets of impressionism and adapted them to suit his personal style, contrasting large areas of color with dot and dash patterns of fat pigment to produce an overall balance of surface texture and a striking, decorative surface. To summarize Miller's philosophy, the artist once reported that "art's mission is not literary, the telling of a story, but decorative, the conveying of a pleasant optical sensation."[74]

The painter's landscapes are more rare. There is an early *Brittany Road*, painted in 1900, which Marie Louise Kane rightly compares to William Lamb Picknell's famous *Road to Concarneau* (Corcoran Gallery of Art).[75] Then a late work, *Landscape, Provincetown*, is from the 1930s. *Landscape with Figure* falls somewhere in between. It has an especially free use of thick impasto textures and shows heavy scumbling. The brushwork in the foreground seems arbitrary and expressive. The ultimate effect is glowing and dream-like.

[73] See Marie Louise Kane, *A Bright Oasis: The Paintings of Richard E. Miller* (New York: Jordan-Volpe Gallery, 1997).

[74] Helen L. Earle, *Biographical Sketches of American Artists* [1924] (Charleston, SC: Garnier and Co., 1972), p. 215.

[75] Kane, 1997, p. 15, fig. 10.

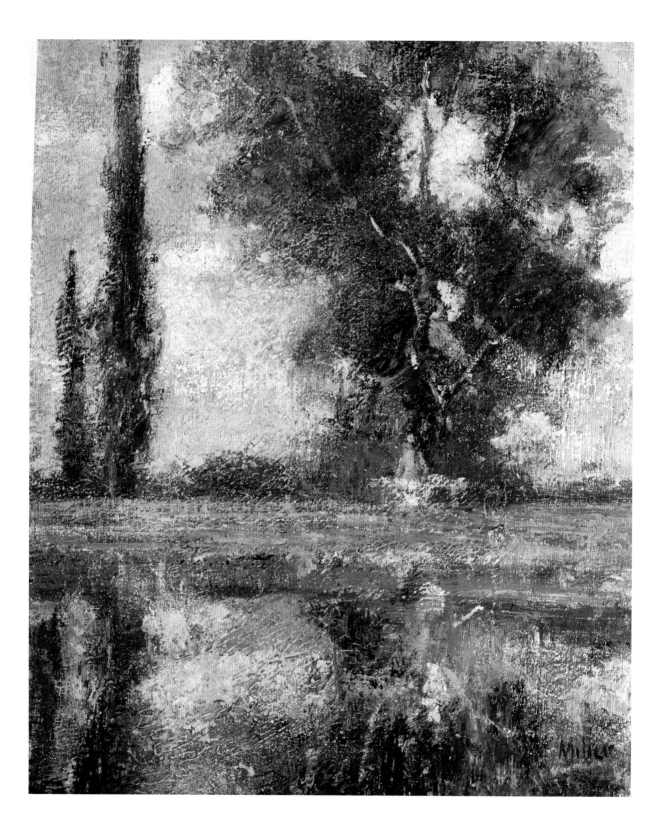

89

45. FRANCIS LUIS MORA
(Montevideo, Uruguay 1874 - 1940 Gaylordsville, Connecticut)
Two Fishermen
Oil on canvas, 25 x 30
Signed lower right

Mora, who moved with his family from Uruguay to Boston, studied with his father Domingo Mora (d. 1911), with Edmund Tarbell and Frank W. Benson (1862-1951) in Boston, and under H. Siddons Mowbray at the Art Students League in New York. While in Europe in 1896, Mora admired El Greco's spiritual art, Goya's combination of boldness and delicacy, the strangeness in Manet's oeuvre and his use of black, and the draftsmanship and elegance in the work of Degas. He described meeting William Merritt Chase in the Prado. Mora gained popularity for his realistic depictions of a wide variety of figure types, using staccato brushwork and at times, a dissolution of form (*The Picnic*, in the Newark Museum). He became a National Academician in 1906 and was an art instructor at the New York School of Art. For Mora, who still acted within the Genteel Tradition, the artist is a minister who provides comfort and inspires through his or her creations:

> Art is the whispering of the great voice of nature, that quietly, peacefully,
> steadily, lifts men to higher thoughts, nobler deeds, and loftier aspirations,
> . . . penetrating the thickest of mortals, and reaching those who seem to be
> farthest from the finer impulses. . . . [76]

In his art Mora approached Manet's "dark impressionism," which suggests some contact with Robert Henri. *The Fortune Teller*, in the Butler Institute of American Art, from 1905 (exhibited later at the Panama-Pacific International Exposition along with three other paintings) and *Spanish Fête*, dated 1906[77] are the type of Spanish subjects Henri would have appreciated, and in fact, Mora served on juries with Henri, and at the 1907 jury session of the National Academy, he sketched Henri in a small diary.[78] Mora discovered Sorolla's art during another trip to Spain in 1908. Mora's painting *Off for the Day*, dated 1914, is reminiscent of similar sunny holiday imagery of Bellows. In *Two Fishermen*, Mora chose a monochromatic emerald green palette with thickly applied pigment, perhaps seeking the subtle tonalist effects of Whistler or Thomas Wilmer Dewing. The composition could not be more simple: the centrally placed boat acts as a major horizontal in a field of green, while the standing man offers a minor vertical. Mora's portrait of *President Warren G. Harding* (1930) hangs in the White House. He is a major early twentieth-century American artist who deserves to be researched further.

[76] Mora, "Unpublished notes and letters," 1940.

[77] Charles Caffin, *The Story of American Painting* (New York: Frederick A. Stokes Co., 1907), p. 371.

[78] Bennard Perlman, *Robert Henri: His Life and His Art* (New York: Dover Publications, 1991), p. 74.

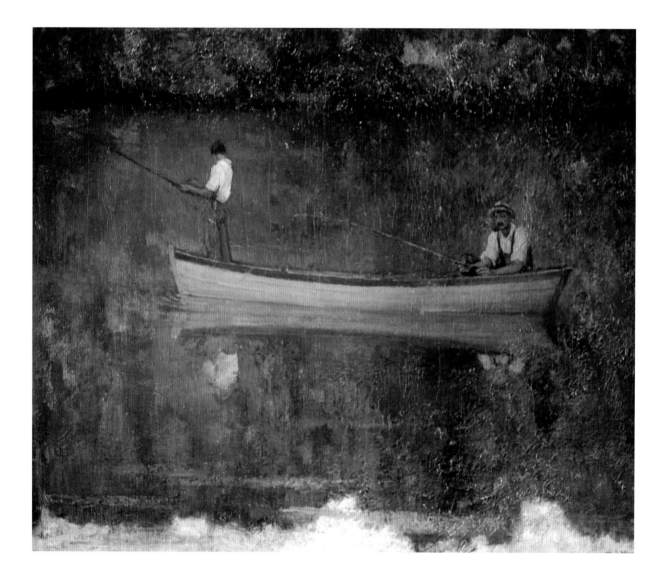

46. F. LUIS MORA
(Montevideo, Uruguay 1874 - 1940 Gaylordsville, Connecticut)
In the Orchard
Oil on canvas, 51¾ x 72 in.

This major work by Mora has been out of public view for decades. The large plein air landscape may be Mora's most impressionistic painting.[79] Members of a family sit around a small table on their back lawn, on a hot summer day. The golden light filters through the foliage and highlights the solid human forms below. This delicate and haphazard use of spotlighting, developed earlier by Renoir, is utilized here by Mora with great facility. The composition could not be more pleasing. The standing woman on the right faces the entire group and acts as a conspicuous framing device, creating what Heinrich Wölfflin termed a "tectonic" or closed composition, which characterized High Renaissance art.[80] In such pictorial arrangements vertical and horizontal elements dominate and there is usually strict symmetry. In Mora's painting a strong vertical element obviously acknowledges the frame. The seated woman on the left, anchored by her baby who looks out at us, checks the movement beyond the left framing edge. The young man, who makes eye contact, also engages the viewer and helps to link the viewer's space with the landscape area. Without this communication between two spatial realms, Mora's picture might have looked too aloof, like a classical relief. The four central figures feature similarly positioned embracing arms, which is a unifying motif. The painterly highlights of dappled sunlight are most outstanding. All in all, one is reminded of Mora's Boston roots and the oeuvre of Edmund Tarbell, one of his teachers, in this image of the "Good Life" of the American impressionist.[81] Tarbell's famous painting with the same title in the Terra Foundation (1891) must have been on Mora's mind.

[79] See Mikaela Sardo Lamarche, *Francis Luis Mora (1874-1940). A Legacy Reconsidered*. Exh. cat. (New York: ACA Galleries, 2005), cat. no. 26.
[80] Heinrich Wölfflin, *Principles of Art History* [*Kunstgeschichtliche Grundbegriffe*] (1915; New York: Dover Publications, n.d.), pp. 124-145.
[81] Boyle, 1974, pp. 178-179.

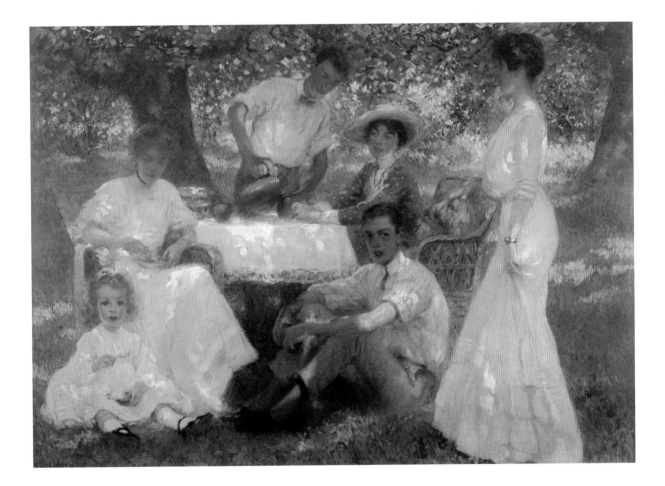

47. WILLIAM SIDNEY MOUNT
(Setauket, Long Island, New York 1807 - 1868)
Portrait of a Young Girl
Oil on board, 16½ x 12½ in.
Signed, reverse

Mount was one of the first students at the National Academy of Design in 1826-27. He worked from plaster casts and copied prints, following the conventional curriculum, when he was not at his job as a sign painter. His first works were history paintings and portraits, but genre painting was his true calling. Mount found inspiration in the paintings of John Lewis Krimmel (1789-1821). One early work, *Bargaining for a Horse* (New-York Historical Society) relies somewhat on Sir David Wilkie's *Errand Boy*. Luman Reed, his patron, offered to finance a study trip to Europe but Mount declined, explaining that to be an original artist does not require travel abroad. He did not believe in copying paintings. Mount was indeed a success in his own country, and his images became even more popular as they were engraved for books and magazines. The American Art-Union distributed prints to its members, including some by Mount. In addition, Goupil, Vibert and Company distributed Mount's images internationally. Alfred Frankenstein pointed out that Mount "was the best-known American painter so far as the European audience was concerned. . . ."[82] His most famous paintings are *Farmers Nooning*, 1836, *Dance of the Haymakers*, 1845, *The Banjo Player* of 1856 (all three: Museums at Stony Brook, New York), *Eel Spearing at Setauket* (1845; New York Historical Association, Cooperstown) and *The Painter's Triumph* (1838; Pennsylvania Academy of the Fine Arts, Philadelphia).

Mount wrote volumes on the technique of painting – media, varnishes, specific pigments to use, glazing and scumbling, and how to prepare canvases. He was also preoccupied with folk remedies and offered all kinds of recommendations, for instance, "For dysentery, take blackberry syrup or two or three tea spoonfuls charcoal." He drank only cold water. His gift for intense and detailed naturalistic observation was remarkable. Mount enjoyed painting en plein air and he designed a horse-drawn wagon with large glass windows, which he called his "Portable Studio." The charming **Portrait of a Young Girl** recalls his *Girl Asleep* (Museums of Stony Brook, New York) of 1843, in its simplicity and straight-forwardness.

[82] Alfred Frankenstein, *William Sidney Mount* (New York: Harry N. Abrams, Inc., 1975), p. 10.

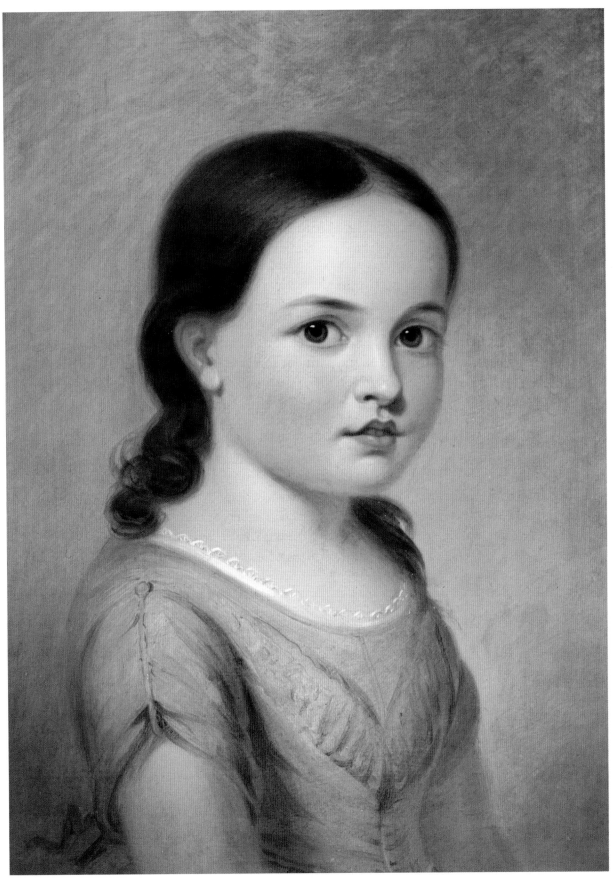

48. ROBERT LOFTIN NEWMAN
(Richmond, Virginia 1827 - 1912 New York City)
Little Red Riding Hood
Oil on canvas, 14 x 10 in.
Signed lower right

It is believed that Rufus W. Weeks of New York purchased this canvas from the artist in 1894. The romantic theme from Grimm's *Fairy Tales* prompted Newman to execute several versions. Earlier, Sir Thomas Lawrence did a *Portrait of Emily Anderson as Red Riding Hood* and it is interesting that in America, thirteen versions of the theme were on display in the various Philadelphia and New York annual exhibitions between 1838 and 1866. Newman's version was part of a one-man show at the Museum of Fine Arts, Boston in 1894 and later it was exhibited at the Whitney Museum of American Art, in 1935.[83]

Young Newman, who grew up in Tennessee, was inspired by biographies of the old masters and he copied prints. In 1850 he took his first of three trips to Europe and, with an introduction from William Morris Hunt, he became a student under Thomas Couture. He taught him to apply pigment in a broad manner to preserve the spontaneous quality of the ébauche through vigorous brushwork: "[Couture's] foremost aim was freshness and purity of colour, which he sought to achieve by mixing colours as little as possible and by placing on the canvas the exact tint he desired without disturbing it afterwards."[84] Newman could have met Manet, also one of Couture's students. On his second sojourn to France he met Jean-François Millet at Barbizon, which further encouraged a painterly, progressive mode of painting. Back home in 1864, Newman was drafted into the Confederate Army, in Richmond, Virginia and he ended up in the Topographical Department until the fall of Richmond, when he moved to New York. According to Landgren, Newman's "color and vigorous brushwork he had inherited from Couture found favor among the young artists opposing the Academy."[85] Newman also knew Albert Pinkham Ryder.

In *Little Red Riding Hood*, the little girl faces the viewer, emerging from a dark background as a luminous mass. At her side stands a rather tame wolf, barely indicated as a silhouette. Forms have been drawn with the brush and contours remain vague. As Landgren explains, "His figures are defined less by their contours than by the way light falls on them, setting them off in relief against their backgrounds."[86]

[83] *R. L. Newman.* Exh. cat. (Boston: 27 March - 17 April 1894), cat. no. 71; *Paintings by Robert Loftin Newman.* Exh. cat. (Whitney Museum, 15 January - 8 February 1935), cat. no. 10.

[84] Albert Boime, *The Academy and French Painting in the Nineteenth Century* (London: Phaidon Books, 1971), p. 69.

[85] Marchal E. Landgren, *Robert Loftin Newman 1827-1912.* Exh. cat. (Washington, DC: Smithsonian Institution Press, 1974), p. 44.

[86] Ibid., p. 90.

97

49. SAMUEL OSTROWSKY
(Malin, near Kiev, Russia 1885/86 - 1946 Chicago)
Woodland Stream
Oil on canvas, 24 x 16 in.
Signed and dated 1916, lower left

Vladimir Donatovitch Orolovski (1842-1914), a Russian landscapist, was the first to promote a shy country boy named Samuel Ostrowsky, by introducing him to Kiev's academy. All went smoothly until a fire destroyed the humble home of his parents — the young painter left for Chicago to live with an uncle, who ousted him for not accepting an industrial job.[87] After some preliminary training at the Art Institute of Chicago and a period of designing sets in New York, Ostrowsky left for Paris to be trained in the Académie Julian, and spent three years in France. He exhibited in the Paris Salon of 1914.

Evelyn Marie Stuart's article in 1916 gives a good idea of Ostrowsky's early period, which was his impressionist phase. Ostrowsky expressed admiration for Alfred Sisley and Claude Monet, to which the sparkling, broken brushwork of *A Silvery Morning on the Hudson near Milton, New York* attests. "One feels the very motion of the water," writes one critic, "the vibration of the air, the agreeable freshness of the early morning light."[88] In the same vein is **Woodland Stream**, an outstanding example of Ostrowsky's impressionism. There is a superb use of broken brushwork, however, the treatment of color is slightly conservative for a work from 1916. Then during the 1920s, Ostrowsky experimented with Cézannesque compositions and street scenes directly influenced by the Ecole de Paris. *Une rue à Antony* (1928), for example, is very close in style to Maurice Utrillo's *Eglise de la Ferté-Milon* (Dalzell Hatfield, Los Angeles), painted around 1910. Ostrowsky stated a few years later that Bonnard and Utrillo were two of his favorite artists.[89] He prided himself in being a cosmopolitan artist, saying that true artists work "for the whole world and for all time." [90]

Back in the States, Ostrowsky exhibited his works at the Art Institute of Chicago between 1917 and 1942, at the Society of Independent Artists in the 1920s, and with the Museum of Modern Art's "Sixteen Cities" show. His bold *Still-life with Fish and Melon* (Smart Museum of Art, University of Chicago) was shown in Chicago's Century of Progress Exhibition of Paintings and Sculpture in 1933. During World War II, Ostrowsky taught at the Jewish Peoples Institute on Chicago's West Side and he exhibited with the Chicago Society of Artists. Both of Ostrowsky's parents were killed by the Nazis, and his palette became darker as the war went on, according to the artist's son Efrem.

[87] Waldemar S. George, *S. Ostrowsky*. Les Artistes Juifs series (Paris: Editions «Ars», n.d)., p. 10.

[88] Evelyn Marie Stuart, "An Atmospherist and His Art," *Fine Arts Journal* 34 (October 1916): 419.

[89] J. Z. Jacobsen, *Art of Today: Chicago 1933* (Chicago: L.M. Stein, 1933), p. 101.

[90] Ibid.

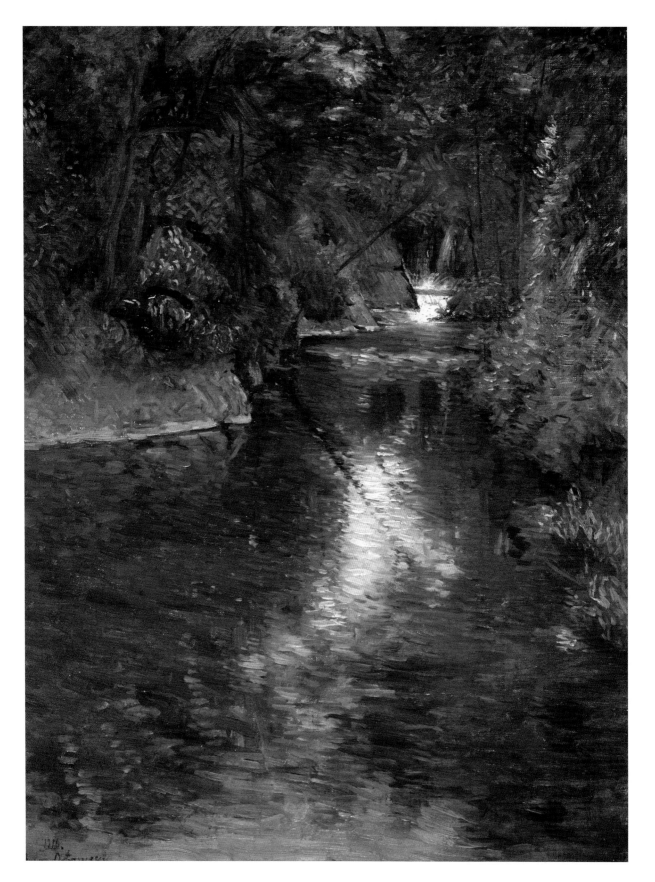

99

50. ROBERT EMMET OWEN
(North Adams, Massachusetts 1878 - 1957 New Rochelle, New York)
Snow Storm
Oil on canvas, 25 x 30 in.
Signed lower left

Young Robert Owen studied in the Drury Academy in North Adams, then in 1898 at the Eric Pape School of Art in Boston. Meanwhile, he had been submitting pen-and-ink drawings to *Life* Magazine, *The Boston Globe*, *Christian Endeavor*, and other publications. In his earliest paintings, Owen combined sharply outlined architectural structures with sketchy impressionistic figures, as Claude Monet rendered them in *Boulevard des Capucines* (Nelson-Atkins Museum of Art, Kansas City, Missouri). In 1900, Owen went to New York City, married Miriam Rogg three years later, then moved to Bagnall, Connecticut in 1910. He studied for a while with tonalist Leonard Ochtman, assisted in the formation of the Greenwich Society of Artists in 1912 and became a member of the Connecticut Academy of Fine Arts in 1915. Owen continued his illustration work and rarely abandoned his strong tendency to define solid objects with prominent outlines.

Owen established his own gallery in New York in 1923, then moved into the Rembrandt Building, adjacent to Carnegie Hall. He exhibited his works at the National Academy of Design (1912 and 1914) and at the Connecticut Academy of Fine Arts in Hartford. In 1936, eighty-six of his paintings were shown at the Dwight Art Memorial, Mount Holyoke College, in South Hadley, Massachusetts. Later in 1941 he moved to New Rochelle to work as artist-in-residence at the Thomas Paine Memorial Museum.

Snow Storm evokes the subtle art of Twachtman. The viewer, in the middle of a heavy snowstorm, seems to be standing on a bridge over a stream in the center of the picture space. This is balanced by a central tree and a country house, while the tree on the left prevents the composition from being too symmetrical. Both the stream and the picturesque wooden fence lead the eye into the distance. Two smaller buildings lie at the vanishing point. The windblown snow softens all forms, including natural and man-made, and provides a unity of texture. As in depictions of snowstorms by other impressionists, the range of values is purposefully limited.

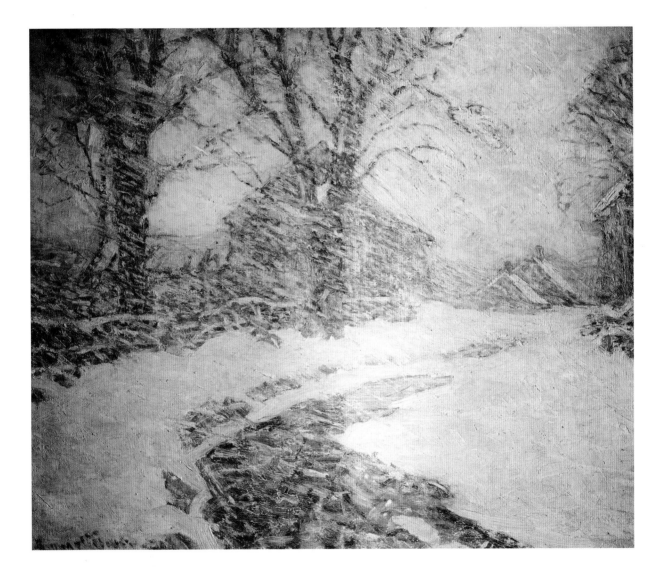

51. PAULINE PALMER
(McHenry, Illinois 1867 - 1938 Trondheim, Norway)
Yellow Roses
Oil on canvas, 30 x 24 in.
Signed lower left

Pauline Palmer became one of the Midwest's most prominent impressionists and a leading woman painter. Between 1893 and 1898 she studied at the Art Institute of Chicago, then temporarily with William Merritt Chase and Frank Duveneck, before transferring to the Paris academies. She also studied privately with Richard Miller. Palmer made her debut at the 1903 Paris Salon, on which occasion Guillaumina Agnew wrote about Palmer's popularity in *The Sketch Book* that July: "Mrs. Palmer was the favorite among all the American artists here. . . ." At the St. Louis Universal Exposition Palmer won a bronze medal for three works. C. J. Bulliet noted how her portrait of a Spanish boy, *Rojerio* was compared to works by Goya, and therefore was praised highly.[91] But her home base was Chicago, where, at the Art Institute, she exhibited over 250 works between 1896 and her death. She was also the first woman to serve as president of the Chicago Society of Artists (1918 to 1929).

After working in the Barbizon School tradition, Palmer lightened her palette, grew more bold in the application of pigment, conceived of more casual compositions, and adapted the impressionist way of painting. Later she would abandon painting en plein-air for a Fauve-like expressionism. Palmer never tired of learning and later took lessons from Charles Hawthorne at Provincetown. Yet she would not tolerate radical modernism. Palmer left the Chicago Society of Artists after three works by abstract artists were accepted for exhibition, then she formed the more conservative Association of Chicago Painters and Sculptors. William H. Gerdts praises Palmer as "one of the earliest and finest" Chicago outdoor figure painters who worked in the impressionist aesthetic.[92]

Palmer's still-life, *Yellow Roses* is a lush bouquet placed in the center of the composition in a rich blue glass vase. The background wall is in the complementary tonality of violet, rendered with dynamic brushwork. Rather than a meticulous old master delineation of every petal and leaf, Palmer indicates each blossom in the impressionist manner. Nature's lushness is conveyed through thick impasto brushstrokes, which the sophisticated viewer recognizes as actual paint.

[91] C. J. Bulliet, "Artists of Chicago Past and Present," *Chicago Daily News*, 8 February 1936.

[92] William H. Gerdts, *Art across America*. 3 vols. (New York: Abbeville Press, 1990), vol. 2, p. 313.

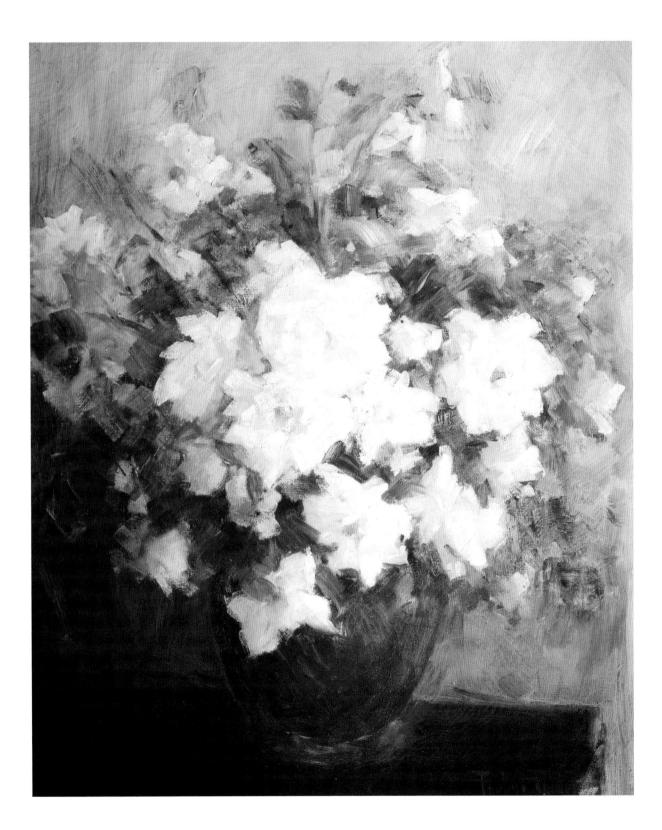

52. PAULINE PALMER
(McHenry, Illinois 1867 - 1938 Trondheim, Norway)
Tyrolean Bells
Oil on canvas, 50 x 34 in.
Signed lower right

Palmer traveled to Austria in 1912, when *Tyrolean Bells* was painted. That same year she exhibited two tempera paintings at the Art Institute of Chicago annual (*In the Austrian Tyrol* and *A Daughter of the Tyrol*). A year later, *Tyrolean Bells* appeared in her one-woman show at the Art Institute of Chicago, "Paintings of Pauline Palmer," between 24 March and 8 April 1913 (cat. no. 53), then in 1914 at the Toledo Museum of Art, Palmer's *The Tyrolean Girl* and *Austrian Tyrol* were two of sixty-six works in another solo show. Little is known, however, of American painters who worked in Austria, despite that country's natural beauty and breathtaking scenery. Back in 1877, Frank Duveneck stopped in Innsbruck on his way to Venice. According to Josephine W. Duveneck, he did a portrait of Susan B. Anthony while in Innsbruck.[93] In October of 1885, Robert Blum and Otto Bacher took a short sketching trip to the Tyrol. Bacher was not that pleased with the scenery but he enjoyed visiting the old castle at Rumbelstein with frescoes he thought were from the Dark Ages.[94] Elizabeth Nourse spent six weeks in Borst, a village in Southern Austria, in the summer of 1891.[95] Palmer obviously wanted to capture the authenticity of the regional costumes in her two charming models, who stand against the magnificent backdrop of purple mountains. On a hill in the middleground is a picturesque village dominated by a Baroque church whose façade is characterized by an flame-like ogive arch, derived from the French Flamboyant Gothic style. The bell tower gives the picture its title.

[93] Josephine W. Duveneck, *Frank Duveneck: Painter - Teacher* (San Francisco: John Howell Books, 1970), p. 67. The portrait has not been located.

[94] William W. Andrew, *Otto H. Bacher* (Madison, WI: Education Industries, Inc., 1981), p. 130.

[95] Mary Alice Heekin Burke, *Elizabeth Nourse, 1859-1938. A Salon Career* (Washington, DC: Smithsonian Institution Press, 1983), p. 142. The village was so remote, there were no hotel accommodations.

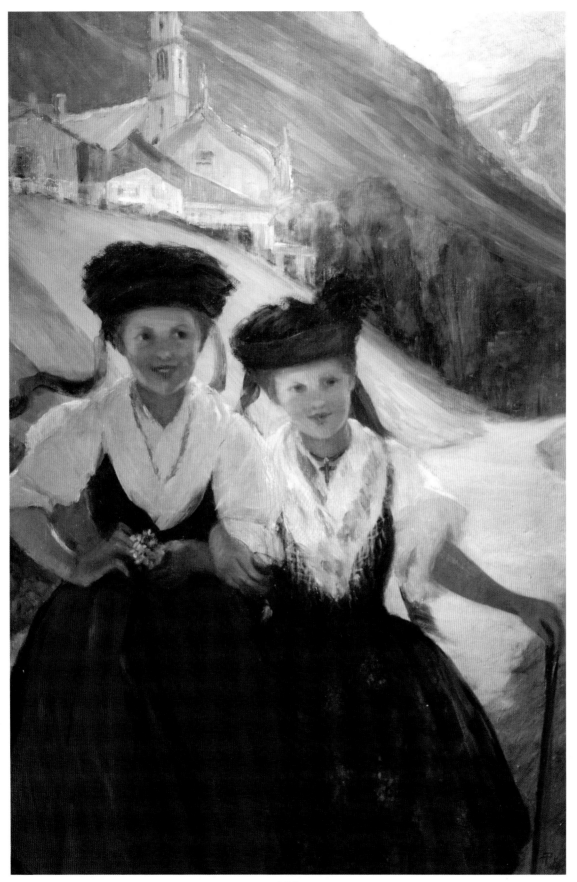

53. CARL W. PETERS
(Rochester, New York 1897 - 1980 Rochester)
Stream in Winter
Oil on canvas, 36 x 40 in.
Signed lower right
Date: 1928

Carl W. Peters was Rochester, New York's painter of regional landscapes, especially snow scenes, and an important muralist during the New Deal era. In addition, he captured the picturesque genre of Cape Ann during the summer season. Peters grew up on the family farm in Fairport, served abroad during the first world war, then commenced his career as a professional painter. He studied under John F. Carlson and Charles Rosen (1878-1950) at Woodstock and heard Robert Henri lecture there. From Woodstock, Peters discovered Rockport, and became active in Rochester's local expositions. He won the Third Hallgarten Prize at the National Academy of Design for *From a Window* (now in the National Museum of American Art, Smithsonian Institution), then was given a solo show in 1926. Two years later, his painting *Around the Bend* won the Second Hallgarten Prize. In 1930, Peters was commissioned to paint a mural inside the Art Deco Genesee Valley Trust Company Building. The striking panel was called *Rochester, Past, Present and Future*. During the Great Depression, Peters decorated Rochester schools with more murals, taught outdoor landscape painting, joined the traditionalist landscape painters who called themselves the Geneseeans and won yet another Hallgarten Prize. Peters became a master painter of New York regionalism, capturing the modern agrarian ideal and the Spirit of Place.

Stream in Winter was still unlocated at the time of publication of Richard H. Love's comprehensive monograph on Peters, in 1999.[96] The painting, executed in early 1928, won the first prize in the class of paintings in oil at the annual spring exhibition of the Rochester Art Club (May 1928).[97] An anonymous reviewer in a local paper wrote that "*Stream in Winter* . . . is a picture enjoyed by laymen as well as by artists. . . . It takes little imagination to feel the chill of the snow or to see the sun that has come out brightly between the leafless trees. Winter in its bleak, white beauty is all here, and trees and stream stand out boldly in a field of snow."[98]

(TEXT CONTINUED ON PAGE 147)

[96] Richard H. Love, *Carl W. Peters: American Scene Painter from Rochester to Rockport* (Rochester, NY: University of Rochester Press, 1999), pp. 531-532.

[97] 15th Annual Exhibition of Works by Rochester Artists and Craftsmen, Including the 46th Annual Exhibition of the Rochester Art Club, May 1928, cat. no. 61. The canvas was re-exhibited that September in the Rochester Exposition Art Exhibition.

[98] "Awards made in Rochester Art Exhibit," *Rochester Democrat and Chronicle*, 5 May 1928, p. 14.

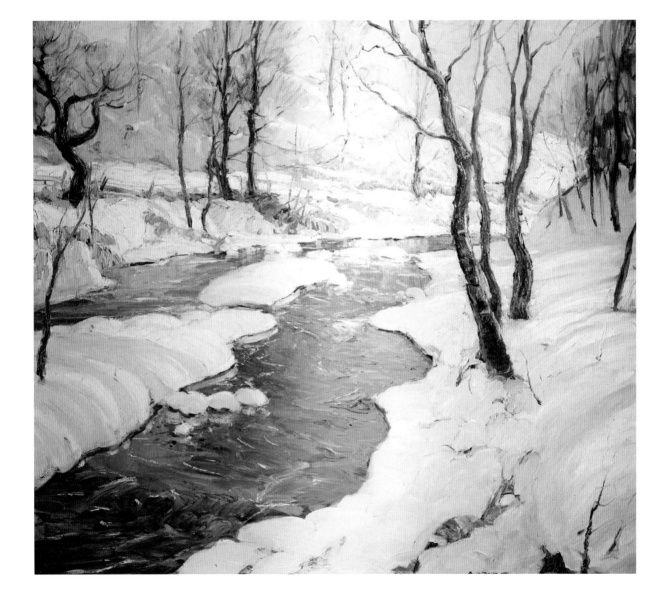

54. CARL W. PETERS
(Rochester, New York 1897 - 1980 Rochester)
Lanesville
Oil on canvas, 25 x 30 in.
Signed lower right
Date: ca. 1929

The Cape Ann imagery of Peters spans fifty-some years of the artist's annual summer trips to the picturesque area. Peters probably discovered the area as early as 1915 with Emile Gruppe. Several of Peters's Woodstock colleagues had praised the aesthetic pleasures of both Gloucester and Rockport and we know that Peters began to visit the area regularly in the summer of 1925. At that time there were three major exhibitions every summer,[99] and several big-name painters had been working there: in Gloucester — Childe Hassam (1859-1935), Stuart Davis (1894-1964), Theresa Bernstein (1889-2002) and her husband William Meyerowitz (1887-1981); and in Rockport — Aldro T. Hibbard (1886-1972), Charles Gruppe, Emile's father, Harry Aiken Vincent (1864-1931), William Lester Stevens (1888-1969), Tony Leith-Ross (1886-1973) and Frederick Mulhaupt (1871-1938), just to name a few. Peters identified with the more traditional colony of artists at Rockport who resisted modernism and he would delight in the quiet place as a kind of paradise for many summers to come. Peters truly loved the irregularly structured fisherman's huts, the crooked alleys, the odors of fish and black tar, the multitude of masts thrusting upwards from boats tied to the piers, the schooners and marine genre, the hustle of early morning workers in fish houses and sheds, and the clutter of lobster traps piled up along the massive cubes of granite that line the docks.

Lanesville, also called *Lane in Lanesville*, was probably painted in 1929 since it was in the one-man show at the Syracuse Museum of Fine Arts in the following February. It was on display again in 1931 at the Peters exhibition in the public library of Binghamton, New York. Rather than the busy dock activity, what we have here is a woman with her child walking down a tranquil lane, which winds along the shore, on a warm summer afternoon. The two men seem to be watching the boats that have been dragged ashore. We stand in the cool shaded area in the foreground. In the distance is a large, impressive three-story house and other buildings.

[99] These were the North Shore Arts Association, the Gloucester Society of Artists and the Rockport Art Association.

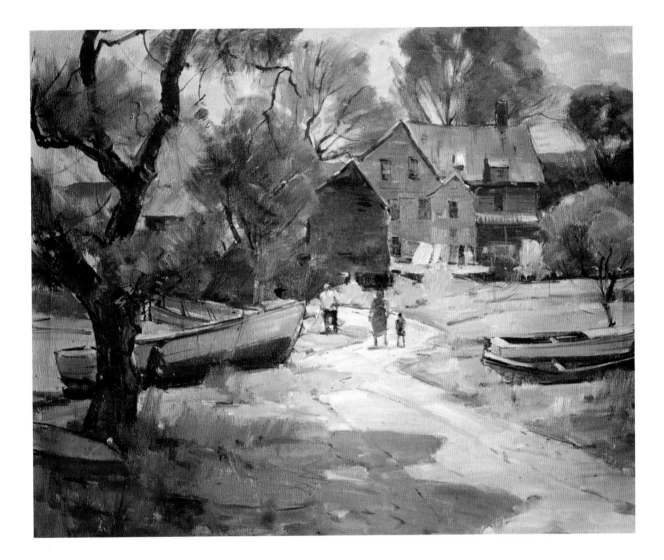

55. HAL ROBINSON
(1875 - 1933)
Woodland Stream
Oil on canvas, 28 x 35 in.
Signed lower left

Hal Robinson painted at Old Lyme and exhibited *After a Spring Rain, After the October Storm, The Last Glow, Saw Mill River* and *The Ice-Bound Hudson* between 1909 and 1911 at the National Academy of Design. At the Corcoran Gallery he showed *After a Spring Rain* in 1910. In the following year he exhibited *A Gray Day in November* and *The Ice Pond after a Thaw* at the Carnegie International. *Woodland Stream* was most likely executed at Old Lyme. Basically naturalistic, Robinson's painting style shows a degree of assimilation to impressionism in the violet hues on rocks and trees and throughout the stream, and in the expressive impasto pigment in the foreground. He obviously worked from a fully loaded brush that results in a textural impasto that is a delight in itself: it is thick, generous and direct: strikingly a result of the general plein air attitude, of the naturalness that was around him. Large parts of the bare, foreground trees are also violet. There are areas of saturated pigment where foam strikes against the rocks and bright areas of red and orange along the left bank. Yet there is no systematic use of broken color, as Childe Hassam practiced. Hassam's arrival at Old Lyme in 1903, along with that of Willard Metcalf, changed the orientation of the artists' colony almost completely from tonalism to impressionism. Robinson was responding to those innovations.

Robinson was strongly concerned with light and its effects on different surfaces. Light does its handiwork on the trees and rocks. We see the textural quality of varied objects, almost a tour de force. Objects are not diffused in space, however; light mitigates the contours of trees and rocks and it seems to permeate forms. Robinson puts the viewer in the center of the composition and makes him part of the scene. One might imagine the artist himself painted while standing in the stream, like a salmon-fisherman. He definitely reveals a closeness with nature in this manner of composing a picture. The fan-like upper leafy areas of the trees in the background are treated as an impressionist would.

When Robinson died in 1933, the Lyme Art Association was undergoing financial problems. Florence Griswold would live until 1937, guiding visitors through her colonial house. But largely the Griswold Mansion had become a nostalgic curiosity. On the other hand, Old Lyme remained the choice of many landscape painters, and as late as the early 1960s, Will Howe Foote (1874-1965), William Chadwick, Guy Wiggins (1883-1962), and Harry Hoffman (1871-1964) were still exhibiting there.

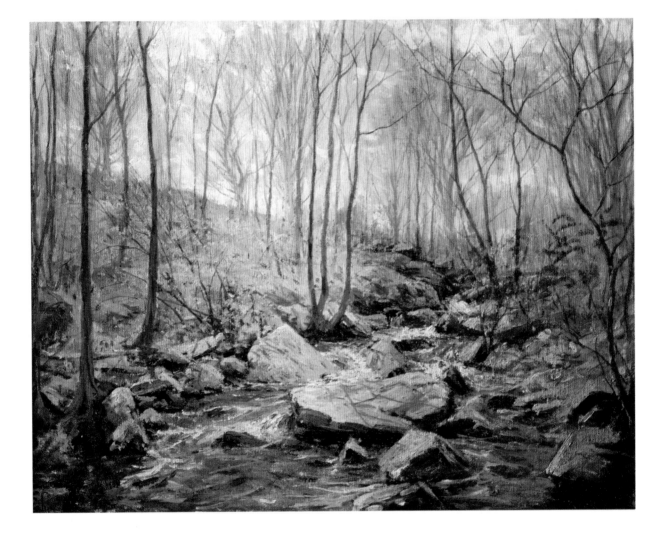

56. SUSAN GERTRUDE SCHELL
(Titusville, Pennsylvania 1891 - 1970)
Loading the Wagon
Oil on canvas, 25 x 30
Signed lower right

Gertrude Schell began her studies at West Chester State Teachers College then transferred to the Pennsylvania Museum School of Industrial Art, where she would later become a faculty member (1930-60). She was a member of the National Association of Women Painters and Sculptors, then in 1934 she joined the group known as the Philadelphia Ten, a loosely knit society of women painters. Schell's landscapes have been characterized as "powerful, personal, majestic, striking and theatrical."[100] An impressionist would never utilize such dark values as burnt umber and black but Schell loved to juxtapose the darkest darks and the lightest lights for dramatic effect. Forms often give a silhouette effect.

Schell herself stated one of her goals was "to record moods of nature rather than to give photographic representations of scenery."[101] She was part of the mid twentieth century "Romantic survival" in American painting, which was a step beyond impressionism in its choice of more dramatic effects of nature over the sunny atmosphere of impressionist landscapes. She also belonged to the regionalist movement in her preference for home-grown American subject matter; she once pointed out that since American painters had learned from the old masters, one ought to capture the beauty right here at home. Besides Lancaster, Pennsylvania and Mystic, Connecticut, the rugged Gaspé Peninsula in Canada, north of Maine, attracted Schell. She was honored with a solo show in 1962 at the Woodmere Art Gallery in Philadelphia and two years after her death there was a memorial exhibition.

In describing another image of the Gaspé Peninsula in Quebec, Patricia Sydney states how it "focuses on poverty and dullness, on struggle and hardship. Schell's drab colors and roughly textured paint reflect the monotony of life in this remote area and define a landscape where poor farmers eke out an existence."[102] *Loading the Wagon* appears to be from the same area. Men are at work at a horse-drawn wagon at the edge of a bay, loading goods. The human forms are dramatically back-lit and cast long gray-violet diagonal shadows. Across the bay, at the foot of a massive cliff is a village, hugging the shore line. The buildings have been rendered in a highly subtle manner, in blue-violet, and the effect is wonderful. The theme recalls Ashcan subjects of industrial workers, though the location is a harsh, rocky, remote location that would have pleased Rockwell Kent, who sought out similar "primitive" sites in Alaska, Maine, and Greenland.

[100] Patricia Tanis Sydney, in Talbott and Sydney, 1998, p. 163.

[101] Susan Gertrude Schell, quoted in Geraldine Smith, "Making Ideas Tangible," *Philadelphia Inquirer*, 25 May 1941.

[102] Talbott and Sydney, 1998, p. 164.

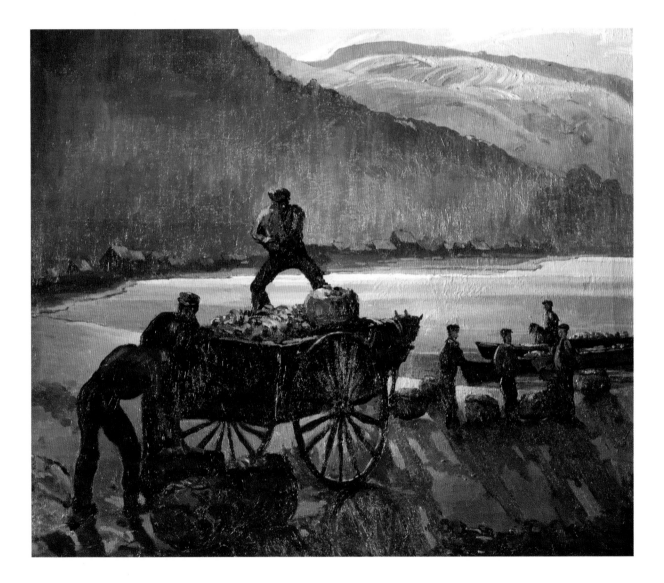

57. GEORGE F. SCHULTZ
(Chicago 1869 - 1934)
Summer Afternoon
Oil on canvas, 36 x 24 in.
Signed lower left

George F. Schultz's father taught him to love art and the beauties of nature. At age fifteen, he was known as a "decorator of souvenirs," perhaps decorative paintings on porcelain. Schultz would become a highly respected artist who exhibited over one hundred works at the Art Institute of Chicago annuals, between 1889 and 1925.[103] It was noted that Schultz spent part of 1895 on Monhegan Island, which artists had discovered in 1858. There he was inspired by Samuel Triscott (1846-1925), who is known for his watercolors and early pictorial photographs of the island. An exhibition of Schultz's watercolors of Monhegan scenery at Thurber's Gallery in Chicago in 1896 was reviewed in *Arts for America.* The author was particularly moved by "a huge, strongly painted rock enveloped in fog, called *Solitude.*" Schultz, he stated, "paints with a firm, true hand and [has] a feeling for color that is delightful." In April of 1898, Schultz exhibited oils at Thurber's Gallery. At that time he was still best known as a watercolor painter. The reviewer in *Chicago Inter-Ocean* admired his "delicate, loose and pleasing" touch. One work from that show, entitled *Reflections*, appeared in the March issue of *Brush and Pencil*. This simple view of a pond, perhaps inspired by Monet, includes water lilies on the left, in a dazzling reflection of the bright sky above.

It was reported in 1906 that several works by Schultz were part of the permanent collection of the Palette and Chisel Club. A year later he showed paintings at the Art Institute of Chicago in a solo show. He also exhibited *Converse with Nature's Charms* at the Carnegie International (1914) and *The Voice of the Brook* at the Pennsylvania Academy of the Fine Arts two years later. Schultz won the William H. Tuthill Prize of $100 at the AIC in 1918, for *Surging Seas.* In addition, he was president of the Chicago Water Color Club and he belonged to three other clubs: the Arche, the Cliff Dwellers, and the Union League Club. Highly active in Chicago's cultural events, Schultz was an outstanding naturalist painter who would often work in a pure impressionist technique (*Beside the Stream*). In *Summer Afternoon* (ca. 1905), the elegant model stands just to the right of the picture's central axis. While enjoying the fragrance of a small flowering tree, she wears a violet summer dress that features deeper violet shadows. Sunlight strikes her left shoulder and highlights the entire left side. The figure is differentiated from the surrounding landscape, which is the general rule in American impressionism. Throughout, the controlled brushwork is superb: each flower petal and leaf is rendered in one stroke, but it is a free, unstudied application of impasto.

[103] The literature on Schultz includes the following: "Local Tone," *Arts for America* 5 (March 1896): 69; "The Chicago Artists' Exhibition," *Brush and Pencil* 1 (March 1898): 191-196; "Among the Artists," *Chicago Inter-Ocean*, 10 April 1898; Arthur Anderson Merritt, "Work of Chicago Artists," *Brush and Pencil* 9 (March 1902): 336-348; T. E. MacPherson, "Exhibitions of the Palette and Chisel Club," *Brush and Pencil* 17 (January 1906): 15-17; Evelyn Marie Stuart, "Annual Exhibition of Local Artists," *Fine Arts Journal* 32 (April 1915): 167-179.

115

58. EVERETT SHINN
(Woodstown, New Jersey 1873 - 1953 New York City)
Dancers on Stage
Oil on canvas, 18 x 14 in.
Signed lower left

 Another member of the Eight, Everett Shinn turned from such Ash Can themes as people sleeping under bridges to the glamour of Uptown, fashionably dressed ladies, and the excitement of the theater. Like his colleagues in the Eight, Shinn was a staff artist at a Philadelphia newspaper and he joined others at Robert Henri's studio where the spirit of modern urban realism was born. Shinn was constantly busy with illustration work, decorative projects such as murals and folding screens, and easel paintings. His first one-man show was in 1899, the year he began exhibiting at the Pennsylvania Academy of the Fine Arts. In 1900 Shinn was briefly in London and Paris. Six years later Albert E. Gallatin called him a kind of American Degas. At the celebrated debut of the Eight in 1908 Shinn exhibited his famous work now in the Art Institute of Chicago, *The Hippodrome, London* (ca. 1905) and *The Orchestra Pit* (Private coll.). Shinn also participated in the Exhibition of Independent Artists in 1910, and within a year he finished the rather dark murals in Trenton's City Hall, which represent interiors of local steel mills and pottery kilns. Milton W. Brown pointed out, these murals were important, "in that they treated a contemporary industrial subject rather than an historical or allegorical scene."[104]

 Shinn was invited to exhibit in the Armory Show but he refused. In fact, he had turned to the past rather than looking ahead to modernism, taking on commissions for neo-Rococo decorative murals in private residences.[105] Between 1920 and 1940 there is little record of Shinn's activities. For a few years he worked under Samuel Goldwyn as an art director. Then he contributed "Recollections of the Eight" to the Brooklyn Museum's catalogue of an exhibition, "The Eight," which opened in November of 1943. Shinn managed to outlive all other members of the Ash Can School.

 Dancers on Stage might be related to Robert Henri's many depictions of colorful Spanish dancers, matadors, and peasants. Shinn himself did not visit Spain but he exhibited *Spanish Music Hall, Paris* late in life (1943) at the National Academy. Most likely, our Spanish dancer, accompanied by a guitar player complete with sombrero, and *Spanish Music Hall* are recollections of the Paris experience of 1900. One might compare *Dancers on Stage* to Shinn's *Footlight Flirtation* (1912; Altschul Collection) in its technique. In both, the figures have been drawn with the brush in a highly expressive manner. The dancers in both works have a hand-on-hip stance with the weight on one leg, while the foot of the free leg is turned parallel to the picture plane.

[104] Milton W. Brown, *American Painting from the Armory Show to the Depression* (Princeton University Press, 1955), p. 25. See also Thomas Folk, "Everett Shinn: The Trenton Mural," *Arts Magazine* 56 (October 1981): 136-138.
[105] C. Matlack Price, "Revival of Eighteenth-Century French Art," *International Studio* 51 (January 1914): CLXVIII-CLXX.

59. SIGURD SKOU
(Oslo, Norway 1876 - 1929 Paris)
Concarneau Harbor
Oil on canvas, 30 x 36 in.
Signed lower right

Sigurd Skou, whose art Edgar Lee Masters praised as showing "honesty, strength and joy in life,"[106] traveled to America in 1893 to work as a stevedore on Norwegian fruit ships to the West Indies. By 1902 he became a naturalized citizen. Five years later he was in Paris, probably to enroll in the academy of Norwegian-born Christian Krohg (1852-1925), in Montparnasse. An article in Brooklyn's *Nordisk Tidende* (March 1923) informs us that Skou studied with the dynamic Swedish painter Anders Zorn (1860-1920), who made six trips to America and was well known throughout Europe. Zorn was the Scandinavian counterpart of Joaquín Sorolla: both delighted in broad, bravura brushwork, virtuoso effects of sunlight sparkling on bodies of water, and both focused on modern life.

Skou married Bertha Gladys Dickey (1891-1951) in 1916 and a son, Carl Sigurd, Jr., was born a year later. Skou became a member of Allied Artists of America, the New York Water Color Club, the American Watercolor Society, and the Salmagundi Club, where he would later win the Foster Prize. In 1917 and again in 1918, Skou exhibited at the Society of Independent Artists. Also in 1918 he came to Chicago where he worked as an illustrator. Between 1919 and 1930, he exhibited oils and watercolors at the annual exhibitions of the Art Institute of Chicago. The same institution honored him with a special show in December of 1921. That year he became a member of the Palette and Chisel Club. In the 1920s he participated in Norwegian-American exhibitions, also in Chicago, and exhibited his works at the Pennsylvania Academy of the Fine Arts, the National Academy of Design, and the Corcoran Gallery. Skou, active in the Manhattan art scene with his wife Berthe, also a painter, was one of the founders of the Grand Central Art Galleries in 1922.

Skou's canvas entitled *In Harbor, Brittany*, exhibited at the Grand Central Art Galleries in 1926, is a plein-air coastal scene at Concarneau, executed with the palette knife, whose strokes define the expanse of glittering water dotted with sailboats. Another work that demonstrates how Skou was a master technician is *Concarneau Harbor*. Entirely executed with a palette knife, the canvas began as broad areas of thinly applied color. Despite the thick impasto pigment in Skou's intricate web of broken color, there are tiny areas of the canvas that show through here and there. Upon some of the more diluted areas of washes, Skou scratched the surface with the palette knife to create greater luminosity. Skou worked in other modes, as well: *Daughters of the Gods* (Grand Central Art Galleries) reveals the modernist direction that he took.[107]

[106] Edgar Lee Masters, "Sigurd Skou — An Appreciation," *The American Art Student* 9 (1926).
[107] Illustrated in Robert R. Preato, Sandra L. Langer, and James D. Cox, *Impressionism and Post-Impressionism: Transformations in the Modern American Mode 1885-1945* (New York: Grand Central Art Galleries, 1988), p. 69.

60. JOHN SLOAN
(Lock Haven, Pennsylvania 1871 - 1951 Hanover, New Hampshire)
New York, New Haven & Hartford Yard, Coaling House
Oil on canvas board, 12 x 16 in.
Signed lower left

A leading painter of the Ash Can School and an ardent left-wing contributor to *The Masses*, John Sloan[108] later lost interest in depicting class struggle. He would find a new direction after settling in Santa Fe, and would become preoccupied with the female nude, pursuing "Art for Art's Sake." *New York, New Haven & Hartford Yard, Coaling House* is still very much under the influence of Robert Henri's group known as the Eight (or Ash Can School).[109] First, the restricted palette of black and gray with only minor touches of ochre, violet and blue, reflects the Eight's return to the techniques of Edouard Manet. The strikingly bold forms, all defined in black, are fundamentally geometrical simplifications. Movement and industrial activity are suggested by the gray steam, mixed with the clouds in the background, all of which comes more from Claude Monet's aesthetic vocabulary. This is, on the other hand, the "backyards" of the unglamourous working world, directly opposed to the sunny aspects of life that the American impressionists doted on. Sloan himself was quoted as rejecting the "prettiness" of impressionism, stating specifically that his paintings around 1907 "show my resistance to the impressionist influences."[110] As reported by Lloyd Goodrich, Sloan objected to "the whole spirit of impressionism, its sweetness, prettiness, the emphasis on effect."[111]

After seeing Van Gogh's work at the Armory Show, Sloan became more experimental with color and already by 1915 there are more decorative and abstract compositions. In addition, he applied the color theories of Hardesty Maratta. In 1917 Sloan became involved with the Society of Independent Artists. In Santa Fe, beginning in 1919, Sloan promoted Native American art in which he sought new inspiration.

[108] The basic reference for Sloan is Rowland Elzea, *John Sloan's Oil Paintings: A Catalogue Raisonné*, 2 vols. (Newark: University of Delaware Press, 1991).

[109] *John Sloan's New York Scene from the Diaries, Notes and Correspondence 1906-1913*. Ed. Bruce St. John (New York: Harper and Row, 1965), is of special interest as a primary source.

[110] John Sloan, *The Gist of Art: Principles and Practice Expounded in the Classroom and Studio, Recorded with the Assistance of Helen Farr* (New York: American Artists Group, 1939), p. 215.

[111] Lloyd Goodrich Papers, Archives of American Art, reel 688.

61. RUSSELL SMITH
(Glasgow, Scotland 1812 - 1896 near Pittsburgh)
The Tunnel near Giornico on the St. Gotthard Pass
Oil on canvas, 47 x 63¾ in.
Signed and dated lower center:
"Russell Smith / 1863"

The Tunnel near Giornico on the St. Gotthard Pass is a major, large-scale work by Scottish-born artist William Thompson Russell Smith (1812-1896).[112] The painter settled in Pittsburgh, Pennsylvania in 1822. Between 1829 and 1832 he was trained by James Reid Lambdin (1807-1889), a student of Thomas Sully. In 1833, Smith turned from portraiture to scene painting for local theaters.[113] One critic proclaimed that as a scenic artist Smith "had no peer in America, exceeding all who had gone before him and those of his own day; especially in the naturalness and beauty of his landscape productions, almost everything being close copies of natural subjects."[114] In his landscape painting, Smith relied on the tradition of Joshua Shaw, Thomas Birch and Thomas Doughty.[115] Although he was influenced by the Hudson River School, he did not share their love of detail.

Between 1834 and 1889 Smith exhibited 134 paintings at the Pennsylvania Academy of the Fine Arts. Smith's landscapes also appeared at the Artists Fund Society in Philadelphia, at the Apollo Association in New York and one year at the National Academy of Design (1836). In 1838 Smith married Mary Priscilla Wilson who was a flower painter, and their two children, Xanthus R. Smith and Mary Smith, would follow as artists. In the 1840s Smith traveled through the White Mountains and the Appalachian Range. He toured Europe with his family in 1851-52: they were able to visit the major museums where he could study the old masters firsthand. The family went through Wales, Scotland, Switzerland, Italy and the Netherlands, and ended the tour in Paris and London. Falk calls Smith Philadelphia's leading landscape painter.

(TEXT CONTINUED ON PAGE 147)

[112] A major source for scholars is the Smith Family Papers, Archives of American Art, Washington, DC. A monograph appeared in 1956: Virginia E. Lewis, *Russell Smith: Romantic Realist* (Pittsburgh, PA: University of Pittsburgh Press).

[113] Chestnut Street Theater; Walnut Street Theater; Pennsylvania Theater, created by Francis Courtney Wemyss. The painter's brother David Russell Smith was one of the founders of Pittsburgh's Thespian Society.

[114] *Jenkintown Times Chronicle*, 14 November 1898.

[115] Robert Wilson Torchia, *The Smiths: A Family of Philadelphia Artists* (Philadelphia: Schwarz, 1999), p. 14.

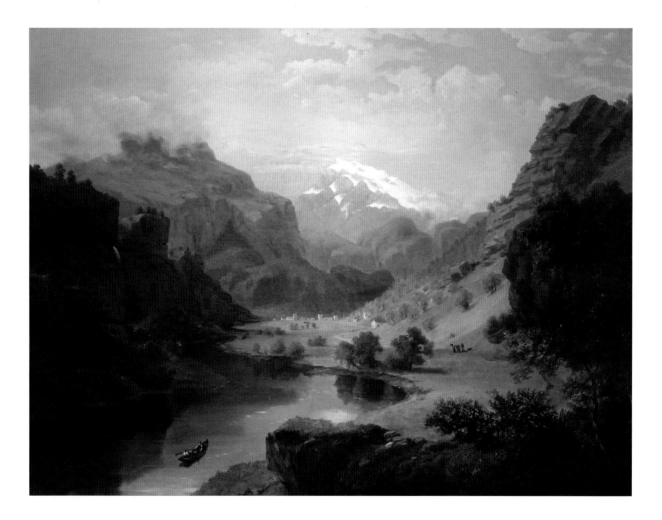

62. ANNA LEE STACEY
(Glasgow, Missouri 1871 - 1943 Pasadena, California)
The Wharf, Gloucester, Massachusetts
Oil on canvas, 16 x 20 in.
Signed lower left

Anna Lee Stacey (née Day), who would be regarded as "a leading painter among Chicago artists,"[116] received her early art training at the Pritchard School in Kansas City. At the Art Institute of Chicago she studied under the tonalist Leonard Ochtman, between 1893 and 1899. She arrived in the fall, in time to see the World's Columbian Exposition, where impressionist works from the Loan Collection brightened the walls of the Fine Arts Palace. Anna came to Chicago with her husband, another artist, John Franklin Stacey (see following entries), who had already studied at the Académie Julian (1883-85). Anna won a prize for a watercolor at the West End Woman's Club Salon in 1896 and began to exhibit at the Art Institute's annual shows. Between 1895 and 1939, she exhibited almost three hundred works there. Both Anna and John Stacey had their paintings featured in an exhibition at the Art Institute in December of 1920. The prolific couple worked in the Tree Studio Building (recently commercially metamorphosed by nearsighted Chicago developers). Anna served on the jury for the Art Institute's 1907 winter exhibition. She studied and traveled in Europe — in France, Italy, Spain, and Belgium at various times between 1900 and 1914. While Stacey's execution became more daring and spontaneous, nearly approaching a Fauvist look, at times her works seem repetitive and stylized. Stacey was also attracted to California: in 1915, she took part in the Panama-Pacific International Exposition, exhibiting *In Furs* and *Moonlight, Granada* (ca. 1914) and later in 1939, she returned to San Francisco. The last two years of her life were spent in Pasadena.

In *The Wharf, Gloucester, Massachusetts*, we focus on a group of figures at the end of a wharf. A slightly off-center sailboat and its reflection establish a stable vertical element. The limited palette and subtle range of values recall the works of Whistler but generally there seems to be an influence of *Japonisme*. Rather than evoking Cape Ann's particular Spirit of Place, Anna Lee Stacey has achieved more of an Art for Art's Sake, universal image.

[116] Frances Cheney Bennett, *History of Music and Art in Illinois* (n.p. Société Universelle Lyrique, 1904, p. 516).

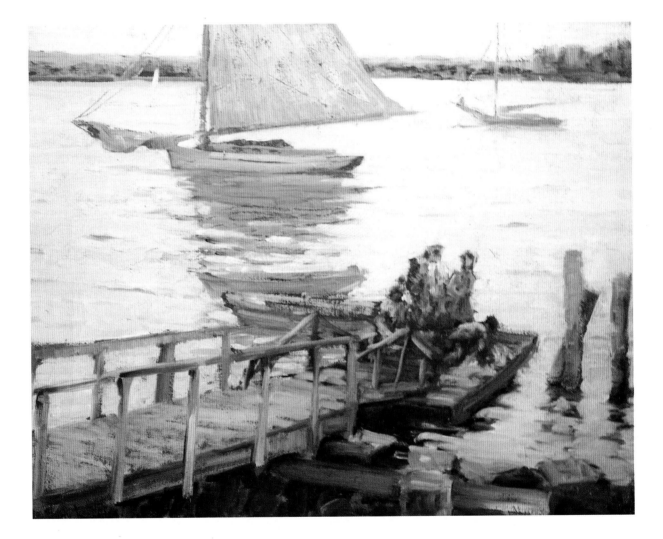

63. JOHN FRANKLIN STACEY
(Biddeford, Maine 1859 - 1941 Pasadena, California)
French Landscape
Oil on canvas, 25 x 30 in.
Signed lower right

Among the many American students who studied at the Académie Julian in Paris under Boulanger and Lefebvre was John Franklin Stacey. After the Paris experience (1883-85), Stacey went to Kansas City where in late 1888 he became the third director of the Kansas City Art Association and School of Design, which had opened that January.[117] In 1891, John married Anna Lee Day (see previous entry) and by the fall, the couple arrived in Chicago. Like the prolific Anna, John exhibited faithfully at the Art Institute of Chicago (1894-1933). Both were familiar faces at the Tree Studio Building.[118] Mr. Stacey spent some summers painting in New England. He served as juror for the Art Institute's exhibition in 1898 and taught at the R. T. Crane Manual Training School. In 1903, he was vice-president of the Chicago Society of Artists, which had been organized in 1887. There were actually two separate organizations named the Chicago Society of Artists. One, founded in 1887, appointed Henry Fenton Spread as president and established their headquarters at the Athenaeum Building in 1891. After 1913, the CSA broke into two groups, one conservative and the other modernist-oriented. The Society took a definite modernist turn at that time.[119] The Union League Club, Chicago has three of Stacey's landscapes.

Stacey served on the jury of the Art Institute and Municipal Art League's Twelfth Annual Exhibition of "Works by Chicago Artists" in February of 1908. He won medals at the St. Louis Universal Exposition in 1904, at the Buenos Aires Exposition in 1910 and in 1924 he was presented with the Art Institute's Logan Prize. He moved with his wife to Pasadena, where he died in 1941. Anna outlived him by only two years. The Otis Art Institute in Los Angeles established the John F. and Anna Lee Stacey Scholarship Fund "to help serious students of conservative art (drawing and painting) to study for a year. . . ."[120]

(TEXT CONTINUED ON PAGE 148)

[117] Now known as the Kansas City Art Institute. Stacey replaced Elmer Boyd Smith (1860-1943) and was followed by Alfred Houghton Clark, also in 1888. We conclude, there must have been administrative problems that created such a quick succession of directors, for we do know that Smith was barely able to survive on the salary he received.

[118] See Morse, 1999.

[119] See Louise Dunn Yochim, *Role and Impact: The Chicago Society of Artists* (Chicago: CSA, 1979).

[120] Quoted from *Architectural Forum* (July 1946), p. 74.

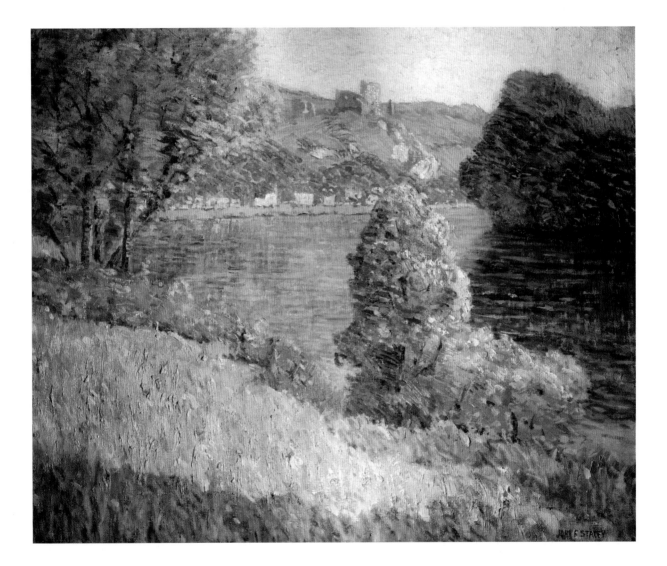

64. JOHN FRANKLIN STACEY
(Biddeford, Maine 1859 - 1941 Pasadena, California)
Boulder Strewn Forest, Marblehead, Massachusetts
Oil on canvas, 36 x 48 in.
Signed lower right

This delightful forest scene features a parallel row of birch trees that suggest a "doorway" into the deep woods, dominated by great boulders. The technique, which is pure impressionism, is most evident in the four trees on the right, whose bark — normally thought of as white — is enlivened by multicolored strokes of bright pigment. This creative concept of color extends through the entire forest to the clearing in the distance. Marblehead was fairly popular with artists; there is a Marblehead Art Association that organized annual exhibitions. Incorporated in 1649, the town was an important fishing and shipping center.[121] Will H. Low's *Skipper Ireson's Ride* (1881; Albany Institute of History and Art) illustrates an event from Marblehead's history. William H. Gerdts, who illustrates the work, explains, "Low's disagreeable subject was the punishment meted out to a sea captain falsely accused of allowing sailors to drown at sea."[122] The tarred and feathered captain is driven out of the community by an angry mob. Low's title comes from John Greenleaf Whittier's poem, written in 1856.

[121] See the Federal Writers' Project's *Massachusetts: A Guide to Its Places and People* (Boston: Houghton Mifflin Co., 1937), pp. 273-279.
[122] Gerdts, 1990, vol. 1, p. 58.

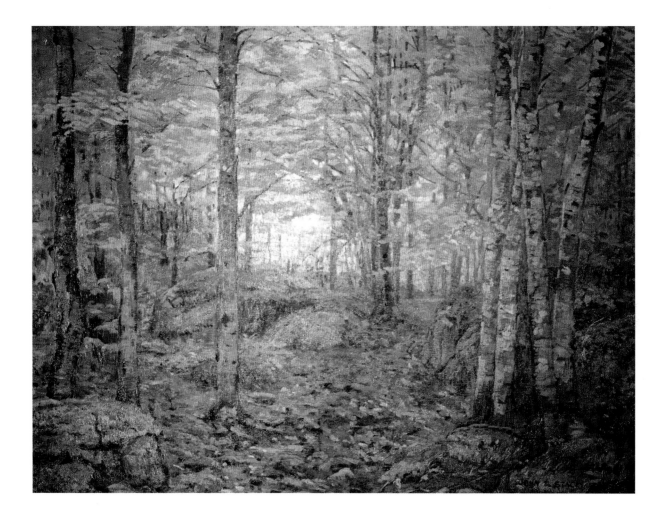

65. ALICE KENT STODDARD
(Watertown, Connecticut 1883 - 1976 Newton, Pennsylvania)
Pink Blossoms
Oil on masonite, 16 x 20 in.
Unsigned

Rockwell Kent's cousin, Alice Stoddard, studied at the Moore School of Art in Philadelphia then transferred to the Pennsylvania Academy of the Fine Arts where Thomas Eakins and Thomas Anshutz were her instructors. She won the PAFA's Cresson Traveling Scholarship in 1905 and later exhibited eighty works at the Pennsylvania Academy between 1908 and 1964. In addition, Stoddard took lessons from William Merritt Chase. For her *Portrait of Elizabeth Sparhawk Jones* (PAFA), Stoddard won the Mary Smith Prize in 1911, the year she began exhibiting at the NAD. On Monhegan Island that year she executed *Horne's Hill* and *Mending Nets*.

Stoddard sent three works to the Panama-Pacific International Exposition in San Francisco (1915) and she seems to have been inspired by Cecilia Beaux in her loosely painted *Tapestry and Lace* and *Woman in White Blouse* (Private collection), which features a similar subtle juxtaposition of light tones. The Pennsylvania Academy also has a figure painting of a woman seated casually between two cats, titled *Polly* (before 1928). This portrait of Mrs. H. Lea Hudson also recalls Cecilia Beaux's style. For *A Child of Monhegan*, Stoddard probably looked at works by Robert Henri. Stoddard was best known for her depictions of children but this small Fauvist-inspired landscape, *Pink Blossoms*, is highly experimental and it shows Stoddard was even more of a free spirit. The open field bordered by trees includes broad blue-violet shadows and a dirt road in the center, rendered in pink: a daring palette that recalls Matisse. In addition, the trees are highly abstract swirls of violet and green foliage.

66. JOHN HENRY TWACHTMAN
(Cincinnati, Ohio 1853 - 1902 Gloucester, Massachusetts)
Trees
Oil on canvas, 7 x 9 in.
Signed lower left

Frederick Christian Twachtman and Sophia Droege, John Twachtman's parents, were from Hanover, Germany. Frederick was employed by the Brebeman Brothers window shade factory. Twachtman spoke very little of his childhood, which was not a happy time. He met Frank Duveneck at the McMicken School of Design in Cincinnati in 1874. After Duveneck's successful Boston exhibition, he invited Twachtman to accompany him back to Europe. Twachtman enrolled in the Munich Academy and also worked with Duveneck at the picturesque, abandoned Holy Cross Monastery in Polling. In 1877, Twachtman went to Venice with Duveneck and William Merritt Chase. Some of his Venetian scenes resemble Corot or Courbet rather than the sunny images that one associates with Duveneck. But thanks to Lisa Peters's article on Twachtman in Venice,[123] one can see clearly how the artist was already moving from the dark palette of Munich in 1877.

After Twachtman returned to America, he became a member of the Society of American Artists and debuted at the National Academy of Design, where his works were shown until 1898. Back in Italy in the fall of 1880, he rubbed elbows with John White Alexander, Otto Bacher, Joseph R. DeCamp, Julius Rolshoven (1858-1930), Theodore Wendel, and others, known as the "Duveneck Boys." As a result of further trips to Europe, the blacks and browns of the Munich school disappeared. In the late 1880s, Twachtman joined his friend J. Alden Weir in Branchville, Connecticut.[124] In the fall of 1889 he began teaching at the Art Students League, a post he kept until his death. Twachtman bought a farm at Roundhill (Horseneck Falls) near Greenwich (ca. 1890-91). There and at Cos Cob, Twachtman discovered his definitive style, which lasted through the 1890s. Contemporary critics found Twachtman's paintings to be more delicate, marked by gray-greens and silvery blues, compared to the "barbaric color" of the French impressionists (*New York Sun*, 5 May 1893). The same critic declared that Twachtman came closer than any other American painter to tackling some of Monet's plein-air technical problems.

At the turn of the century, Twachtman became part of the group of painters known as the Ten, who resigned from the Society of American Artists. Today's critics see a great spirituality in Twachtman's oeuvre, and even back in 1915, a Japanese connection had been suggested. Twachtman was arguably the most subtle American landscape painter of his time, a genius of the first rank. He succeeded in creating a conceptual image of nature quite mystical and ethereal. In arranging solids and voids, using flattened areas of spontaneous color, Twachtman was a master of composition. He was genuine and full of integrity but a painter's painter, not appreciated by the casual viewer.

[123] Lisa Peters, "John H. Twachtman: A 'Modern' in Venice, 1877-1878," in *The Italian Presence in American Art* (New York: Fordham University Press, 1989), vol. 2, pp. 62-80.

[124] Eliot Candee Clark, *John Twachtman* (New York: Privately printed, 1924), p. 26.

67. ROBERT VONNOH
(Hartford, Connecticut 1858 - 1933 Nice, France)
Springtime
Oil on canvas, 12 x 16 in.
Signed lower left

Robert William Vonnoh was born to parents of German lineage in Hartford, Connecticut on 17 September 1858. At the age of seventeen, he enrolled at the Massachusetts Normal Art School in Boston and after two years he made the acquaintance of the precocious Edmund Tarbell. Vonnoh was appointed instructor of drawing and painting after his graduation in 1879, then was offered a position at the Roxbury Evening Drawing School and also at the Thayer Academy at South Braintree, Massachusetts. By 1881, Vonnoh sought new artistic inspiration in Europe. In Paris, he became a student at the Académie Julian. Already in 1883, he exhibited the striking portrait, *John Severinus Conway* in the Paris Salon.

The spirit of artistic upheaval was in the air when Vonnoh returned to Boston and viewed the "Foreign Exhibition" held at the Mechanics Building where various impressionist works were seen by many Americans for the first time. Vonnoh accepted the post of principal at the East Boston Evening Drawing School; in 1884 he began teaching at the Cowles Art School, where he helped guide the efforts of impressionist Lilla Cabot Perry (1848-1933). Vonnoh transferred to teach at the School of the Museum of Fine Arts, Boston in 1885 then he returned to Europe. He settled in Grèz-sur-Loing near the Forest of Fontainebleau and along with Edward Potthast, digested the concepts of plein-air painting, including those of Bastien-Lepage. The avant-garde Irish painter Roderic O'Conor influenced both Potthast and Vonnoh. At the Paris Universal Exposition of 1889, Vonnoh was honored with a bronze medal for a portrait. By 1890, he had learned the basics of the impressionist technique. His *Peasant Woman's Garden* (Terra Museum of American Art, Chicago) is one of his most beautiful and impressive impressionist works. Vonnoh is the perfect example of an American painter influenced by impressionism outside of Monet's realm of Giverny.

Robert Vonnoh returned to America in 1891 to assume the position of principal instructor in portrait and figure painting in Philadelphia's Academy; he influenced such painters as Edward Redfield (1869-1965), William Glackens, Walter E. Schofield (1867-1944), and John Sloan. In 1900 he was elected an Associate of the National Academy. Vonnoh discovered the quiet artists' colony at Old Lyme around 1905. Vonnoh wrote an article himself, published in *Arts and Decoration*, in which he stated how he believed American artists were highly regarded abroad. He continued to win honors and medals, and his work was sought by collectors and museums. In America during the war, Vonnoh began to exhibit his works at Old Lyme and resumed his teaching at the Pennsylvania Academy in composition, landscape, and figure painting. He remained there until 1920; three years later came another solo show, at the Ainslie Galleries in New York, which traveled to Kansas City and Los Angeles. While working again at Grèz, Vonnoh experienced worsening eyesight. The year of Monet's death, 1926, Vonnoh was honored with another one-man exhibition, this time at the Durand-Ruel Galleries in New York. He remained in France, unable to paint, and died in Nice on 28 December 1933, while America was in its Great Depression.

68. JOSEPH VORST
(Essen, Germany 1897 - 1947 Overland, Missouri?)
Weighing Cotton
Oil on board, 48 x 46 in.
Unsigned

The multi-talented Vorst studied under a leading German impressionist, Max Liebermann (1847-1935), who had traveled to Barbizon and to Paris to see paintings by Manet first hand, including *In the Conservatory*, which ended up in Berlin. Liebermann would eventually purchase three Monets, two Cézannes, a painting by Pissarro, five by Degas and many more by Manet. Liebermann became the champion of French impressionism in Berlin.[125] His own style is much lower in key but his brushwork is dynamic. A year after Vorst was born, Liebermann founded the Berlin Secession. Vorst's home town of Essen acquired a collection of modern art in 1921, which became the Museum Folkwang, one of the earliest of its kind.[126]

Vorst made his way to Missouri, most likely to escape the Nazis, for we know that he was a member of the American Artists' Congress, and he signed the famous "Call" in 1936 at the group's first congress; this was a left-wing organization that stood up to combat fascism.[127] Also in 1936 Vorst exhibited *Missouri Mules* at the Art Institute of Chicago. His painting *Drifters on the Mississippi* and *Picking Strawberries* appeared there in two subsequent exhibitions. In 1939, Vorst's *Drought* was shown at the Corcoran Biennial and on a grander scale, many more visitors saw his *Madonna of the Tiff Miners* at the New York World's Fair. Also in 1939, Vorst was represented on the West Coast, at the Golden Gate International Exposition, with a work called *Fear*. In addition, during that busy year, Vorst completed a mural in the Vandalia, Missouri Post Office (*Corn Harvest*) but a year later his concept for another decorative project in the Paris, Arkansas Post Office, called *Rural Arkansas*, was accepted only after he agreed to make alterations. Critics wanted him to incorporate more modern farm implements – to replace his farmer with a simple plow.[128]

(TEXT CONTINUED ON PAGE 148)

[125] See Horst Uhr, "Impressionism in Austria and Germany," In *World Impressionism, The International Movement 1860-1920.* Ed. Norma Broude (New York: Harry N. Abrams, Inc., 1990), p. 359. An early monograph is Karl Scheffler, *Max Liebermann* (Munich: Piper Verlag, 1922) and more recently is Sigrid Achenbach and Matthias Eberle, *Max Liebermann in seiner Zeit* (Berlin: Nationalgalerie, 1979), in which a chapter is devoted to his collection of impressionist paintings.

[126] See Paul Vogt, *Das Museum Folkwang Essen* (Cologne: Verlag M. DuMont Schauberg, 1965).

[127] Matthew Baigell and Julia Williams, *Artists against War and Fascism: Papers of the First American Artists' Congress* (New Brunswick, NJ: Rutgers University Press), 1986.

[128] Marlene Park and Gerald E. Markowitz, *Democratic Vistas: Post Offices and Public Art in the New Deal* (Philadelphia: Temple University Press, 1984), p. 17.

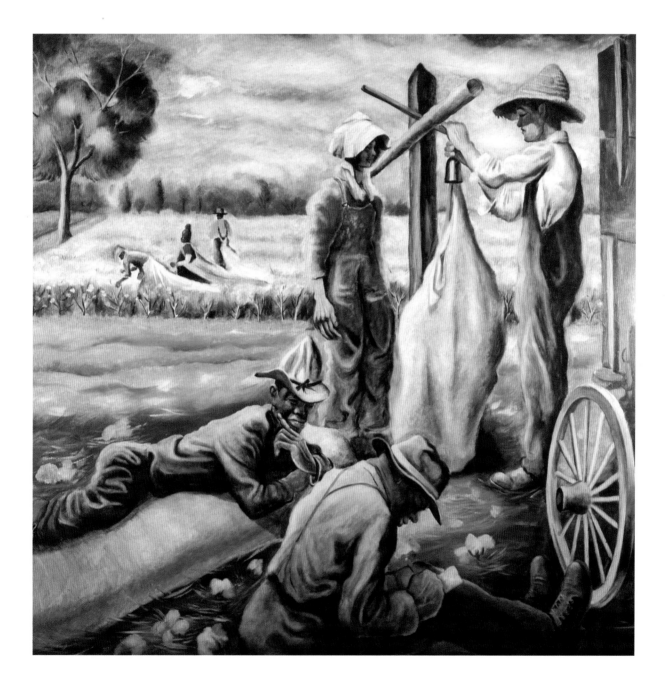

69. J. ALDEN WEIR
(West Point, New York 1852 - 1919 New York City)
Still-life with Copper Pot
Oil on canvas, 30 x 25
Signed lower left

Known as a leader of the National Academy and at the same time a member of the "rebels" who broke away from the Society of American Artists to form the Ten American Painters, mainly a group of impressionists, Julian Alden Weir[129] was the son of a painter, Robert Walter Weir (1803-1889), who was a friend of William Cullen Bryant. Teen-age Julian went off to the National Academy of Design to study, where he met William Merritt Chase and Albert Pinkham Ryder. In the fall of 1873 he discovered England and France: in Paris he passed the rigid entrance exam to the Ecole des Beaux-Arts and took lessons from Jean-Léon Gérôme. Weir went to Brittany, visited Holland, then had a painting accepted at the Paris Salon. He met everyone from Bastien-Lepage, Sargent, and J. Carroll Beckwith to Edouard Manet. Later he traveled to Spain to study Velázquez.

In 1877 Weir strolled through the French impressionists' third group show and was appalled: "I never in my life saw more horrible things." He was still under the spell of academic drawing and only later would he become sensitive to the impressionist way of seeing things. Another trip to Europe was arranged by the collector Erwin Davis who took Weir along to purchase paintings. Davis also accepted a painting from Weir in trade for a 150-acre farm in Branchville, Connecticut. There Weir created a strong bond with Twachtman who lived in nearby Greenwich. Around 1889-90, Weir's palette turned brighter and he began to use broken color as well as more vigorous brushwork.

In December of 1897 Weir joined others in forming the Ten, in order to find a more suitable exhibition space and to distance themselves from dilettantes and "business and society painters." Weir was highly successful in the exhibition of his paintings, which won awards. The conservative Weir was also connected to the group that organized the Armory Show, and as unlikely as it seems, he submitted thirteen works in different media. When John White Alexander resigned as president of the National Academy in 1915, Weir was elected to replace him. Weir's *Still-life with Copper Pot* was probably executed before 1890. During the early 1880s, he preferred to paint floral still-lifes, whose flowers are highlighted against dark backgrounds.

[129] See Dorothy Weir Young, *The Life and Letters of J. Alden Weir* (New Haven, CT: Yale University Press, 1960) and Doreen Bolger Burke, *J. Alden Weir, An American Impressionist* (Newark: University of Delaware Press, 1983).

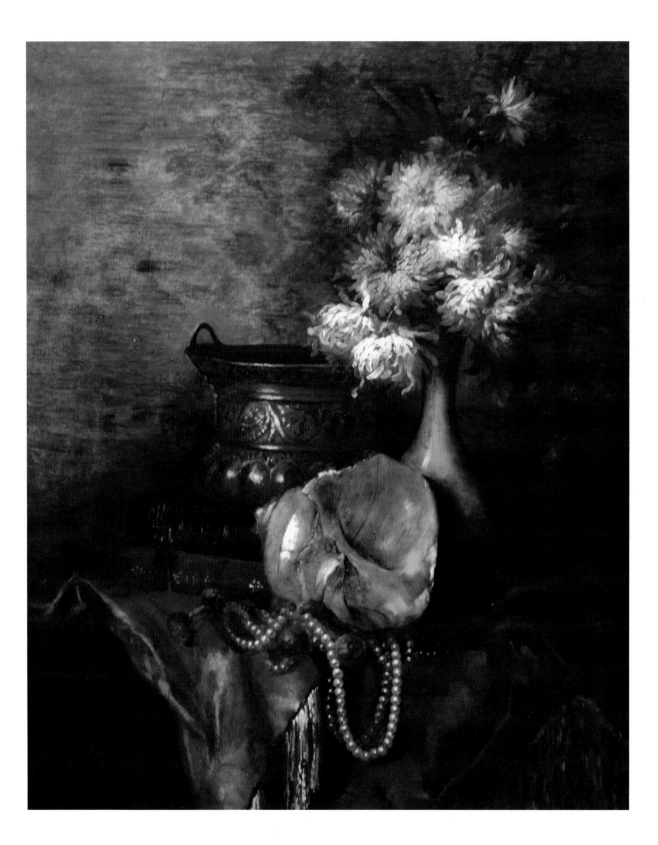

70. FREDERICK BALLARD WILLIAMS
(Brooklyn, New York 1871 - 1956 Glen Ridge, New Jersey)
The Interrupted Rehearsal
Oil on canvas, 24½ x 29¼ in.
Signed lower right

Williams, brought up in Bloomfield and Montclair, New Jersey, studied art at the Cooper Union, at the National Academy of Design and elsewhere. Following travels in Europe, Williams called Glen Ridge, New Jersey his home. Williams was active in the most prestigious artists' associations: the Lotos Club, the Salmagundi Club, The New York Water Color Club, and the National Arts Club. The National Academy presented him with the Isidor Gold Medal for his painting *Chant d'amour* (lost) in 1909 and a year later he took part in the Santa Fe Railway's organized excursion of artists to the Southwest, along with De Witt Parshall (1864-1956), Eliott Daingerfield, Thomas Moran and Edward Potthast. The destination of this group of painters was the Grand Canyon. One reporter explained, "This Western jaunt represents an early instance of corporate patronization of the arts for it was financed by the Atchison, Topeka and Santa Fe [Railroad] . . . never before had so large a group of serious artists made such a pilgrimage to the Far West with the avowed intention of studying a given point of their own country. . . and thus will this visit to the Grand Canyon become historical."[130]

The exhibition record of Williams is too extensive to outline here. Nine of his paintings were on view at the Pan-American Exposition in Buffalo in 1901. His works appeared regularly at the National Academy of Design, the Pennsylvania Academy, the Corcoran Gallery and the Boston Art Club. *The Interrupted Rehearsal*, an example of his idyllic landscapes, filled with eighteenth-century figures inspired by Watteau, seems to correspond to the Rococo revival that occurred in mural painting. Edward Shinn also went in that direction. These are imaginative, not plein air landscapes that were executed in the studio. For Eugen Neuhaus, who wrote a survey of American painting in 1931, Williams represented "a very special phase of American art," and he associated him with the visionary Blakelock and the Romantic school. He explained that Williams's "fondness for historical costume is not to be regarded as a slavish imitation of period characteristics, but rather as a result of the artist's conviction that in the rich silks and brocades . . . he finds the greatest opportunity for the emphasis of rich color and textural qualities which are so delightfully evident in his work."[131]

[130] Quoted in Arlene Jacobowitz, *Edward Henry Potthast 1857 to 1927* (New York: 1969).

[131] Eugen Neuhaus, *The History and Ideals of American Art* (Stanford University Press, 1931), pp. 238-239.

141

71. ALEXANDER WYANT
(Evans Creek, Ohio 1836 - 1892 New York City)
Landscape
Oil on canvas, 24 x 22 in.
Signed lower right

Young Alexander traveled through Ohio and Kentucky as a portrait and sign painter. The view of works by George Inness in Cincinnati in 1857 was a revelation — two years later Wyant met Inness. Following a disappointing trip to Germany, Wyant stopped in London and admired works by Constable. Wyant's early landscapes, according to one critic, showed "something of that harshness which is associated with the German school," but there is also a trace of the Hudson River School. Naturally, what he gleaned from studying the paintings of Inness contributed to a greater softness. By 1868 Wyant was an Associate of the National Academy and a full member only a year later. His works in the early 1870s demonstrate a greater feeling for atmospheric perspective. Wyant's *Landscape* in the Art Institute of Chicago made Peter Bermingham think of John F. Kensett (1816-1872) and Jasper Cropsey. Following a stroke, instigated by an arduous trip to the West, Wyant had to paint with his left hand. His works became smaller, more intimate and subjective in feeling. In 1878 he became a founding member of the American Watercolor Society and the Society of American Artists.

The moods of Wyant's landscapes vary. *Any Man's Land* (1880; Los Angeles County Museum of Art) is a stunning and impressive storm scene that immediately recalls Barbizon School painters Théodore Rousseau (1812-1867) and Narcisse Diaz de la Peña (1807-1876), while *An Old Clearing*, in the Metropolitan Museum of Art (1881) harks back to Hudson River School ideals. Spassky, however, notes "a looser, more textured surface, which reflects light and brightens the dark foreground."[132] But Wyant remained faithful to the golden-brown palette of the Barbizon School, while delightful impasto touches in the foreground often livened up the surface, suggesting a nod to impressionism. Our *Landscape* has none of the typical, golden-brown hues because it is a pure summer landscape from around 1882. The large, prominent tree is in the middleground, while we, the viewers, stand on a path in the center. One can easily argue that the crispness of detail and "German hardness" have disappeared. Eliot Clark wrote how, "as a result of this life in the country Wyant's work became not only more personal but more truly American." He pointed out as well that Wyant painted en plein air in the late 1870s and early 1880s.[133]

[132] Natalie Spassky, *American Paintings in the Metropolitan Museum of Art* (New York: 1985), p. 416.

[133] Eliot Clark, *Alexander Wyant* (New York: Privately printed, 1916), p. 39.

CONTINUATION OF ENTRIES

BENTON: *Lord, Heal the Child*, continued

> The healer started a hymn. The instrumentalists broke in. The congregation burst into voice. The rafters shook. Three or four roaring hymns were sung or stamped. Then the woman preacher started again. Her soft, careful voice droned on and on. The little child, the object of her attention, was asleep in an old man's arms. The church was still. Never in a Holiness gathering have I seen such quiet. [Later] tears rolled down the cheeks of the woman preacher. . . .[134]

The focal point is the preacher with the little girl. To the left in the final version are a trio of singers led by a conductor. Benton used his favorite diagonal composition, defined by the floorboards, while the directional movement of the preacher crosses this diagonal. She forms a classical triangular form, symbolic of her protection of the child.

A few preparatory drawings are known.[135] The painted sketch contains all the elements of the final version. It is kind of elaborate *ébauche*, a sketch whose emphasis is on broad areas, and in which there is very little detail and only three basic values, minimal modeling and a lack of facial features. Here the figures have a unified cubistic simplicity. All of the forms work wonderfully together in a repetition of the angular shapes of arms and legs and this interlocking of figures creates a perfectly balanced composition.

BUTLER: *Catskill Clove*, continued

Asher B. Durand wrote from the Catskill Clove to his son in September and October 1848, and described how difficult the access was. He used details of the area's geography for his famous painting *Kindred Spirits* (formerly, New York Public Library), which commemorates the friendship of Thomas Cole and William Cullen Bryant. Then in the following September, Durand returned to the area where he met John F. Kensett and others. Much later Sanford Robinson Gifford painted his dreamy amber-toned and mist-laden *Kaaterskill Clove* (1862; Metropolitan Museum of Art), and other painted sketches survive. In 1865 James David Smillie executed *Kaaterskill Clove*, now in the National Museum of American Art. It recalls *Kindred Spirits* with the figures on the ledge, and seems rather conventional. Also previous to Butler's version is Walter Launt Palmer's predominately blue *Catskill Clove* (Albany Institute of History and Art), a pastel dated 1880.

In *Catskill Clove*, Butler decided on a close-up view, dispensing with framing trees, ledges and accessory figures, as if the viewer is floating in the air. The V-shaped cleft anchors the simple composition and provides the opening into the distance where the eye is led. No painter before had

[134] Thomas Hart Benton, *An Artist in America*, 4th ed. (Columbia: University of Missouri Press, 1983), pp. 105-106.

[135] See Karal Ann Marling, *Tom Benton and His Drawings. A Biographical Essay and Collection of His Sketches, Studies, and Mural Cartoons* (Columbia: University of Missouri Press, 1985), figs. 3-3 and 3-4: *Little Girl at Holiness Service Tennessee* (?), ca. 1928-30; *The Holiness Band, Tennessee*, 1930-34. In addition, Gambone, 1989, fig. 1.6, illustrates *Holy Rollers, West Greenville, S.C.*, which is directly related to our painting.

used such a vibrant, dynamic palette, however, the color range is not entirely imaginary. A glance at Cole's version reveals the warm russet tones, bright reds, ochres and yellow-greens that one actually observes in the autumn at Catskill Clove. Nature's hues constituted a springboard for Butler who intensified the color scheme in the application of his own post-impressionist riot of broken color. It is almost as if in this work, a Fauve painter was being tamed by nineteenth-century naturalism. Certain details are pure Butler, and we recall slightly earlier works. For instance, the brilliant yellow sky resembles the one in Butler's own *Sunset, Giverny Church* of 1910.

HASSAM: *Newburgh, New York*, continued

The view from the house was superb — one could see all the way to West Point. Hassam visited Reynolds Beal at Newburgh as early as 1907-08 and he returned in the spring of 1916 and again in October of 1919.

We are looking toward the east, down a swiftly descending slope to the Hudson River, through a group of trees. The darkest mass, on the far right is balanced by three evenly spaced trees that provide a screen of verticals across the picture space. This dated work fits into Hassam's post-impressionist mode. A French impressionist would never have shown such marked contours to define the trees. In addition, rather than the usual closely juxtaposed strokes of broken color, which we associate with the earlier oils and watercolors, Hassam applied broader, almost violent brushwork and an expressionistic use of color -- note the surprising blue areas on the tree on the far left, which recall Franz Marc and the German Expressionists. Highly saturated blues and an autumnal orange are used overall. One might call this an experimental work but it is still within the realm of nature and plein-air cheerfulness. The solid structure is remarkable.

HOPKINSON, *Surf in Morning Sunlight*, continued

Surf in Morning Sunlight was exhibited at the Pennsylvania Academy in 1907 (cat. no. 264). At that time, the painter was renting a space in Boston's popular Fenway Studios, built after the Harcourt studio was destroyed by fire in 1904. This painting features a close-up view of a rugged coast whose focus, between two major diagonals, is a crashing wave, rendered in remarkably thick impasto. The general effect is decorative, reflecting the influence of Japanese prints: the hanging bough in the upper left is a specific Japanese motif. The stylistic element of juxtaposed areas of pure color also serves to heighten the effect of movement of the water. The artist sought to render a direct and spontaneous impression, using a plein-air style in bright sunlight, with blue and purple shadows, following the discoveries of the French impressionists.

MANSFIELD: *Niagara Falls*, continued

We know that Mansfield painted en plein air at Niagara Falls in the summer of 1904, however he worked on his Niagara paintings in his studio into the year 1906. For Frederic A. Sharf, these works "indicate a drama which had never been present in his landscape work."[136] David Huntington wrote how Niagara was "visited, described, photographed and painted more than any

[136] Sharf and Wright, 1977-78, p. 44.

other scene on this continent."[137] John Trumbull (1756-1843), Thomas Cole, Alvan Fisher (1792-1863), Samuel F. B. Morse (1791-1872), John F. Kensett, Albert Bierstadt, George Inness, and many others painted Niagara Falls but Frederic Edwin Church's 7½- foot-wide panoramic version in the Corcoran Gallery, dated 1857, is the most famous of all renderings. Some of Church's "grand and sublime" naturalistic effects may be recalled in viewing Mansfield's vertical format, in which the edge of the falls is the focus. Like Church, who abandoned "Old World" landscape compositional prototypes, Mansfield omitted the ledge or safe foreground zone where the viewer could look on from a distance. Instead, there is no foreground "buffer" area, and we hover directly over the water. Inness also achieved this effect in his version. One almost thinks of Turner in the outstanding rendering of foam, fine mist, rainbow and clouds, all different forms of moisture flowing marvelously together. Mansfield also suggests the thunderous noise of the falls, which seems less emphatic in Church's sweeping panorama.

PETERS: *Stream in Winter*, continued

Richard H. Love offers a more profound analysis: "With no figure present in the cold, bleak environment, Peters has presented the viewer a glimpse of Geneseeland's winter solitude. An icy stream meanders into the distance directly through the center of the composition, a device that recalls [Birge] Harrison and the picturesque photographs of [Rudolph] Eickemeyer. Winterbound, leafless trees line the banks of the stream, while snow provides a blanket that forbids human intrusion in the quiet wilderness. A small snow-covered island strip separates the stream as it carries chunks of snow and ice on its way through the countryside from the lower left of the picture to the middleground where it disappears from sight. On the far side of the stream's bank is a fence fairly buried by huge drifts. No doubt Peters worked up his large image from a smaller sketch, but he also spent a good deal of time working at his easel in the snow. . . Peters's brushwork is superb as he describes the movement of the icy water. Swirling crescent strokes portray fast-moving water, which in spite of its shallowness, seems almost ominous. With no less skill, he paints the snow in daring strokes of blue and white as a winter sun emits its strange effulgence."[138]

SMITH: *St. Gotthard Pass*, continued

In his day, Smith was celebrated: Tuckerman devoted several pages to his biography in 1867. He praised "the peculiar breadth and boldness – the remarkable freedom of touch and scope . . . the fresh and free interpretation of nature reproduced with singular vitality. Everything from his hand, in whatever department of art, breathed the fresh open air, sunlight, or impalpable shadow."[139] The setting is near Giornico on the St. Gotthard Pass (Tunnel), which, from the north, overlooks the Ticino, a canton in Southern Switzerland, bordering Italy. The Ticino River, on the canton's eastern border, appears through the foreground and gently meanders into the background. Two men in a

[137] David C. Huntington, *The Landscapes of Frederic Edwin Church: Vision of an American Era* (New York: George Braziller, 1966), p. 64.

[138] Love, 1999, p. 531.

[139] Henry T. Tuckerman, *Book of the Artists: American Artist Life. . . .* [1867]. (Reprint. New York: James F. Carr, 1967), pp. 518-521.

rowboat are transporting barrels. Immense mountains rise dramatically on both sides, and in the distance, even more spectacular, is a snow-capped mountain. Arthur Rimbaud described the road in 1878, "which is scarcely six meters wide . . . is filled up, all along the way, on the right by a snow drift nearly two meters high," and two years later, the American writer Constance Fenimore Woolson (1840-1894) said "the scenery on the St. Gotthard Road is wonderfully grand . . . The road, a model of engineering, was perfectly smooth, but so winding and dizzy, going in long zigzags on the edge of the most frightening precipices. . . ." Smith would have crossed the bridge erected in 1830. He also wrote on the region:

> Waterfalls abound every where, and many are of such size, height or beauty as would render other less favoured places in this aspect distinguished but here are too common. The snow covers all the higher alps entirely at present and lies in banks and clefts of those much lower coming down even to the [illegible] of the rivers. At the top of the pass of St. Gothard is all snow (middle of June). The lake frozen and the buildings, some rocks and the road showing partly through. The fallen avalanches lie in lower ravines in immense fields covering the [illegible].[140]

Here Smith used a classical Hudson River School-type composition with large, dark masses on either side of a central open area where the viewer is led back into space. The focal point is the snow covered mountain peak in the background. The buildings in the middleground, basically Italian in style with red tile roofs, are quite close to structures that are still to be found in the region today. Related to our painting is an 8 x 12-inch oil sketch, *Val Ticino, St. Gothard Route, Switzerland*, dated 1852, which was featured in two exhibitions.[141]

STACEY: *French Landscape*, continued

Although Stacey's palette was sometimes dark and murky, **French Landscape** is high-keyed in color. The viewer delights in shimmering broken color from an impressionist palette, a vigorous plein-air technique, a rich use of impasto in the foreground, vivid purple shadows, in sum, everything associated with the French aesthetic. Stacey must have been inspired by examples of pure American impressionism at Chicago's World's Columbian Exposition or perhaps he made a return trip to the region where this picturesque view of a village with ruins of a castle was painted.

VORST: *Weighing Cotton*, continued

One further post office mural came in 1942: *Time Out*, in Bethany, Missouri. Vorst re-exhibited *Picking Strawberries* in 1940 at the Pennsylvania Academy and a year later his work, *After the Flood* appeared there. In 1942 he exhibited *Refugees* at the Whitney Annual and a year later his *Good Lord Gives Peace* was on view at both the Corcoran Gallery and at the Art Institute. For two more years Vorst submitted paintings to the Whitney: *Family Festival* (1945) and *The Keeper*

[140] Archives of American Art, Smith Family Papers, roll 2036, frame 0419.

[141] Exhibited in *Russell Smith, 1812-1896. Romantic Realist. Paintings, Watercolors, Drawings* (Pittsburgh, PA: University of Pittsburgh, Department of Fine Arts, 1948). Later this oil sketch was illustrated at Vose Galleries: *Russell Smith (1812-1896): Views of Europe 1851-1852 and Later* (Boston: Vose Galleries, February 1981), p. 7.

(1946). Vorst worked as an illustrator for *Esquire* and executed lithographs. He died in 1947 at the age of fifty. In ***Weighing Cotton***, the figures occupy the right part of the composition, inside a simple right triangle. In the background area we see the cotton fields. Vorst abandoned most modernist precepts that he had learned in Germany, to develop a regionalist style, essentially naturalistic, and he seemed to delight in everyday, homespun themes from the world of the American worker.

BIBLIOGRAPHY

Adelson, Warren, Jay E. Cantor and William H. Gerdts. *Childe Hassam, Impressionist.* New York: Abbeville Press, 1999.

Albright, Adam Emory. *For Art's Sake.* Privately printed, 1952.

Alexandre, Arsène. *Frank Boggs.* Paris: Le Goupy, 1929.

Bermingham, Peter. *Jasper F. Cropsey 1823-1900.* Exh. cat. College Park, MD: University of Maryland Art Gallery, 1968.

Bernard LaMotte (1903-1983). Exh. cat. Boston: Vose Galleries, 1993.

Berry-Hill, Henry and Sidney Berry-Hill. *Ernest Lawson: American Impressionist 1873-1939.* Leigh-on-Sea, UK: F. Lewis Publishers, 1968.

Boyle, Richard J. *American Impressionism.* Boston: New York Graphic Society, 1974.

--------. *John Twachtman.* New York: Watson-Guptill Publications, 1979.

Burke, Doreen Bolger. *J. Alden Weir, An American Impressionist.* Newark, DE: University of Delaware Press, 1983.

Carr, V.E. "Carl R. Krafft." *American Magazine of Art* 17 (September 1926): 475-480.

Church, Emma M. "William Penhallow Henderson, Painter." *The Sketch Book* 5 (November 1905): 117-120.

Cikovsky, Nicolai, Jr. *The Life and Work of George Inness.* Outstanding Dissertations in the Fine Arts series. New York: Garland Publishing, 1977.

Clark, Eliot Candee. *Alexander Wyant.* Privately printed, 1916.

--------. *John Twachtman.* Privately printed, 1924.

Connecticut and American Impressionism. A Cooperative Exhibition Project Concurrently in Three Locations: The William Benton Museum of Art, University of Connecticut, Storrs, CT; Greenwich Library, Greenwich, CT; Lyme Historical Society, Old Lyme, CT, 1980.

DeShazo, Edith. *Everett Shinn 1876-1953: A Figure in His Time.* New York: Clarkson N. Potter, 1974.

Du Bois, Guy Pène. *Ernest Lawson.* New York: Whitney Museum of American Art, 1932.

E. Barnard Lintott. Exhibition of Oils, Watercolors and Drawings. Bridgehampton, Long Island, NY: Clayton-Liberatore Gallery, September 1970.

Elzea, Rowland. *John Sloan's Oil Paintings: A Catalogue Raisonné.* 2 vols. Newark, DE: University of Delaware Press, 1991.

Fairbrother, Trevor J. *The Bostonians: Painters of an Elegant Age, 1870-1930.* Boston: Northeastern University Press, 1986.

Feldman, Sandra K. *William Penhallow Henderson, The Early Years: 1901-1916.* Exh. cat. New York: Hirschl and Adler Galleries, 1982.

Frankenstein, Alfred. *William Sidney Mount.* New York: Harry N. Abrams, Inc., 1975.

George, Waldemar. *S. Ostrowsky.* Les Artistes Juifs series. Paris: Editions « Ars », n.d.

Gerdts, William H. *Masterpieces of American Impressionism from the Pfeil Collection.* Alexandria, VA: Art Services International, 1992.

--------. *Monet's Giverny, An Impressionist Colony.* New York: Abbeville Press, 1993.

Gerdts, William H. and Russell Burke. *American Still-Life Painting.* New York: Praeger Publishers, 1971.

Gerdts, William H. and Judith Vale Newton. *The Hoosier Group: Five American Painters.* Indianapolis: Eckert Publications, 1985.

Hale, John Douglass. "The Life and Creative Development of John H. Twachtman." 2 vols. Diss., Ohio State University, 1957.

Hiesinger, Ulrich W. *Childe Hassam: American Impressionist.* New York: Jordan-Volpe Gallery and Munich: Prestel-Verlag, 1994.

--------. *Impressionism in America: The Ten American Painters.* Munich: Prestel-Verlag, 1991.

Hoeber, Arthur. "John W. Alexander." *International Studio* 24 (May 1908): LXXXV-LXXXIX.

Ireland, LeRoy. *The Works of George Inness: An Illustrated Catalogue Raisonné.* Austin, TX: University of Texas Press, 1965.

Kane, Marie Louise. *A Bright Oasis: The Paintings of Richard E. Miller.* New York: Jordan-Volpe Gallery, 1997.

Knudsen, Elizabeth Greacen. *Edmund W. Greacen, N.A.: American Impressionist 1876-1949.* Jacksonville, FL: The Cummer Gallery of Art, 1972.

Lamarche, Mikaela Sardo. *Francis Luis Mora (1874-1940). A Legacy Reconsidered.* Exh. cat. New York: ACA Galleries, 2005.

Larkin, Susan G. "'A Regular Rendezvous for Impressionists': The Cos Cob Art Colony 1882-1920." Diss., City University of New York, 1996.

Leff, Sandra. *John White Alexander 1856-1915: Fin-de-Siècle American.* Exh. cat. New York: Graham Gallery, 1980.

Letsinger-Miller, Lyn. *Artists of Brown County.* Bloomington, IN: Indiana University Press, 1994.

Love, Richard H. *Carl W. Peters: American Scene Painter from Rochester to Rockport.* Rochester, NY: University of Rochester Press, 1999.

--------. *Harriet Randall Lumis: 1870-1953. An American Impressionist.* Traveling exh. cat. Chicago: R.H. Love Galleries, 1977.

--------. *Harriet Randall Lumis: Grande Dame of Landscape Painting.* Chicago: Haase-Mumm Publishing Co., 1989.

--------. *Theodore Earl Butler: Emergence from Monet's Shadow.* Chicago: Haase-Mumm Publishing Co., 1985.

Love, Richard H. and Michael Preston Worley. "The Genteel Tradition in American Painting." *American Art Review* 11 (March-April 1999): 156-163.

M'Cormick, W. B. "Louis Betts — Portraitist." *International Studio* 77 (September 1923): 523-525.

Moore, Sarah J. *John White Alexander and the Construction of National Identity: Cosmopolitan American Art, 1880-1915.* Newark, DE: University of Delaware Press, 2003.

Morse, Annie. *Capturing Sunlight: The Art of Tree Studios.* Exh. cat. Chicago: Chicago Department of Cultural Affairs, 1999.

Myers, Kenneth. *The Catskills: Painters, Writers, and Tourists in the Mountains 1820-1895.* Yonkers, NY: Hudson River Museum, 1987.

Pattison, James William. "Louis Betts — Painter." *The Sketch Book* 6 (December 1906): 171-180.

Peters, Lisa N. *John Henry Twachtman: An American Impressionist.* New York: Hudson Hills Press, in association with the High Museum of Art, Atlanta, 1999.

Schantz, Michael W. *Edmund Darch Lewis 1835-1910.* Exh. cat. Philadelphia: Woodmere Art Museum, 1985.

Schmoll, Anne W. *Charles Hopkinson, N. A. (1869-1962). Moods and Moments.* Exh. cat. Boston: Vose Galleries, 1991.

Sedeyn, Emile. "Frank Boggs." *L'Art et les Artistes* 18 (November 1913): 70-77.

Sharf, Frederic A. and John H. Wright. *Chronology and Partial Checklist of the Paintings and Drawings of John Worthington Mansfield, An American Artist Rediscovered (1849-1933).* Exh. cat. Essex Institute, 1977-78.

Stevenson, Minnie Bacon. "A Painter of Childhood." *American Magazine of Art* 11 (Oct 1920): 432-434.

Stuart, Evelyn Marie. "Annual Exhibition of Local Artists." *Fine Arts Journal* 32 (April 1915): 167-179.

Talbot, William S. *Jasper F. Cropsey 1823-1900.* Outstanding Dissertations in the Fine Arts series. New York: Garland Publishing, Inc., 1977.

Talbot, William S. *Jasper F. Cropsey 1823-1900.* Exh. cat. Washington: Smithsonian Institution Press, in association with the National Collection of Fine Arts, 1970.

Talbott, Page and Patricia Tanis Sydney. *The Philadelphia Ten: A Woman's Artist Group 1917-1945.* Philadelphia: Moore College of Art and Design, 1998.

Torchia, Robert Wilson. *The Smiths: A Family of Philadelphia Artists.* Exh. cat. Philadelphia: Schwarz, 1999.

Warshawsky, Abel. *The Memories of an American Impressionist* [1931]. Kent, OH: Kent State University Press, 1980.

Weber, Bruce. *The Giverny Luminists: Frieseke, Miller and Their Circle.* New York: Berry-Hill Galleries, 1996.

Young, Dorothy Weir. *The Life and Letters of J. Alden Weir.* New Haven, CT: Yale University Press, 1960.

INDEX

156